Trout of the World

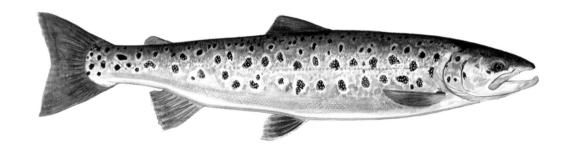

GEGARKUNI ISHKHAN, SEVAN LAKE, ARMENIA

Salmo ischchan gegarkuni

Trout of the World · James Prosek

Revised and Updated Edition

ABRAMS, NEW YORK

FOR JOHANNES SCHÖFFMANN

———

This edition published in 2013 by Abrams, an imprint of ABRAMS
115 West 18th Street · New York, NY 10011

ISBN for the 2013 edition: 978-1-61769-023-5

The Library of Congress has cataloged the 2003 edition of this book as follows:

Library of Congress Cataloging-in-Publication Data
Prosek, James, 1975- Trout of the world / James Prosek
p. cm. Includes bibliographical references (p.).
ISBN 1-58479-152-7
1. Trout. 2. Trout fishing. I. Title.
SH167.T86P84 2003
799.1'757–dc21 2003054387

10 9 8 7 6 5 4
PRINTED IN CHINA

Abrams books are available at special discounts when purchased in quantity for premiums and
promotions as well as fundraising or educational use. Special editions can also be created to specification.
For details, contact specialsales@abramsbooks.com or the address below.

ABRAMS The Art of Books
195 Broadway, New York, NY 10007
abramsbooks.com

Contents

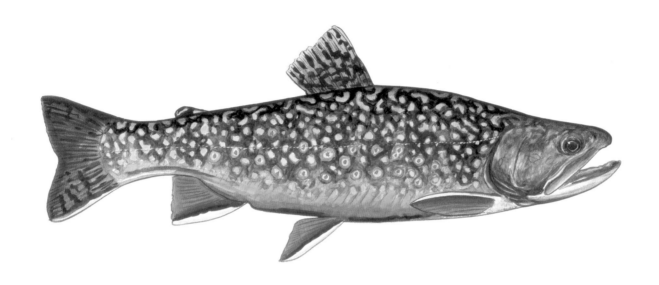

ADIRONDACK BROOK TROUT, ST. REGIS RIVER, WEST BRANCH, NEW YORK STATE

Salvelinus fontinalis

Preface

It has been nearly ten years since the publication of *Trout of the World*, the result of six focused years of travel in an effort to document diversity of the trout of Europe, Asia, and North Africa. I had an opportunity to expand the book, so I have painted thirty new fish, replacing some and adding new ones based on new discoveries. For instance, as a result of the research of Aleš Snoj and Johannes Schöffmann in remote parts of the Atlas Mountains of Morocco, our knowledge of the evolution of African trouts has grown. I've also included a handful of North American trout—ten, to be exact—to make this truly a book on the trout of the entire world (trout are native only to the Northern Hemisphere). These North American trout were chosen based on personal biases. I just like them.

Because this new edition contains more fish yet the same number of pages, we doubled fish on some of the pages, which has granted me (and, I hope, the reader) the opportunity to compare characteristics of two fish more intimately. The primary point is to bring to light some of the amazing beauty I have had the good fortune to witness by spending time around, and probing into, our precious few remaining coldwater wildernesses.

This book is a collection of paintings of 120 individual trout, but it is also a single statement about natural diversity. I have deliberately chosen to paint populations of fish within a species category (like *Salmo trutta*, the brown trout) for which there are no names. My intent is to show that all diversity is worth preserving, not just that which has been placed in a category constructed by humans for the convenience of communication. In the process of making this book, as well as its predecessor on the trout of North America (*Trout: An Illustrated History*, Knopf, 1996), I began to wonder, after painting hundreds of specimens, about how we communicate natural diversity. I had discovered that taxonomists could not agree on how many different kinds of trout there were. So I was forced to ask the question, how is that determined? This led to an ongoing personal inquiry into how we divide, name, and order nature in general. Where do you draw lines in nature? How do you decide to give a name to one creature and not another? Some of my thoughts on taxonomy and classification in their current state—they are always changing—can be found in the introduction to the North American trouts on page 211.

Why trout were the creatures that pulled my heartstrings as a youth, I cannot say exactly. But they persist in doing so. If I'm given the opportunity, this work will only continue to expand over the course of my life, to itself evolve like the trout and all living creatures.

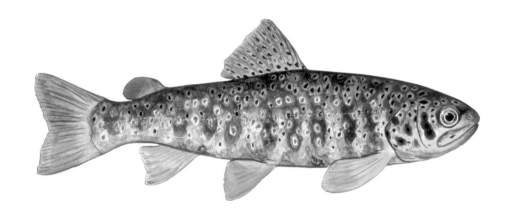

TIGRIS TROUT, ÇATAK ÇAY, EASTERN TURKEY

Salmo trutta

Introduction

Such was my passion for fishing in college that any mention of a spring or brook in literature set my mind to wondering about the trout that dwelt there. The Greek Muses were always found by fountains and streams, especially the spring Hippocrene on Mount Helicon created by the hoofprint of Pegasus. I also read of the Castalian spring on the side of Mount Parnassus, sacred to Apollo, the god of light, music, and poetry. In *Paradise Lost,* John Milton wrote of the springs that bubbled forth in the Garden of Eden. These seemed especially tantalizing:

> There was a place…
> Where Tigris at the foot of Paradise
> Into a Gulf shot under ground, till part
> Rose up a Fountain by the Tree of Life

This spring must still be there, I thought, and as far as I knew, it was within the native range of the brown trout. A glance at my world atlas showed that the headwaters of the Tigris snaked out of the mountain ranges of eastern Turkey, south of Mount Ararat and Lake Van. But who knew for sure if there were trout there, let alone had been there to catch them?

I began to entertain the idea of searching for the Tigris trout and wrote a letter to eminent ichthyologist Robert Behnke at Colorado State University to see if he had any information. "I know of only one man who has caught trout in eastern Turkey," Behnke replied several weeks later. "His name is Johannes Schöffmann, and he lives in southern Austria." Behnke knew of Schöffmann primarily through his articles in the Austrian journal, *Österreichs Fischerei*. Schöffmann had published the only recent information on the trout of the Euphrates River, as well as those of Morocco, Lebanon, and the Balkans. I wrote to him in the winter of 1995, and he replied with an invitation to visit him at his home in Austria.

While on a trip to Europe in the summer of 1996, I arranged to meet Schöffmann and detoured from Paris seventeen hours by train to his village, Sankt Veit an der Glan, near the southern Alps. He met me at the station, and we drove the short distance to his home, a small apartment on the floor above a bakery. By the professional nature of his articles it was natural to assume that Schöffmann had been formally trained in ichthyology. It was, therefore, a surprise to learn that he was a baker.

Communicating in our best mutual language, which happened to be Spanish, Johannes introduced me to his family. His wife,

Ida, welcomed me as some rare being who possessed a passion for trout equivalent to her husband's. Their two children also knew, but perhaps did not fully understand, the extent of their father's monomania for trout. Johannes, therefore, was pleased to share his photographs and discoveries with me. Taxidermic specimens of trout from Turkey, Spain, Greece, and Croatia hung in his den above shelves of reference books on freshwater fishes in many languages.

The next day, Johannes, Ida, and I made an excursion to Slovenia and the emerald Soca River. It was not until we began to fish, in an area closed to fishing, that I learned Johannes's unique method of collecting trout. He donned a wetsuit, dove into the river, and chased the trout under stones, coaxing them into a small handheld net. His efficiency and speed were remarkable, and in several minutes he had captured two specimens of *Salmo marmoratus*, the marble trout. The marble trout, peculiar to rivers flowing to the Adriatic Sea, was a deep golden-olive color with light vermiculated markings, resembling polished marble. Later that day—over wine, prosciutto, and grilled calamari at a nearby café—we discussed the beauty of the fish and talked of all the places in the world we dreamed of fishing for native trout. Johannes mentioned that his next expedition, planned for the following summer, would be through the Balkans, Greece, and Turkey, the ultimate task being to catch a specimen of trout from the Tigris River. He invited me to come along.

In the summer of 1997, we traveled in his Land Rover from Austria through Italy, by ferry to Greece, and into Turkey. Along the way we fished rivers and streams of the Mediterranean, Adriatic, Black, and Caspian Sea basins. Together we caught many trout in hues from golden to amber to olive, each type possessing its own distinctive pattern of red and black spots and its own unique spirit. We were excited by these successes, but Johannes was determined to reach the headwaters of the Tigris. Very little was known about the Tigris trout; for this reason they were of paramount importance to him. The only written information Johannes could find was published by the Italian biologist Enrico Tortonese of Torino University in his paper, "The Trouts of Asiatic Turkey" of 1954. The single female specimen Tortonese observed was from a stream he called Sitak, in southeast Anatolia, which was most likely a village and river called Çatak.

Two weeks into our journey, we reached the Tigris River and the headwater streams near the Iraqi border, inhabited by the trout of Eden. The garden, however, was not so easy to enter again. Southeast Turkey had been occupied for many years by the Turkish military in an effort to keep the Kurdish people from separating and establishing their own nation of Kurdistan. For this reason, we had trouble gaining access. The members of the military warned us of Kurdish guerrillas in the hills. They told us we could be kidnapped and taken hostage, but we were persistent. Army personnel searched our vehicle to see if we were a threat, but at last we appeased them with cartons of cigarettes. They laughed and started to believe that we actually wanted to catch *alabalik*, or trout.

A van of police officers escorted us to a stream near the town of Çatak, about thirty miles from the Iraqi border. We were allowed three hours to fish in a swift and freezing-cold river and caught nothing. It did not look promising. Tanks and armored vehicles lined the road as the army prepared for a military operation in Çatak that

evening. We abandoned our mission and headed west again toward the Mediterranean coast.

Johannes was disappointed by our first effort but not deterred. Five years later, in the autumn of 2002, he returned with Ida to southeast Turkey, convinced the military to let him go where he wanted, paid Kurdish militia members to guide him to the streams, and caught six specimens. Johannes observed unique characteristics—large rounded fins and irregular black and red spots—and marveled at the thought that this trout had evolved in isolation over several thousand years.

My passion for fishing as a boy led me to an admiration of trout, and at the age of nine I began painting them in watercolors. Colorful and streamlined, they seemed to occupy a mysterious realm within the most pristine coldwater wildernesses. I first painted the native brook trout of my home streams. Then I began to research what other trout lived in North America. That research culminated, ten years later, in the publication of a book of seventy watercolors of North American trout. I next wished to seek out and document in watercolors the trout of Europe, Asia, and North Africa.

The trip to Turkey with Johannes was the first in a series of expeditions over six years in this attempt to catalog the biodiversity of the world's trout. This did not include trout from the beautiful streams of Patagonia, South Africa, or New Zealand, as these trout are introduced (there are no native trout in the Southern Hemisphere, or even south of 24° north latitude). I soon discovered after traveling from Iceland to Kyrgyzstan, Sardinia to Mongolia, Spain to

Kamchatka, that if my mission was to paint all the variations of trout the world over, then I had embarked on an impossible task. The trout were different not only in every country, island, or basin, but from every major river drainage, or sometimes within the same lake or stream. I wondered how such remarkable diversity of color, form, and pattern had come about.

Over millennia, trout have survived monumental climatic changes, notably the advance and retreat of glaciers. The ice forced the trout in the northern regions to find refuge in more southern rivers or in the oceans. At the end of the last Ice Age about thirteen thousand years ago, trout began to re-colonize rivers and lakes in northern latitudes that had been frozen for thousands of years. As the glaciers retreated, water from the melting ice allowed trout to permeate waterways previously unavailable to them. When much of the melted ice flowed back to the ocean, these trout were left stranded in different drainages. In isolation they adapted to diverse habitats and conditions and evolved into the many varieties of trout that exist today.

In 1653, Izaak Walton published his observations concerning the native trout of England in his *Compleat Angler:* "And you are to note, that there are several kinds of trouts, but these several kinds are not considered but by very few men, for they go under the general name of trouts." Walton observed and noted diversity in tame pigeons, in spiders, and many kinds of fish, but in "trouts especially, which differ in their bigness and shape, and spots, and color." Sir William Jardine in his *British Salmonidae* of 1841 also marveled at the many variations in color and form among trouts of Scotland: "In

waters of greater extent, the varieties are very remarkable. Sometimes almost every bay has its 'kind' of trout; and the opposite sides of an island, a few acres in extent, oftentimes affords trout very different both in markings and in quality." Ichthyologist Albert Günther was baffled while trying to classify the many kinds of char he had observed in 1866: "There is no other group of fishes which offer so many difficulties to the ichthyologist with regard to the distinction of species as well as to certain points in their life history as this genus." Anglers on fabled Lough Melvin, Ireland, have given names to the different types of trout they observed within the lake: gillaroo, sonaghen, and ferox. Similarly on Lakes Ohrid in Macedonia and Sevan in Armenia, several sympatric (or co-occurring) forms are recognized by local fishermen: *kharmrakhait*, *gegarkuni*, *bahtak*, *ishkhan*, *yabani*, and *bodjak*.

In the nineteenth century, over fifty species classifications were given to describe the brown trout in the United Kingdom alone. It is for the most part accepted today that these British trout all belong to a single highly variable species, *Salmo trutta*. Since then, hundreds more subspecies of trout and char have been described, but many are now considered doubtful. Ichthyologists, as Günther attested, have been frustrated by trying to account for the immense diversity of the trout under the terms of Linnaean classification. It is not so easy to fit millions of years of evolution into neat little boxes, much as we'd like to. Although classification on the subspecies level can prove valuable—not only as a platform for discussing an organism's place in the evolutionary web, but also as a conservation tool—I am partial to Darwin's opinion on this subject from *The Origin of Species*: "It is immaterial for us whether a multitude of doubtful forms be called species or subspecies or varieties; what rank, for instance, the two to three hundred doubtful forms of British plants are entitled to hold, if the existence of any well-marked varieties be admitted."

Modern taxonomy sees the trout in terms of evolutionary branches based on genetics, not morphology (the study of physical form and structure of organisms on which older taxonomic standards were founded). Biologists like Louis Bernatchez at Laval University in Quebec and Aleš Snoj at Ljubljana University in Slovenia, are studying DNA in order to define the characteristics that make each population of trout distinctive and to create a map of their evolutionary history. Knowledge of the current genetic work combined with my own observations of the physical appearances and habits of thousands of trout over thousands of miles have helped create an even clearer picture of trout evolution. (The classifications in this book take into account these observations, along with environmental pressures, sociology, morphology, and genetics.) Sadly, it is becoming more and more difficult to gather any living data, as the native trout are rapidly vanishing.

In a relatively short time, especially since the beginning of the twentieth century, trout habitats have been reduced and degraded by war, dams, mining, pollution, and irrigation. In regions throughout Turkey, the Balkans, Armenia, and Kyrgyzstan, survival of the people is a priority and conservation is a luxury. Explosives, bleach, nets, traps, and stream diversions are employed to catch and snare trout for food. I often wished I'd arrived on these streams at least a hundred years before and witnessed their trout populations at peak abundance.

In some cases Johannes and I devoted three weeks of rigorous travel by vehicle and foot in search of a single specimen.

What is so alarming is the ease with which native fish populations can be destroyed; we can exterminate an entire migration of salmon, for instance, by constructing a single dam. Many unique populations have already been decimated, like the giant migratory brown trout of the Caspian Sea, which once attained weights in excess of one hundred pounds. We should be conscious of, humbled by, and careful with the powers to alter nature that lie within our hands. The introduction of the predatory Nile perch to Lake Victoria, East Africa, upset the native populations of cichlids, once (arguably) the most diverse and interesting concentration of native fish species in the world. Tijs Goldschmidt wrote in his book, *Darwin's Dreampond*, that "all it had taken to cause the total disruption of the ecosystem of the largest tropical lake in the world was a man with a bucket."

In an ecosystem controlled by man, the species that is most easily propagated artificially in hatcheries may eventually be selected to survive. The rainbow trout, in that case, will dominate. The lesser-known subspecies, varieties, and strains will be preserved only in isolated pockets, as the ever-changing evolutionary web is reduced to a trout zoo.

But all is not lost yet. There are still pristine mountain brooks and spring-fed streams winding through hay fields; there are still fern-covered pools thinly veiled from our societies. I have often found hope, identity, and purpose in such places and in the beauty of the trout that inhabit them. The ephemeral and mysterious brilliance of the trout have influenced the music of Franz Schubert, the paintings of Gustave Courbet and Winslow Homer, the poems of Alfred Tennyson and W. B. Yeats. The trout, like the lone angler who chases them, is an ideal, a symbol of a life apart from the ruckus of business and politics. As you leaf through these pages, I hope the trout will engage you with their vitality.

BROWN TROUT AND ATLANTIC SALMON

PARTLY BECAUSE of the varied and far-reaching habitats it has adapted to, the brown trout is among the most diverse vertebrate species on the planet. "There is some five times more genetic diversity among brown trout populations in Ireland alone," writes Andrew Ferguson of Queens University in Belfast, "than among human populations throughout the world."

Originally described by Linnaeus in 1758 as *Salmo trutta*, the brown trout's native range is in itself vast—from Iceland in the west to Afghanistan and Kyrgyzstan in the east, from the coastal rivers of the Barents and White Seas in and above Norway and Russia in the north to the brooks of the Atlas Mountains in North Africa in the south. In the nineteenth and early twentieth centuries, the variations in its coloration and spots led its admirers to name over fifty species, most of which are now considered doubtful.

Modern salmonid ichthyologists agree that there are several ancient lineages of brown trout, but how these lines are defined and how long they have existed are not often clear. "The genetic variation in brown trout," claims Robert Behnke, "is not clearly partitioned by geographical regions as is the case with the four major subspecies of cutthroat trout." When considering the evolution of brown trout, one must realize that the last glaciation, which commenced about seventy thousand years ago, covered most of northern Europe and Asia. Trout were absent from these regions until the ice began to melt and retreat about thirteen thousand years ago, when they re-inhabited the new waterways from the oceans. Some more ancient trout had survived in glacial refugia, or unique areas left untouched by glaciers. These relict populations were often joined by post-glacial invasions of other varieties.

I have organized the brown trout more or less from west to east, starting in Iceland and Scandanavia and working along the coast of northern Europe, heading south through the United Kingdom, France, Portugal, and Spain to North Africa, then east through Italy, the Balkans, Greece, and Turkey into Central Asia, where the curve straightens out with a median of about 41° north latitude.

The Atlantic salmon, *Salmo salar*, is an anadromous (spawning in freshwater rivers and spending its adult life in the sea) relative of the brown trout. It is native to rivers on the Atlantic Coast of Europe from Portugal to northern Russia, as well as the rivers of Iceland. The Atlantic salmon is now endangered through much of its native range.

Sea-run Brown Trout, Hafralónsá River, Iceland

Sea Trout, Karup River, Denmark

Irish Sea Trout, Erriff River, Ireland

THE INSTINCT to migrate to the sea is common among brown trout populations where access to salt water is available. This is thought to be the case because the trout's ancient ancestors came from the sea (although an opposing school maintains that the earliest trout evolved in freshwater and were forced into the salt by advancing glaciers). Sea trout inhabit rivers and streams flowing to the sea in Iceland, and from the Iberian Peninsula at the 42nd parallel northward along the coasts of western Europe to the Baltic, North, Barents, and White Seas.

Although they are anadromous like the Atlantic salmon, sea-running brown trout do not make the journey of thousands of ocean miles that salmon do; instead they mostly feed in the estuaries and bays, returning up rivers to spawn. Still, some brown trout must have been oceangoing to have colonized Iceland from Europe, though they did not make it as far west as North America like their cousins, the Atlantic salmon.

Although sea trout are not commonly thought to have made long upstream journeys, those of the Dunajec River of Poland, whose headwaters are in Slovakia, were large lean trout that migrated several hundred miles from the sea to their spawning grounds. The characteristics of the Dunajec fish—silver sides, lean shape, and long journey—led many to confuse this species of trout with Atlantic salmon. The Russian ichthyologist Leo Berg wrote in the 1930s, "if it is true that the salmon ascending the Vistula to the Dunajec is *Salmo trutta,* then the sea trout migrates very far."

Sea trout fishing is a cult activity in Europe, especially in the United Kingdom, Denmark, Sweden, and Norway, where it is done at night with dark flies and specialized tackle. My friend Pierre Affre pulled many a good sea trout from the tidal streams of Normandy as a child, though sadly the waste runoff from pig farming eventually destroyed the best fishing. Entire books have been devoted to secrets of sea trout fishing, most notably those by Hugh Falkus. In Scotland there are many local names to describe the different life stages of sea trout: herling, hirling, whitling, phinnock, silverwhite, blacktail, and bull-trout. In coloration, sea trout can vary greatly, especially in the number and size of spots. They are bright silver when first returning from the sea but turn darker, with orange and brown hues toward spawning. Brown trout, unlike the Atlantic salmon, continue to feed in the river as spawning approaches.

If you're ever up around the town of Thórshöfn, Iceland, along

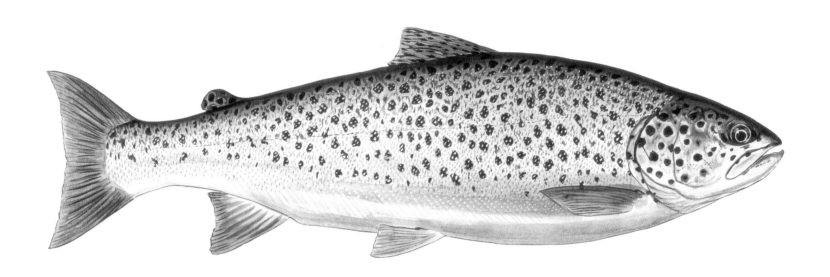

SEA-RUN BROWN TROUT, HAFRALÓNSÁ RIVER, ICELAND

Salmo trutta

BROWN TROUT: ATLANTIC TROUTS

19

the rough, rugged coast, be sure to pack a fishing rod and make an occasional cast in the roadside ponds with outlets to the sea. You may be surprised at what you catch among the surroundings of fallen sod roof homes, rounded stones, sheep, and driftwood.

One cool September morning while fishing the estuary of the Hafralónsá River in northeast Iceland, under a stiff north wind from the Greenland Sea, I felt a strong tug. I had been salmon fishing with flies for three days and hadn't caught a fish yet, so I was happy to find a trout on my line. Sea trout have saved more than a few otherwise "skunked" or "blank" days of salmon fishing. When the fish came closer, I saw it was a good trout, maybe 3 pounds (1.4 kg), and its large black spots were so close together that they almost linked, giving the illusion of a dark field behind white spots. When I pulled it up onto the bank, I marveled at its markings against the green Icelandic grass.

The Danish fish (opposite) was painted from a specimen caught in the Karup River by Mogens Thomassen, the head of the local Karup fishing club. The trout grow exceptionally big there, up to 40 pounds (18.1 kg), according to Danish ichthyologist Michael Hansen.

The Irish sea trout is from the Erriff, a spate river in the Connemara region of west Ireland. There are sea trout in almost every river of the Connemara as well as in most lakes. Unfortunately, there has been a dramatic decline in the numbers of sea trout returning to all these Irish rivers because of a proliferation of sea lice from the artificial propagation of Atlantic salmon in coastal bays.

Some of the most astounding sea trout fishing today is in the Rio Grande River of Argentina's southern tip, on Tierra del Fuego. The trout were introduced there from England nearly a hundred years ago, obviously a strain with a propensity for sea migration. These monsters sometimes weigh in excess of 30 pounds (13.6 kg), are thick and silver, and even leap when hooked, sometimes several times.

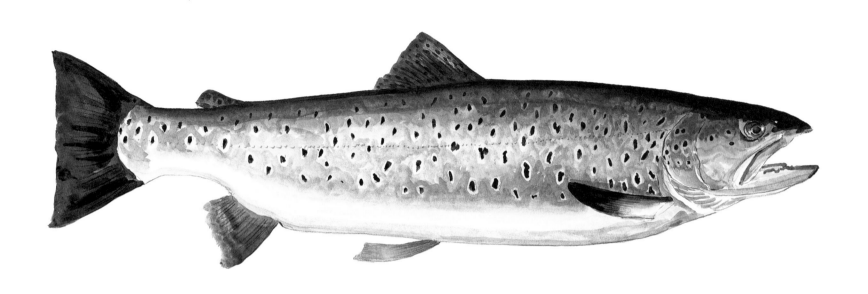

SEA TROUT, KARUP RIVER, DENMARK

Salmo trutta

BROWN TROUT: ATLANTIC TROUTS

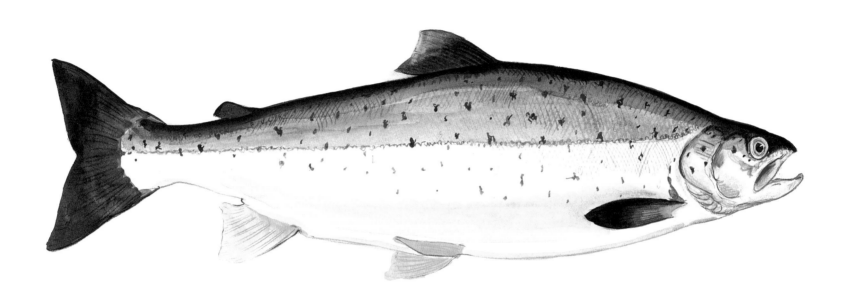

IRISH SEA TROUT, ERRIFF RIVER, IRELAND

Salmo trutta

BROWN TROUT: ATLANTIC TROUTS

23

Non-marmorated Brown Trout, Otra River, Norway

Marmorated Brown Trout, Otra River, Norway

"ALTHOUGH some of the species in the family *Salmonidae* are among the most extensively studied fish," writes Oystein Skaala, an ichthyologist of Bergen, Norway, "potentially interesting populations have still not been studied, and populations with novel and undescribed features are still encountered." Skaala has found one such novel trout in the Otra River of Norway. He is studying why some of the trout of this river, which flows through the Setesdal Valley of southern Norway and drains into the Skagerrat at Kristiansand, exhibit an interesting pattern of spots that are almost linked, to form a series of wormlike markings.

Local fishermen along the Otra have long recognized the strange morphs (or forms) of trout coexisting with the "normal" native brown trout. They call it the tiger trout. The coloration of these Otra trout vary from more typical brown trout to the marmorated form (from the Latin *marmor,* marble), with some exhibiting characteristics of each. The marmorated trout have a brick-red to greenish field cut with lighter vermiculations, like the winding branches of a river

delta. Skaala makes it clear that this pattern is not a result of hybridization with char (in America they produce a hatchery hybrid between a brook trout and a brown trout called a "tiger trout," which is sterile) but simply an aberration. Skaala's study found no significant genetic differences between the common brown trout form and the marmorated one. He concludes that the results "indicate a colonization by two or more separate lines," which presumably invaded the river at different periods during the end of the last glaciation and now form a "randomly mating population."

Such atypical markings are seen in other trout populations related to *Salmo trutta,* like the marble trout of the Adriatic Basin, *Salmo marmoratus*; the flat-headed trout of Turkey, *Salmo platycephalus*; and occasionally trouts of the Ling River in Scotland, Lough Mask in Ireland, and Lake Poschiavo in Switzerland, where large spots are often so close together that they begin to join and marbling occurs. One could theorize that this pattern evolved as a sort of camouflage for the fish against the uneven texture of the river bottom.

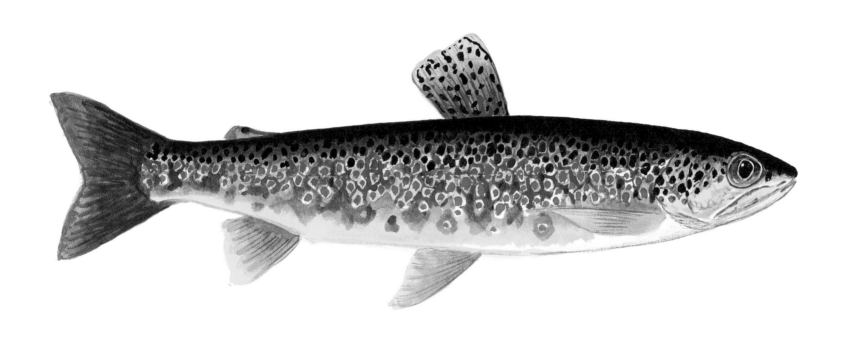

NON-MARMORATED BROWN TROUT, OTRA RIVER, NORWAY

Salmo trutta

BROWN TROUT: ATLANTIC TROUTS

25

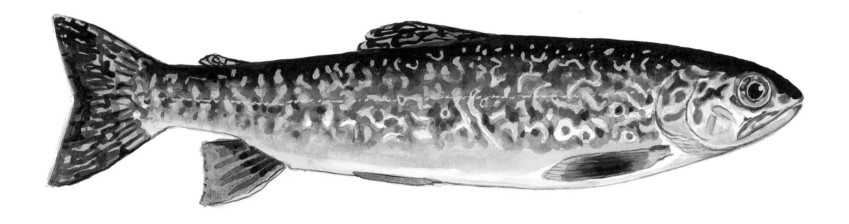

MARMORATED BROWN TROUT, OTRA RIVER, NORWAY

Salmo trutta

BROWN TROUT: ATLANTIC TROUTS

Fine-spotted Brown Trout, Lake Svartavassjonn, Norway

ONE-THIRD of the population of trout in this lake in the Hardanger-vidda area of Norway display a "fine-spotted" characteristic—small black spots covering the body, the dorsal fin, and the tail, with four to seven spots around the pupil of the eye—while the others are like common Atlantic drainage trout. Oystein Skaala attempted through genetic analysis to find out if this fine-spotting is a characteristic that evolved long ago and survives only in relict populations, or if it's a mutation that has arisen since post-glacial colonization. He notes that this is the only known population of fine-spotted trout in Norway.

The conclusion from his electrophoretic genetic analysis was that the trout of this lake carried an ancient allele, the same allele found by Andrew Ferguson in some brown trout populations of the United Kingdom stranded above natural barriers with no access to the sea. According to Skaala, this means that the fine-spotted and other more ancient brown trout that carry this allele "may have colonized rivers and lakes in Britain and Ireland [and Norway] in immediate post-glacial times, while a second colonization took place by migratory brown trout characterized by a younger allele in more recent times." They both hypothesize that this more "ancient" fish colonized the rivers and lakes from the sea, "very early after the retreat of the ice."

Skaala writes that the current genetic methods are limited because they are examining only a few genes. He assumes that more intricate variation will undoubtedly be found in another part of the genome as methods of analysis improve.

As will be shown, fine-spotting occurs in other populations of *Salmo trutta*, in North Africa, southern Spain, Corsica, some streams in the Appenines of northern Italy, and in northwest Iran. No doubt there are others as well.

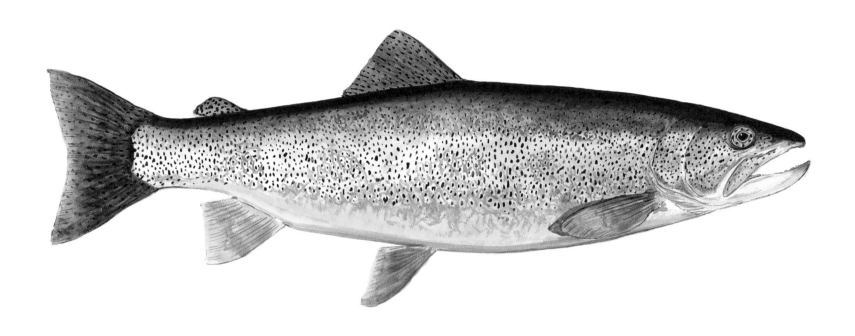

FINE-SPOTTED BROWN TROUT, LAKE SVARTAVASSJONN, NORWAY

Salmo trutta

BROWN TROUT: ATLANTIC TROUTS

29

Brown Trout, Black Forest, Germany

TROUT FROM the headwaters of the Rhine River in the Schwarzwald, or Black Forest, of western Germany were the first population of *Salmo trutta* to be successfully introduced to North America. The famous shipment of these trout across the Atlantic in 1883 was sent as a gift by Frederich Felix von Behr, head of the German fisheries society, to the American fish culturist Fred Mather, after meeting him at the International Fisheries Exhibition in Berlin in 1880. The brown trout has since become perhaps the favorite trout among American fly fishers.

I have caught many a gorgeous specimen of this brown trout from little creeks that run through dairy farms and woodlands of my home state of Connecticut. If you closed your eyes and smelled the spring air, heard the cuckoos calling and the cows lowing, you could mistake your surroundings for the Schwarzwald itself. The bellies of these small wild fish are yellow like the just-blooming marsh marigold, and their yellow fins are often tipped with white and slim margins of black. Their sides are covered with vermillion and black spots haloed in areolas of white. All of these are typical characteristics of trout from Atlantic drainages.

Some of my fondest memories of fly-fishing as a boy are of catching descendants of those German fish as they rose to take sulfur-colored mayflies.

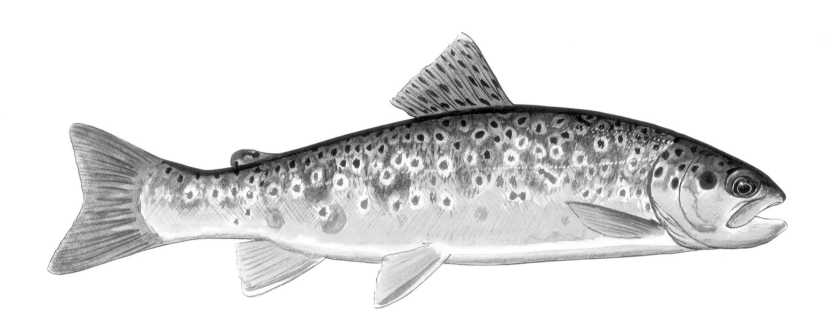

BROWN TROUT, BLACK FOREST, GERMANY

Salmo trutta fario

BROWN TROUT: ATLANTIC TROUTS

Brown Trout, Lough Mask, Ireland

In western Ireland the ritual of trout and mayfly is as much a part of the culture as wool sweaters and fine whiskey. Anglers migrate to the vast loughs of Corrib and Mask in May to witness this harbinger of spring, the emergence of the mayfly and the large trout that come to the surface to eat them. Fishermen catch live mayflies to use as bait or buy them from schoolboys who wake early to collect them, storing them in wooden boxes passed down through generations. The fishermen then impale the flies on fine wire hooks and with a long pole and sinuous, billowing line dap them on the surface to entice a trout to take.

There is no "common" trout in Ireland, in the sense that there is no "common" whiskey—the nuances in both are great—but there is a general look to the fish that inhabit these waters, namely small heads and broad, streamlined bodies. Trout that I saw from Lough Mask had large irregular spots like blackberries. Their eyes were cobalt-blue to coal-black, with a dark blotch on either side of the pupil giving the eye a banded appearance. The trout in the lakes of west Ireland grow large, some over 20 pounds (9.1 kg), with spots on large specimens the size of an Irish ten-pence piece (which, incidentally, is decorated with a leaping salmon). The stories of catching them fill the pubs at night, where the Guinness flows like a river in spate.

Out on the boats in vast Lough Corrib, you could feel as though you are on the sea, especially when the wind is up, which is most of the time. But you need a good wind to dap—as well as to keep the embers alive in your pipe—for the wind is what carries the fly ahead of the drifting boat and makes it dance on the waves.

There are few more dramatic and beautiful places than Connemara in spring, with stone cottages painted green, steep, craggy hills, and elephantine masses of blossoming rhododendron. You, too, may glimpse, as W. B. Yeats did:

The freckled man who goes
To a grey place on a hill
In grey Connemara clothes
At dawn to cast his flies

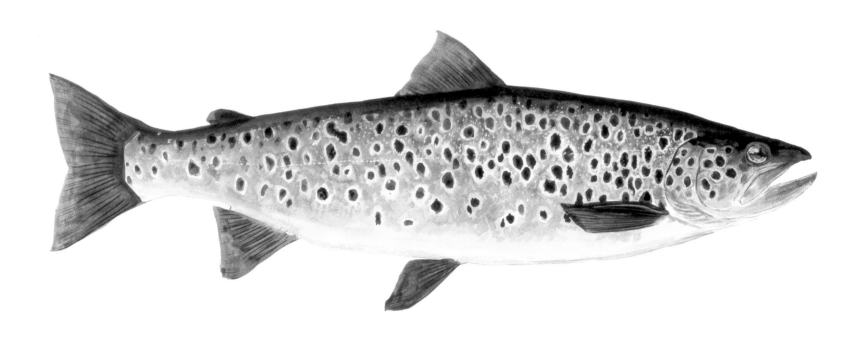

BROWN TROUT, LOUGH MASK, IRELAND

Salmo trutta

Gillaroo Trout, Lough Melvin, Ireland

Sonaghen Trout, Lough Melvin, Ireland

Ferox Trout, Lough Melvin, Ireland

ANGLERS ON Lough Melvin, on the western fringe of Counties Fermanagh and Leitrim, have maintained for centuries that the lake is inhabited by three distinct types of trout. Varying in color from butter-yellow to silver and umber, these three fish are known locally as gillaroo, sonaghen, and ferox. About an hour's drive northeast, on vast Lough Neagh, the locals have long identified three more distinct types of trout, the dollaghan, buddagh, and black buddagh. One begins to wonder as he learns the names of the flies used to catch these trout—green peter, claret bumble, black pennell, kings-mill, gosling—whether this is a culture of imaginative people or if there is some taxonomic validity to these distinctions.

Biologist Andrew Ferguson is a staunch defender of the status of three distinct varieties of Lough Melvin trout (the gillaroo, sonaghen, and ferox) as separate species:

Lough Melvin has a unique salmonid fish community which originates from the end of the last Ice Age, some thirteen thousand years ago. These three types are genetically distinct, due to independent ancestry and natal homing to separate spawning areas, which means that minimal hybridization has occurred since sympatry was established. They differ also in their morphology and ecology. These three types therefore merit designation as separate species: gillaroo, *Salmo stomachicus*; sonaghen, *Salmo nigrippinis*; and ferox, *Salmo ferox.* Their conservation importance needs to be recognized and practical conservation put in place as a matter of urgency.

Robert Behnke disagrees with Ferguson's classifications. Of the Lough Melvin trout Behnke writes, "they are valid biological species, but not valid evolutionary species, because they are all derived from branches within *Salmo trutta.*"

The gillaroo, from the Gaelic *giolla rua,* or "red fellow," is the most colorful of the Lough Melvin trout, with large black and red spots sprinkled over a field of olive-brown and yellow. They feed mostly near the lake bottom on shrimp *(gammarus),* sedge, and snails and rarely grow larger than three pounds. Jonathan Couch in his *History of Fishes of the British Islands* of 1877 observed the gillaroo's unique anatomical feature for digesting such hard foods. "The gillaroo has a gizzard-like structure on the coats of the stomach; and it has been further believed that this thickness of the stomach is caused by its habit of feeding on shellfish or other hard substances." The sonaghen, or

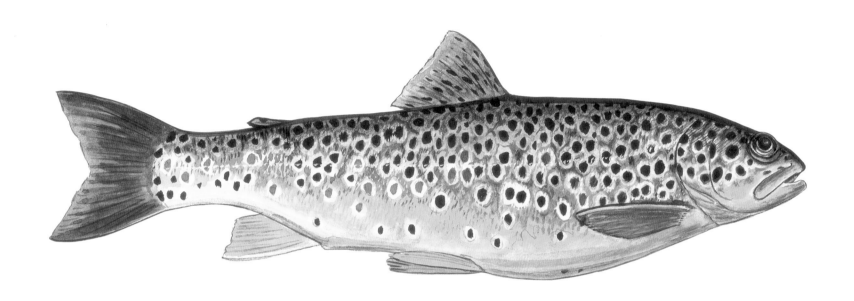

GILLAROO TROUT, LOUGH MELVIN, IRELAND

Salmo stomachicus

BROWN TROUT: ATLANTIC TROUTS

black-finned trout, is silvery to cobalt-blue with numerous large black spots. They feed in areas of open deep water on water fleas, midge pupae, and phantom larvae and don't grow much larger than 1½ pounds (0.7 kg).

The ferox is by far the largest trout in Melvin, a predator with a large head and jaws equipped for eating other fish, such as cisco, pollan, and char. While the gillaroo spawn in the only outlet of Lough Melvin, the sonaghen and ferox spawn in the inflowing rivers. Ferox spawn in the lower, deeper section of one of the inflowing rivers, which is also used farther upstream by sonaghen.

Outside of Lough Melvin, ferox is a ubiquitous name for any long-lived, piscivorous trout that inhabits lakes throughout Ireland and Scotland. Ferguson considers the ferox an older "ancestral" trout, the first to colonize rivers and lakes in post-glacial times, and later joined by invasions of "modern" trout. An entire mythology and cult of fishing has evolved around the catching of these large and ancient fish.

The Scottish ichthyologist Ron Greer is probably the most renowned living devotee of ferox fishing. The ferox for Greer is a "link with our own glacial past," part of the prehistory of the Pleistocene epoch. The relationship between this fish and its primary prey, the arctic char, Greer asserts, is the watery parallel to the wolf and the reindeer. On the lochs of the central highlands, near the village of Dalwhinnie, the locals have varied explanations, some unlikely, for the origin of giant ferox trout. One tale claims that the ferox is a hybrid between a trout and a pike. The anglers' opinions and observations sometimes clash with those of scientists, but Ron Greer has spent a good part of his life trying to account in scientific terms for the things that he and his angler friends have observed.

Greer has helped found an angling association for the pursuit of large ferox trout, called Ferox 85, and maintains that the ferox is, indeed, a unique species of brown trout.

Sir William Jardine, who is credited with coining the name *ferox* (from the Latin; "warlike, ferocious") in his *British Salmonidae,* remarks on the phenomenon of some specimens that have a profusion of spots on every part of the body. "Two specimens were taken during the month of June, in Loch Layghal, in Sutherlandshire, nearly of equal size and similar colors. Both were thickly spotted over on every part of the body with numerous black spots, which contrasted strongly with the yellowish-white tint of the lower part. In ordinary states the spots vary in size and number, but they seldom extend far below the lateral line." On a visit to Lough Mask, I asked locals if they had witnessed trout with spotting on the lower flanks. They answered me with a photograph of one such fish but remarked that such markings were rare, even on large fish.

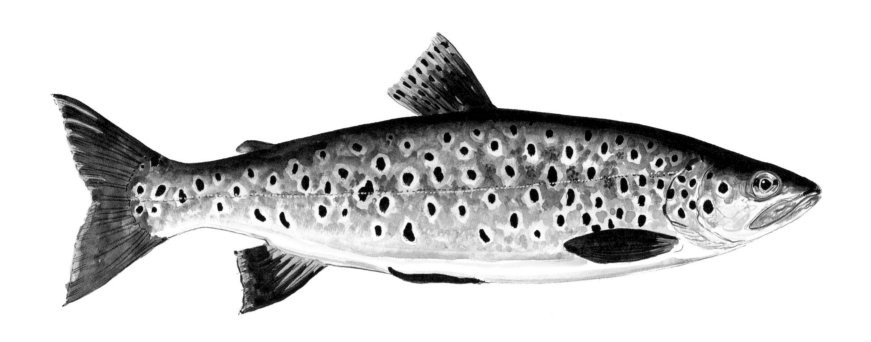

SONAGHEN TROUT, LOUGH MELVIN, IRELAND

Salmo nigrippinis

BROWN TROUT: ATLANTIC TROUTS

37

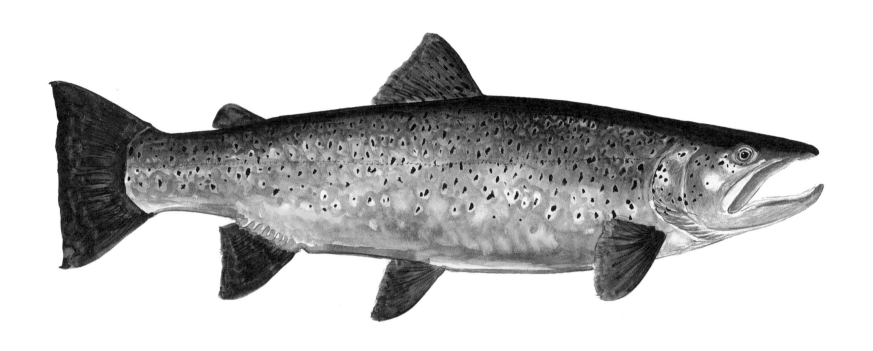

FEROX TROUT, LOUGH MELVIN, IRELAND

Salmo ferox

BROWN TROUT: ATLANTIC TROUTS

Brown Trout, Southwest Highlands, Acid Moorland Stream, Scotland

SIR WILLIAM JARDINE observed, "the very great variety to which the common trout of Scotland appears to be subject has induced us to give representations of several of the more remarkable states from lochs and rivers. In waters of greater extent, again, the varieties, in different parts of the same loch, are very remarkable. Sometimes almost every bay has its 'kind' of trout; and the opposite sides of an island, a few acres in extent, oftentimes affords trout very different both in markings and in quality."

One who sets out to document the brown trout's diversity in watercolors could spend a lifetime doing so in Scotland alone.

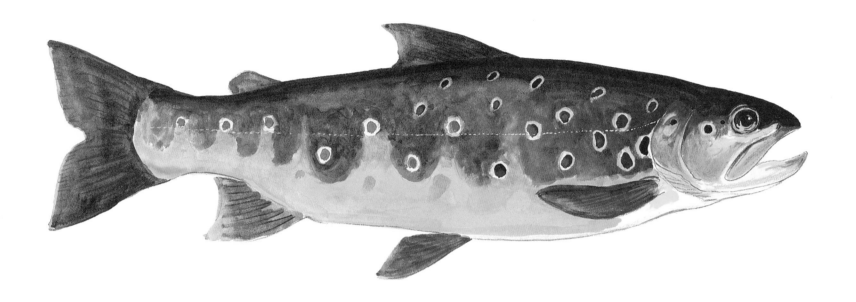

BROWN TROUT, SOUTHWEST HIGHLANDS, ACID MOORLAND STREAM, SCOTLAND

Salmo trutta fario

BROWN TROUT: ATLANTIC TROUTS

41

Brown Trout, Lathkill River, Derbyshire, England

IN THE FIFTH edition of *The Compleat Angler* of 1676, Izaak Walton requested that his friend and adopted son, Charles Cotton, write an addendum on fly-fishing. Cotton's piece is considered to be the first thorough treatise on how to tie flies as well as how to fish with them. Though Cotton lived on the River Dove near Ashbourne in the Peak District, he frequented other rivers in the area, among them the Wye, the Derwent, the Bradford, and a small jewel of a stream called the Lathkill. Of this river, which he refers to as the Lathkin, Cotton writes, "the Lathkin is, by many degrees, the purest, and most transparent stream that I ever yet saw either at home or abroad, and breeds, 'tis said, the reddest, and the best Trouts in England."

In the summer of 1996 I traveled to England and fished in the footsteps of Walton and Cotton. I visited the Lathkill and its keeper, Warren Slaney, and asked him about the "red" fish that Cotton had described. "They are still red," he said, "all you need do is look off the bridge." Under the bridge I saw three large trout finning in the crystal-clear water; indeed, their sides were bright red. The Lathkill can only be fished by its owner, Edward Lord Manners, and his friends, and according to Warren it had never been stocked with non-native trout. He took me to a pen where he was holding several large fish from the river for breeding. He caught one of the monsters, probably 6 pounds (2.7 kg), and held it up for me to see. Sure enough, the fish was a deep brick-red.

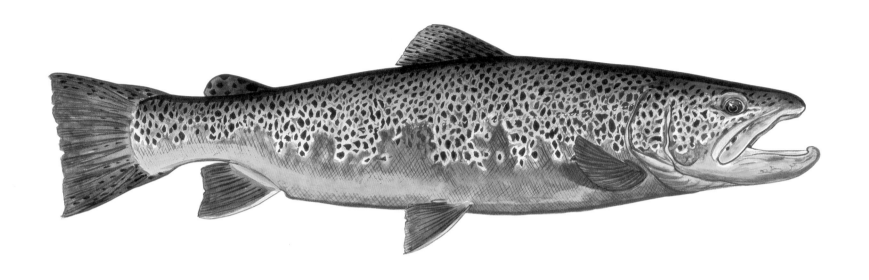

BROWN TROUT, LATHKILL RIVER, DERBYSHIRE, ENGLAND

Salmo trutta fario

BROWN TROUT: ATLANTIC TROUTS

Brown Trout, Tarrant River, Dorset, England

BECAUSE OF the introductions of non-native trout, which either hybridize with the indigenous fish or push them out, it is challenging to find genetically pure native populations of trout in England, or in Europe, for that matter. Even the famed rivers Test and Itchen of Hampshire, though impeccably maintained limestone creeks (chalk streams, as they are known in England), have been profusely stocked, and the wild fish that exist there are at least slightly hybridized with other strains. To find a pure native population, you need local knowledge or hard records going back at least a century. A brook that is inconspicuous and has escaped the pressures of heavy angling is more likely to have its original strain of trout.

English journalist Charles Rangeley-Wilson, who is active in the Wild Trout Society of England, took me fishing on a small spring-fed tributary of the Stour in Dorset, which he said still held pure native brown trout. At Rangeley-Wilson's skilled hand we captured, observed, and released several specimens. I was pleased to see that all the trout were identical in appearance, which in a small stream is often a good indication that the fish are genetically consistent and not hybridized. The coloration—very few and evenly spaced mostly black spots—fit all the early descriptions of southern English trout that I was able to gather. My sources for these descriptions were as varied as an early nineteenth-century book of paintings of English fishes by Sarah Bowdich, to photos of descendants of trout introduced to Tasmania and New Zealand from chalk streams in southern England during the 1860s. In an article Rangeley-Wilson wrote for *Field* he noted, "Before the 4th of May 1864 there were no trout in the southern hemisphere." This was the year that trout were first introduced to Tasmania: three thousand fertilized eggs from the Wey River in Hampshire and the Wick near London (at the time both productive limestone streams), shipped in wet moss over ice. Descendants of the two hundred eggs that survived the journey and hatched were later introduced to New Zealand. These trout still carry the coloration of their ancestors: sparse, evenly spaced black spots (except where Loch Leven trout, a Scottish strain, were introduced; they are a more heavily spotted fish). My friend Pierre Affre confirmed that the native trout of Normandy in western France (which he remembers as a child) had these same characteristics. The geology and types of spring-fed streams in Normandy are identical to those of southern England, which makes sense, because they are in close proximity, separated only by the English Channel.

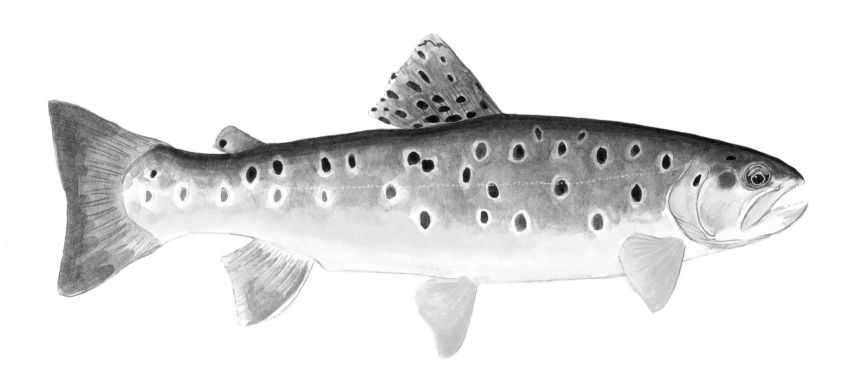

BROWN TROUT, TARRANT RIVER, DORSET, ENGLAND

Salmo trutta fario

BROWN TROUT: ATLANTIC TROUTS

Brown Trout, Brittany, France

Indeed, it would be reasonable to say that the decline of native trout populations in France can be traced to the enjoyment by the French of their delicate flavor. Here are a few general guidelines for trout preparations from the famous French cookbook, *Larousse Gastronomique*:

> In Auvergne, trout is fried with chopped bacon and garlic; stuffed *à la montdorienne* (with breadcrumbs, cream, herbs, and mushrooms); cooked in a fumet and coated with cream sauce; or poached in fillets and served on a julienne of cabbage simmered in cream. Trout *à la d'Ussel* is poached, then, the next day, rolled in breadcrumbs and cooked au gratin. In southwestern France, trout (known as *trouéte* or *truchet*) is fried or braised in white wine with cep mushrooms or stuffed with whiting flesh ground with duck foie gras and cooked *en papillote*. In Savoy, trout is cooked *au bleu* ... in Normandy, trout is pot-roasted with bacon *à la mode de Vire*; cooked in a *matelote* with cider ... cooked *en papillote,* with apple, herbs, cream, and Calvados; or made into a hot pie (a traditional dish of the bishops of Rouen). Mention should also be made of ... trout pâté *à la lorraine,* fillets ground with nutmeg and herbs, mixed with chopped morels, and garnished with whole fillets.

France was one of the first countries to artificially propagate trout, in the 1860s, and introduce them to rivers that had been depleted by overfishing. Later, non-native hatchery trout were introduced from Belgium and the former Czechoslovakia, which further confused the genetic integrity of the indigenous fish.

My first inquiries into the state of native trout in France produced discouraging answers. Yoichi Machino, an ichthyologist from Grenoble, wrote me, "It is almost impossible to see brown trout of native local strain in France. Only in Corsica, you may still find such rivers without stocking." Reports from my Parisian friend Pierre Affre were more encouraging. He seemed to think that there were native strains left in remote headwaters. We ventured to find possible pure specimens in some minute streams he had information about in Brittany and also in high tributaries of the Allier. He also said that trout of the rivers Loue and Doubs of eastern France in the Mediterranean basin were still relatively pure.

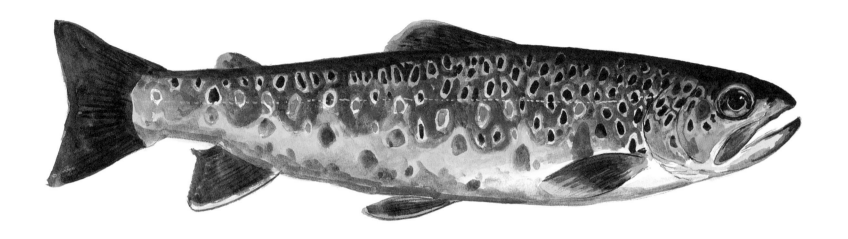

BROWN TROUT, BRITTANY, FRANCE

Salmo trutta fario

Brown Trout, Estorãos Stream, Portugal
Brown Trout, Rio Pisuerga, Spain

THE PECULIAR white blotches on the upper flanks of this fish are consistent with other native trout in Atlantic drainage streams of northern Portugal and the Atlantic provinces of Spain: Galicia, Asturias, and the Pais Vasco. The trout I caught on an expedition with Johannes Schöffmann from the Trubia River in Asturias, the Yuso of Galicia, and the Estorãos of Portugal all had the same three white blotches on their upper flanks. These fish, which represent the southern end of the range of Atlantic trouts, are native to shorter rivers of the coast and perhaps invaded these streams recently. These "south Atlantic trouts" generally have large black and maroon spots haloed in white and white tips on the anal and dorsal fins.

The headwaters of larger Atlantic drainage streams like the Duero and the Tejo have trout that more closely resemble Mediterranean trout. Some of the trout in these high headwaters, like those of Rio Pisuerga, have jaws with slight overbites and more of a mottled pattern than distinct spots. According to Schöffmann, the trout of the Duero basin in Spain represent a separate phylogenetic lineage from the Atlantic lineage. These traits lead me to believe that these fish have spent more time in freshwater eating insects on the river bottom. It is also thought that the south Atlantic trouts are more ancient than their northern cousins, which lost habitat to advancing ice during the last glaciation.

The few rivers with native trout left in Spain have mostly been closed to fishing, although some are posted *sin muerte,* or "no kill."

BROWN TROUT, ESTORÃOS STREAM, PORTUGAL

Salmo trutta

BROWN TROUT, RIO PISUERGA, SPAIN

Salmo trutta

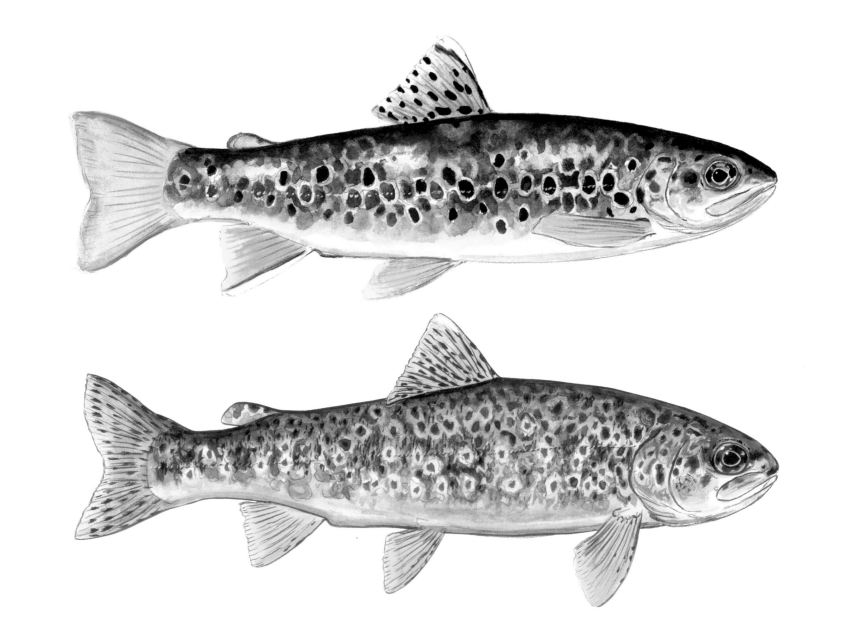

Brown Trout, Zêzere River, Portugal

Brown Trout, Rio de la Hoz Seca, Spain

FOR A WESTERN European country, Portugal still retains a good bit of the unspoiled Old World. Throughout the valley of the Zêzere River, people still live in small stone habitations with no electricity. The Zêzere is a tributary of the Tejo (in Spanish, Tajo), the longest river in the Iberian Peninsula. The Tejo flows into the Atlantic Ocean, yet, peculiarly, its trout exhibit a trait that is common to those from Mediterranean drainage streams: three or four vertical bands or blotches, sometimes quite dark, at equally spaced intervals along the sides.

In the headwaters of the Rhône in eastern France, these vertical blotches are common in trout and the visible source of their local name, *la truite zébrée,* or "zebra trout." Hereinafter the term *zébrée* is used to describe this trait that you will see as a common identifying characteristic of Mediterranean brown trout.

Long rivers of the Iberian Peninsula that flow into the Atlantic have headwaters very close to the Mediterranean. It is possible that toward the end of the last glaciation some of the Mediterranean fish crossed the divide via headwater connections into the Atlantic drainage. This is probably why there are such fish with *zébrée* markings in the Atlantic drainage. Another possibility is that the Mediterranean trout evolved from an ancient ancestor of Atlantic drainage trout that had *zébrée* blotches.

The trout of the Zêzere in Portugal is the westernmost population of brown trout that exhibit strong *zébrée* that I have seen. The easternmost *zébrée* trout I observed are those from the Tohma River in the headwaters of the Euphrates River, southeastern Turkey (these fish crossed from the Mediterranean into the Euphrates, which flows to the Persian Gulf). Other populations of Atlantic trouts with *zébrée* may hold clues to the origins of these fishes. For example, the trout of the Tarn in France have characteristics of Mediterranean fish, even though the river flows into the Atlantic.

Rio de la Hoz Seca (which means "river of the dry gorge") in the province of Guadalajara is an upper tributary of the Tejo, far from the Zêzere, which is closer to the Atlantic. It is an emerald-green, crystal-clear, spring-fed creek filled with trout, just north of a beautiful village called Peralejos de las Truchas—the only place I've ever encountered with the word "trout" as part of its name. As you will see, the fish from this stream greatly resemble some Mediterranean trout.

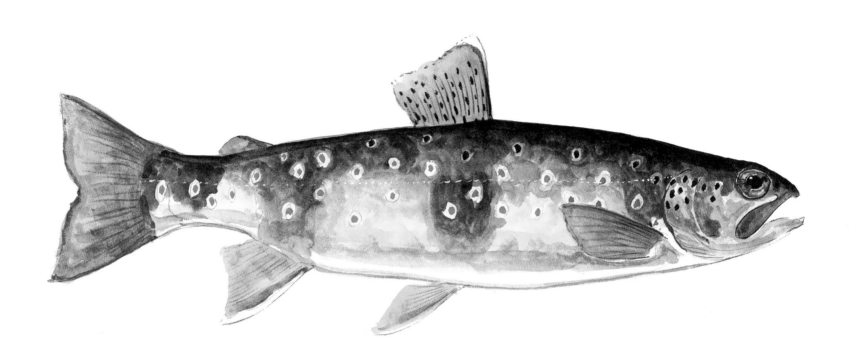

BROWN TROUT, ZÊZERE RIVER, PORTUGAL

Salmo trutta

BROWN TROUT: ATLANTIC TROUTS

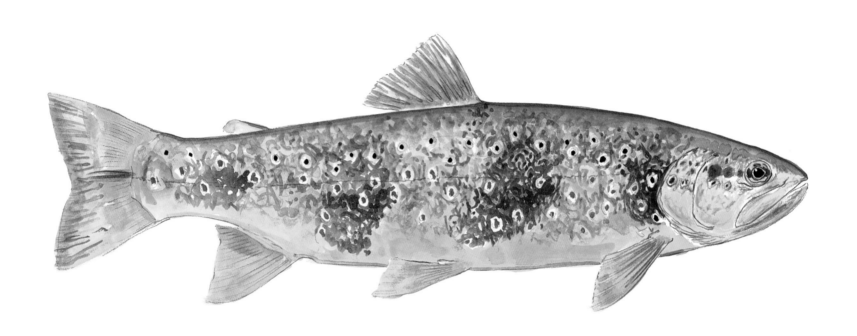

BROWN TROUT, RIO DE LA HOZ SECA, SPAIN

Salmo trutta

BROWN TROUT: ATLANTIC TROUTS

53

Fine-spotted Brown Trout, Dilar River, Andalusia, southern Spain
Fine-spotted Brown Trout, Oued Oum Rbia, Atlas Mountains, Morocco

FRENCH soldiers stationed in North Africa during the pacification of Morocco and Algeria wrote home to their families and friends about the fantastic trout fishing they enjoyed in streams of the Atlas Mountains. In this letter, to the French magazine *La Pêche Illustrée*, the official journal of the national fishing club, dated April 12, 1914, Lieutenant Ameil wrote:

> Everything is getting better and we might have some time to go fishing. In the area of Mèknes-Agoural there are a lot of beautiful small spring-fed streams full of water, it does not look like we are in Africa ... We are going to move in there to pacify the people and I heard the trout are super-abundant [translated by Pierre Affre].

Later widespread stocking of non-native trout by the French in Morocco has made it difficult to find pure native fish there. When Johannes Schöffmann went to look for specimens, he had reliable information on pure indigenous trouts from a Moroccan scientist, Moulsih. Some of the streams flow to the Atlantic side of the strait of Gibraltar and some to the Mediterranean, but genetic analysis by Louis Bernatchez (from tissue samples sent to him by Schöffmann) has revealed that the trout of North Africa are of Atlantic origin.

Trout of the Oued Oum Rbia have fine, peppery spotting along the sides, which is consistent with native trout from certain streams of nearby southern Spain. I have included a trout from the Dilar River, a tributary of the Guadalquivir in Andalusia, from the Sierra Nevada National Park (which I caught on a trip with Schöffman in the summer of 2001), because of its similar appearance to the North African fish. No doubt this fish is related genetically to the trout of Morocco.

FINE-SPOTTED BROWN TROUT, DILAR RIVER, ANDALUSIA, SOUTHERN SPAIN

Salmo trutta

FINE-SPOTTED BROWN TROUT, OUED OUM RBIA, ATLAS MOUNTAINS, MOROCCO

Salmo trutta

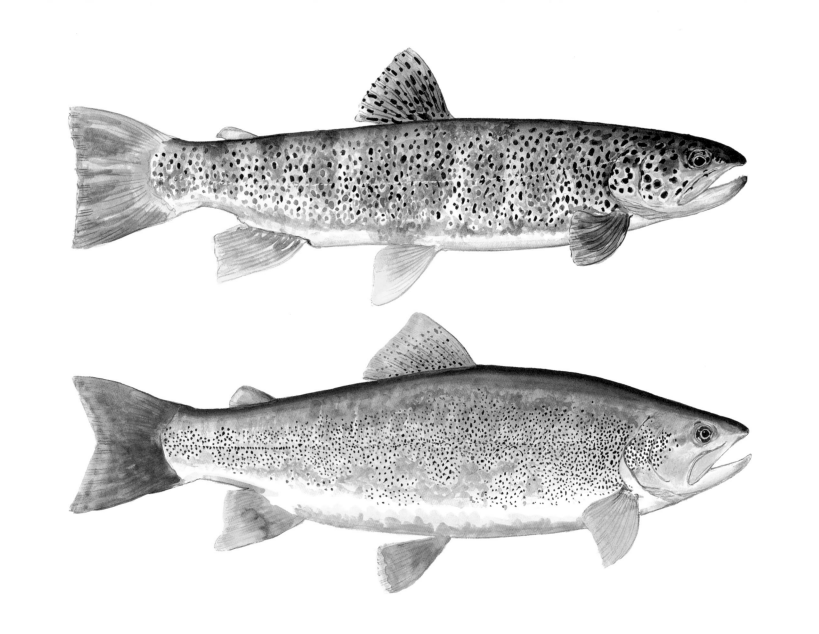

Truite Verte, or Green Trout, Lac d'Isly, Morocco

Trout of Algueman Lake, Morocco

Trout of Oued Ourika, Morocco

Trout of the River Dadès, Morocco

Dwarf Trout of Lac Ifni, Morocco

SEVERAL OLD VOLCANIC lakes in the Atlas Mountains of Morocco contain, or once contained, unique forms of brown trout. These fish were first discovered by French military who were stationed there and who found recreation in the mountain lakes and streams. The unusual trout of Algueman Lake, for instance, was discovered in 1920 by Colonel de Loustal and sent to the famous French ichthyologist Jacques Pellegrin, who named it a new species, *Salmo pallaryi.* Pellegrin remarked that the strange fish resembled the *omble-chevalier,* or char, because of its numerous small scales, slender body, large eyes, short jaws, and smooth, unspotted flanks. He nicknamed it the *truite-omble,* or trout-char, and surmised that it might be a cousin of *Salvelinus.* These trout rarely grew longer than 18 inches (45.7 cm).

Another of these alpine trouts, known only from Lac d'Isly in the province of Er Rachidia, is called the *truite verte,* or green trout. This name derives from its unusual green-bronze hue on the body, often compared in French literature to the coloration of a *tench* (a cyprinid fish, *Tinca tinca*). Like *Salmo pallaryi,* the body of the green trout is devoid of spots. The main food of the green trout is small freshwater shrimp and copepods, a rich source of carotene, which gives them very pink flesh. A young Moroccan ichthyologist studying in Barcelona, Abdelhamid Azeroual, informed me that the *truite verte* are still abundant in Lac d'Isly.

In 1992, Johannes Schöffmann traveled to high Algueman Lake and determined from interviewing local people and observing the

TRUITE VERTE, OR GREEN TROUT, LAC D'ISLY, MOROCCO

Salmo trutta

TROUT OF ALGUEMAN LAKE, MOROCCO

Salmo pallaryi

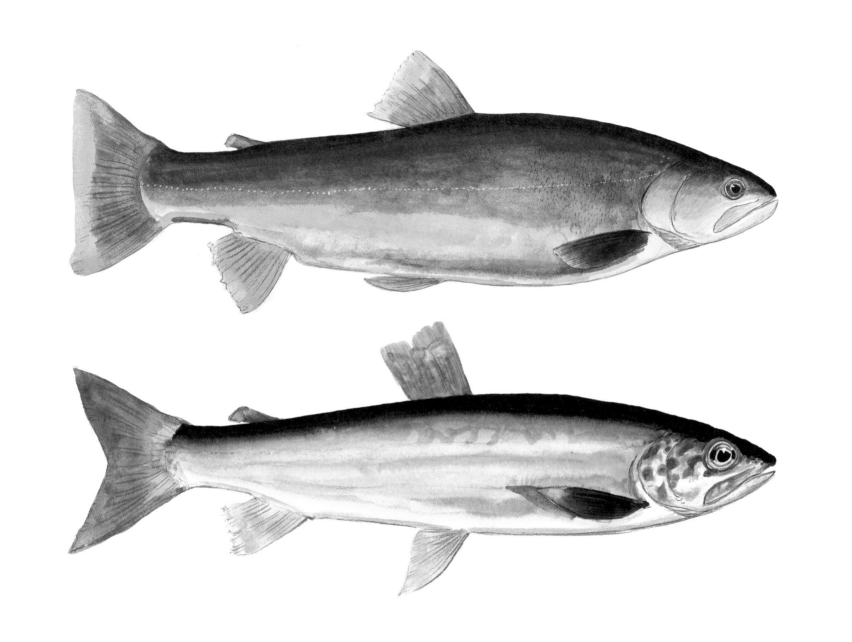

condition of the lake, which had become eutrophied (in advanced stages of algaefication and low oxygen content), that the once-unique trout of this lake were extinct. Robert Behnke wrote of the trout of Algueman, "I once examined four preserved specimens at the British Museum. The specimens showed no spots or markings on their bodies, but had mottled markings on the head—quite distinct from *Salmo trutta*. With environmental changes and introductions of exotic fishes (*Cyprinus carpio* in 1934), I suspect that Algueman Lake is devoid of trout. Maybe it has become reduced to a carp pond."

According to a paper published in 2002 by the Swedish ichthyologist Bo Delling, the trout of Algueman have been extinct since 1938. He theorizes, based on head measurements, that *Salmo pallaryi* belonged to the group of "archaic" or pre-glacial trouts, which includes *Salmo ohridanus, Salmo obtusirostris,* and *Salmo platycephalus.*

Delling recently named a new species of Moroccan trout, *Salmo ifnii,* describing it as having a "lack of contrasting color pattern on the sides of the body except for parr marks and sometimes a marbled pattern." He named it from a preserved specimen from Lac Ifni. In an issue of *La Pêche Independant* of 1933, I read that the trout of Lac Ifni were thought to be the same as those of Algueman described by Pellegrin. The entanglement of local names, angler talk, and scientific classification is, at times, impossible to unravel. Other names have been given to "strange" North African trouts: *Salmo lapasseti* from a stream in Algeria, *Salmo pellegrini* from Ourika stream. Behnke wrote a rebuttal to Delling's recently proposed paper, stating that the criteria on which Delling based *Salmo ifnii* are not significant enough to warrant species status.

We know little of the now-extinct Atlas trout of Morocco but perhaps even less of the status of native trout in neighboring Algeria, where civil war has deterred exploration by foreigners. The type specimen for the first description of a Mediterranean trout, *Salmo macrostigma,* by Duméril in 1858, was from an Algerian stream (though Schöffmann believes these fish may be of Atlantic origin). The name *macrostigma* is Latin for "big spot," which describes the large indigo to purple blotch behind the eye that is common not only to brown trout of the Mediterranean but also to those of the Atlantic and other basins as well. Schöffmann has correctly pointed out that if a species or subspecies name for the Mediterranean trout is to be used at all,

TROUT OF OUED OURIKA, MOROCCO

Salmo pellegrini

TROUT OF THE RIVER DADÈS, MOROCCO

Salmo trutta

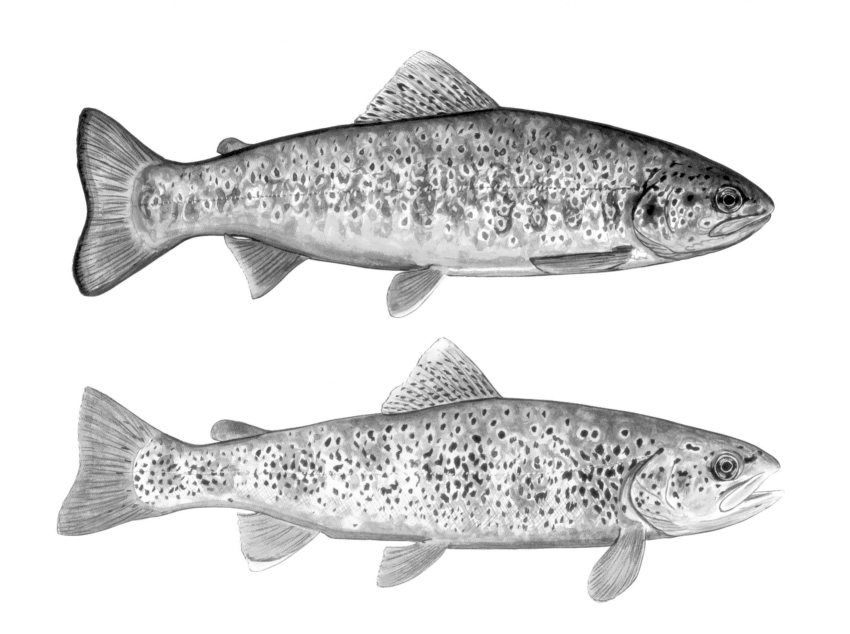

it should not be *Salmo macrostigma,* but *Salmo cettii,* a name given by Rafinesque in 1810 to describe the trout of Sicily. According to the rules of taxonomy, the oldest given name takes priority.

Since the publication of the first edition of this book, Johannes Schöffmann and Aleš Snoj of the University of Ljubljana in Slovenia have done much work to reveal the intricacies of trout evolution. Their fruitful collaboration began on a trip the three of us took to Montenegro to look for the softmouth trout of the Zeta River in 2002.

Johannes recommended that I add three African trout to this updated edition: *Salmo akairos* from Lac Ifni, *Salmo pellegrini* from the upper Tensift River in western Morocco, and the Dadès trout from the River Dadès. The Dadès trout is genetically very distinct from all other lineages and probably the oldest one in North Africa. These trout live in rugged mountain terrain, and their native habitat is very difficult to access. Without the relentless and obsessive work of Schöffmann and others to find these fish and collect tissue samples for genetic work, we would still know very little of the evolutionary history of these fishes.

Manu Esteve, a Spanish biologist known for his videos of spawning salmonids (posted on Youtube.com), from the rare huchen of Hokkaido, Japan, to the softmouth of the Balkans and some of the African trouts, told me that some Moroccan brown trout are more distant genetically from other brown trout than they are from Atlantic salmon.

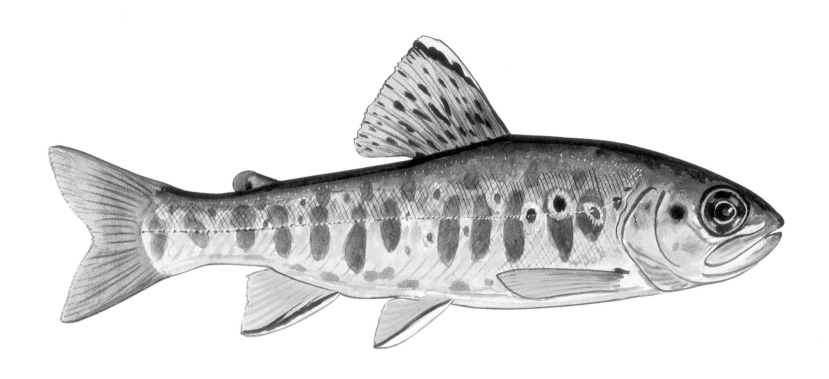

DWARF TROUT OF LAC IFNI, MOROCCO

Salmo akairos

BROWN TROUT: ATLANTIC TROUTS

La Truite Zébrée, Loue River, France

THE FRENCH realist painter Gustave Courbet painted several oil portraits of trout from the Loue, the emerald river that ran through his village in eastern France. The most famous of this group of paintings is simply called *La Truite,* and it hangs prominently in the Musée d'Orsay in Paris. Courbet was an avid angler who saw the trout as a kind of allegory of himself. He painted *La Truite* in the 1860s after having served a prison sentence during which he suffered an uncomfortable bout with hemorrhoids. The trout depicted is large, grotesque, and pale with a hook lodged deeply in its gut; the line is shown coming out of its mouth. The caption in Latin reads: *in vinculi fecit,* or "made in chains."

The Loue runs clear out of caves of limestone, and the trout are few but large. It's not their size that is most peculiar but their coloration, as evident from Courbet's paintings. The trout are striped with three or four vertical dark blotches, characteristics that inspired the local name for this fish, *la truite zébrée,* the "zebra trout."

I later learned that these vertical blotches are typical of many trout from streams that flow to the Mediterranean; the Loue is a tributary of the Rhône, which enters the Mediterranean near Marseilles.

The first published reference to the *zébrée* characteristic in trout was probably by the French ichthyologist Duméril, who described *Salmo macrostigma* in 1858. The Italian ichthyologist Enrico Tortonese wrote in his *Trouts of Asiatic Turkey* of 1954, "*Salmo macrosigma* was said by Duméril to have large black blotches on the sides, evidently the parr-marks, a juvenile feature." But what Tortonese thought were parr-marks, elliptical marks on juvenile trout, were *zébrée,* which are not a juvenile characteristic but a camouflage feature on adults.

Unlike northern populations of brown trout, those native to the Mediterranean basin were not as thoroughly displaced by the advancing glaciers. Their mottled camouflage, tendency to hide under rocks (like a grouper), and their lack of migratory instincts suggest that these trout have been isolated in freshwater for longer periods of time.

In the Franche-Comté region of eastern France there is a name for the phenomenon when a zebra trout has gone dormant beside a rock: *truite dormuse*, or "sleeping trout." Holding still in the current, its dark blotches seem to spread, and the body looks mottled, like a sculpin's.

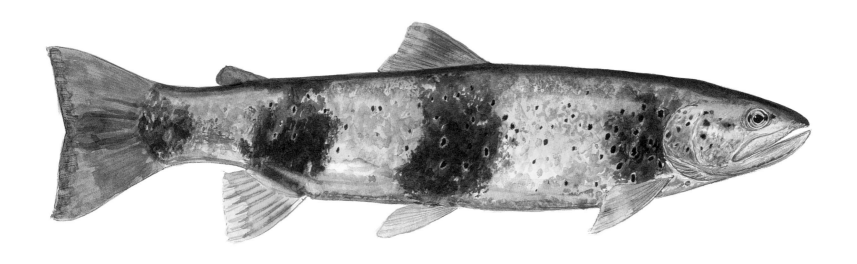

LA TRUITE ZÉBRÉE, LOUE RIVER, FRANCE

Salmo trutta macrostigma

BROWN TROUT: MEDITERRANEAN AND ADRIATIC TROUTS

Fine-spotted Trout, Golo River, Corsica, France

Trota Sarda, Riu Fluminnedda, Sardinia, Italy

Rafinesque's Trout, Tellesiomo River, Sicily, Italy

Brown Trout, Calore River, east of Naples, Italy

SICILY, SARDINIA, and Corsica—islands in the Mediterranean belonging to Italy and France—have genetically and phenotypically diverse and interesting trouts.

Enrico Tortonese described trout he had seen in Sardinia in his *Trouts of Adriatic Turkey* of 1954: "Trouts living in Rio Flumineddu and Rio Posada are indeed only black-spotted on a yellowish ground on the sides."

In seeking streams of these islands through forests of scrub oak, fig, and chestnut, it was just as much a challenge to find water as it was trout. Johannes Schöffmann and I followed place references from works like Tortonese's, and we sometimes walked for miles on dry streambeds before we found a spring-fed pool supporting a handful of trout. The trout of these hot, dry climates, which live in water that can exceed 80°F (27°C), occupy a unique ecological niche for salmonids that typically prefer cold, oxygen-rich water. In this way, they resemble some cutthroats and redband trout of western America, like those in desert streams of Nevada or California.

Trout are pretty much the only freshwater fish that inhabit the tepid streams of these Mediterranean isles, habitats normally occupied by *cyprinid* fishes (the minnow family, which includes carp and tench). "Because of special environmental conditions and the absence of concurring cyprinids," writes Schöffmann in his paper about these trouts of the Mediterranean islands, "the indigenous trouts of Corsica, Sardinia, and Sicily have adapted to comparatively high water temperatures." Given their tolerance for low and warm water, these brown trout would be suitable for stocking in many American streams that have been degraded by irrigation and by logging operations. In Sardinia and Sicily, the few native trout left are seriously endangered because much of their water has been diverted, channeled, or dammed.

Of these three islands, Corsica is the farthest north and the one with the greatest variety of native trout. It is a beautiful Mediterranean island with good food and wine, beautiful clear and tepid streams, and beaches with nude bathers. Unfortunately, it is also the island that has been most profusely stocked with non-native trout, so you must have reliable information to find pure indigenous specimens. The spotting variation on native Corsican trout is evidence of evolutionary mixing and isolation for long periods of time. The trout of the middle Golo,

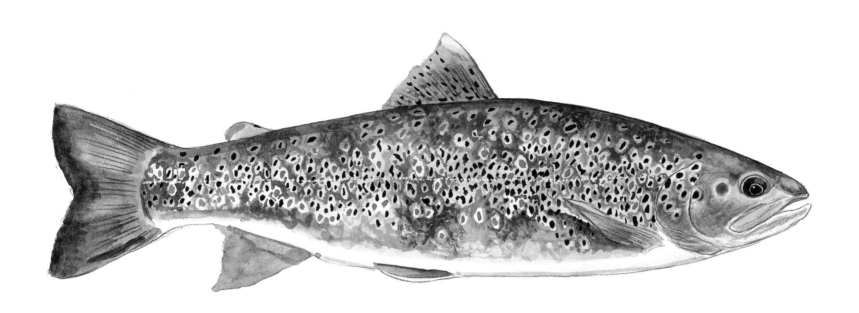

FINE-SPOTTED TROUT, GOLO RIVER, CORSICA, FRANCE

Salmo trutta

BROWN TROUT: MEDITERRANEAN AND ADRIATIC TROUTS

like the one pictured on the previous page, are fine-spotted, rather like those of the Dilar River in southern Spain.

Native trout are scarcer in Sicily, where there is one population left, in the Tellesiomo river. I have called it Rafinesque's trout in honor of the interesting man who first described it as *Salmo cettii* in 1810. In his lifetime Constantine Rafinesque was notorious as a quack biologist. David Starr Jordan, eminent American naturalist, described him in his autobiography, *The Days of a Man* of 1922, "No more remarkable figure has ever appeared in the annals of American science. Clad in a long, loose coat of yellow nankeen, stained yellower by the clay of the roads, and variegated by the juices of plants, a notebook in one hand, a hickory stick in another, his capacious pockets full of wildflowers, shells, and toads." Rafinesque was born near Constantinople in 1783. He came to America at the age of nineteen and apprenticed for two and a half years with merchants in Philadelphia. Returning to Europe in 1805, he spent the next ten years in Sicily, where he published the first of a number of scholarly studies of flora and fauna that were ridiculed then but praised since.

The native trout of Sicily has only black spots with a little red on the adipose fin, which is in sharp contrast to the trout from the Calore River of south-central Italy that has exclusively red spots. As one travels and fishes streams of these areas, one begins to see the great diversity. Some fish of south Italy and neighboring islands also exhibit *zébrée,* either faint or prominent. The native trout of the spring creeks that emerge from the Pontine marshes between Naples and Rome, like those that inhabit the springs at the ancient town of Ninfa, have very dark *zébrée.* One consistent characteristic of Mediterranean trout is a near absence of spots on the dorsal area.

TROTA SARDA, RIU FLUMINNEDDA, SARDINIA, ITALY

Salmo trutta antiocus

RAFINESQUE'S TROUT, TELLESIOMO RIVER, SICILY, ITALY

Salmo trutta cettii

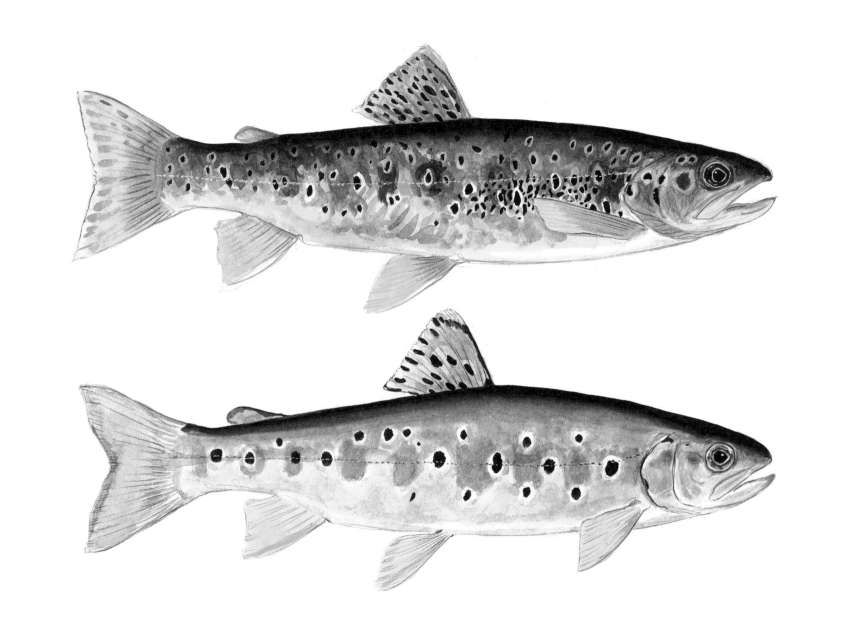

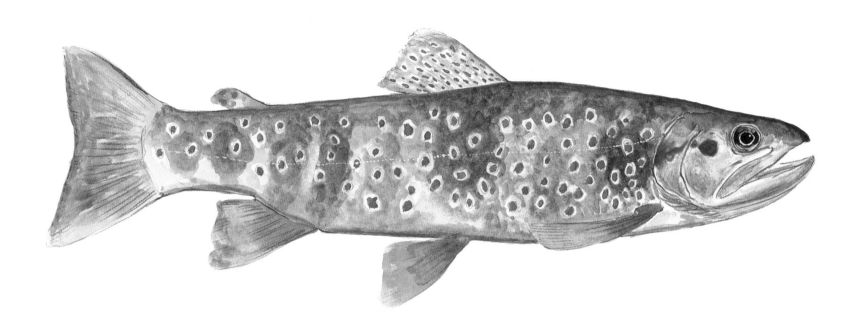

BROWN TROUT, CALORE RIVER, EAST OF NAPLES, ITALY

Salmo trutta

Brown Trout, Lago di Garda, Italy

Brown Trout, spawning female, Lago di Garda, Italy

LAGO DI GARDA, a large alpine lake in northern Italy due west of Verona, is host to a peculiar trout admired for its beauty as well as its table quality. *Carpione,* as it is called by locals, is said to have a smaller mouth than most brown trout, some sources say like a char, while an illustration of *carpione* in the book *Pesci d'Italia* by Silvio Bruno shows a specimen that has a distinct overbite. In coloration, *carpione* has smoky-gray to metallic silver sides with hints of emerald-green and sparse fine black spots. Toward spawning, the males become reddish brown, and the females have virtually no markings on the sides. *Carpione* is a smallish trout with a maximum length of 24 inches (61 cm) and weight of 3 pounds (1.4 kg).

The *carpione* of Garda travel in schools and are mostly active in the early-morning hours or twilight, feeding on plankton and small crustacea at great depths 820 to 980 feet (250–300 m). Most of the year, *carpione* inhabit the southern end of the lake, but for spawning, which occurs twice a year—once between November and January and once between July and August, probably by two separate populations—they migrate to the northern end of the lake, where they spawn over gravel at depths of 660 to 980 feet (200–300 m). Two months after spawning, the fish return to the southern end of the lake.

Extensive fishing for *carpione* over their spawning grounds has made them scarce, but such fishing is now illegal, and *carpione* has been placed on the European list of endangered fishes. Attempts to introduce *carpione* to other large alpine lakes have been unsuccessful.

Once the centerpiece of luxurious Venetian banquets, *carpione* has been prized for its slightly fatty flesh since ancient times. A popular Italian method of preparing fish in a vinegar marinade, called *in carpione*, is described in *Essentials of Classic Italian Cooking:*

> *Carpione,* a magnificent variety of trout found only in Lake Garda, used to be so abundant that, when too many were caught to be consumed immediately, they were fried and then put up in a marinade of vinegar, onion, and herbs that preserved them for several days. *Carpione* has become so rare that few people today have seen one, let alone tasted its extraordinary flesh, but the practice has survived, applied to a large variety of fish, especially sardines.

If caught today, they are probably better off released—the memory of seeing one can be enjoyed with a delicate, locally produced wine like *Lugana.*

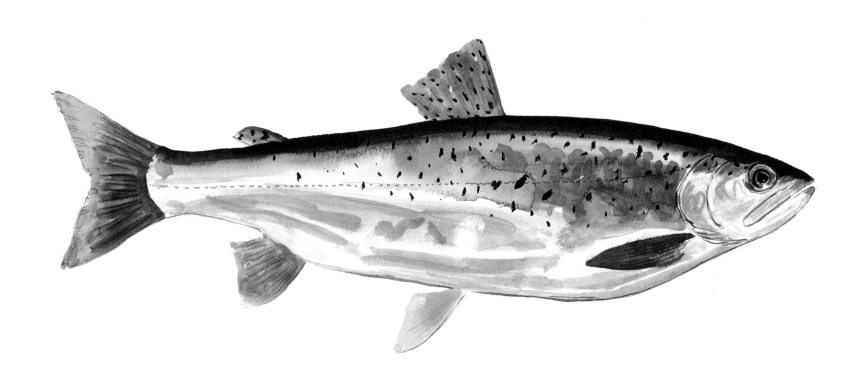

BROWN TROUT, LAGO DI GARDA, ITALY

Salmo trutta carpio

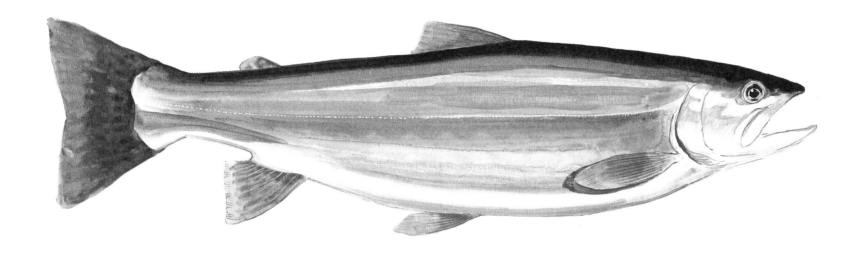

BROWN TROUT, SPAWNING FEMALE, LAGO DI GARDA, ITALY

Salmo trutta carpio

BROWN TROUT: MEDITERRANEAN AND ADRIATIC TROUTS

Cave Trout, Lago di Posta-Fibreno, Italy

TWO TYPES of trout are known to exist in crystal-clear spring-fed Lago di Posta-Fibreno in the province of Frosinone, located in south-central Italy. One is simply called *trota,* the common trout, and the other, like the trout of Lago di Garda, is called *carpione.* The *carpione* trout of Fibreno was named a new species in 1989, *Salmo fibreni,* by Italian icthyologists. A very small trout, sexually mature at 5 inches (12.7 cm) and rarely exceeding 10 inches (25.4 cm), it apparently lives in small holes in the sides of mud outcroppings in the lake and comes out only to feed and to spawn. As Johannes Schöffmann, who has observed them while diving, describes it, "*Salmo fibreni* lives in caves from spring to fall. It leaves the shelter of the caves in November and December to spawn."

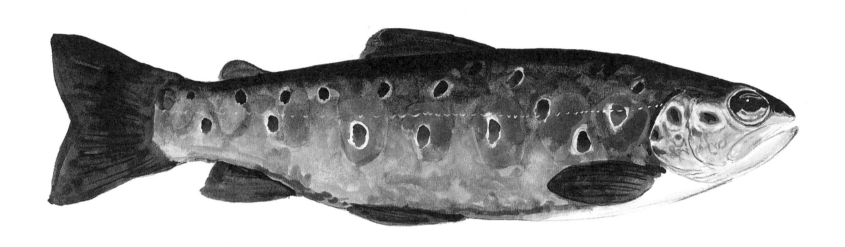

CAVE TROUT, LAGO DI POSTA-FIBRENO, ITALY

Salmo trutta fibreni

BROWN TROUT: MEDITERRANEAN AND ADRIATIC TROUTS

Marble Trout, spawning colors, Zadlascica River, Soča Tributary, Slovenia

Marble Trout, Zadlascica River, Soča Tributary, Slovenia

Southern Marble Trout, Cijevna River, Montenegro

IN A NARROW valley between the Julian Alps runs a turquoise river of stunning clarity, called the Soča. A peculiar trout called the marble trout, one of the largest European salmonid species, lives here. A mounted marble trout of 50 pounds (22.7 kg) hangs in the hotel in the village of Kobarid on the Soča River and is visited by local anglers as the object of a kind of pilgrimage. Such a big fish, however, is rare, and the fly fishermen on the Soča today catch mostly introduced brown and rainbow trout, as well as grayling.

The marble trout, with populations in northern Italy and some Balkan states (Bosnia, Albania, Montenegro, Slovenia, and, possibly at one time, Croatia), is native to certain rivers of the Adriatic Sea basin. It was first described in 1817 by Cuvier after specimens from a lake in Lombardy, Italy. The name he gave it, *marmoratus,* is from the common name in Italy, *marmorata,* or "marbled," which describes the vermiculated markings on the fish's sides that resemble the veins in polished marble. Adult marble trout have long heads, big jaws, and formidable teeth, and they mostly prey on other fish. On a diet of grayling, carp, perch, and other trout, they have the potential to grow very large. According to Meta Povz, they were known to reach 66 pounds (30 kg) in the Neretva River of Bosnia.

The general coloration of marble trout can vary greatly, from olive-yellow to brown or slate-gray. The marble pattern on the sides of the fish can be very prominent or so faint as to be barely detectable, depending on the substrate of the river, the amount of light reaching the stream, and what the fish is feeding on. In many high tributaries of the Soča in Slovenia the gravel on the bottom is pure white limestone and the fish are very pale, but if caught in a dark hole or toward spawning (which takes place between November and January), marble trout can be dark brown or intense orange-yellow. Although red spots on a marble trout can be indicative of a hybrid with brown trout, some individuals in pure populations can have red spots, usually in a formation like a string of pearls along the lateral line. Many marble trout exhibit *zébrée,* or dark vertical blotches that are characteristic of Adriatic and Mediterranean brown trouts. This suggests a close relationship between marble trout and some populations of *Salmo trutta,* an association further solidified by genetic similarities as discovered by the Slovenian biologist Aleš Snoj.

Large marble trout feed mostly at night and are caught by fly anglers usually by accident. Sometimes an angler will be reeling in a small grayling on the Soča River, and a huge marble will ambush

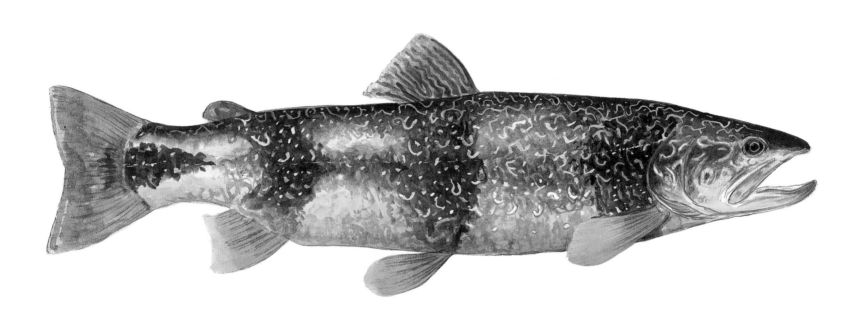

MARBLE TROUT, SPAWNING COLORS, ZADLASCICA RIVER, SOČA TRIBUTARY, SLOVENIA

Salmo trutta marmoratus

BROWN TROUT: MEDITERRANEAN AND ADRIATIC TROUTS

and engulf it. Usually the angler is unprepared for such a monster, the line breaks, and the fish disappears.

Skadarsko Lake in Montenegro, toward the southern end of the marble trout's range, has produced many giant marble trout. I visited Skadarsko Lake with Johannes Schöffmann in July of 2002, and we went out one morning in a small wooden boat with a carp fisherman from the fishing village of Vranjina. In this area, it is well known that large marble trout from the Morača River migrate downstream and spend the winter in the vast lake (in the summer it is too warm for trout) and feed on bleak, carp, and perch. The carp fisher told us that he had caught *glavatica* (the word for marble trout in much of the Balkans) of forty pounds in his carp nets and had heard rumors of fish over 60 pounds (27.2 kg).

Marble trout have historically coexisted with native brown trout in the Neretva (Bosnia) and Morača (Montenegro) Rivers, and perhaps even the Soča, and remained reproductively isolated. If non-native brown trout, however, are introduced, hybridization with marble trout will occur. Because of extensive stocking of non-native brown trout, there are no longer pure native marble trout in the lower reaches of the Soča. Genetically pure marble trout in the Soča system can now be found only in a few high tributaries in and near the Triglav National Park in the Julian Alps: the Zadlascica, Studenc, Lipovscek, and Trebuscica among them. Part of the reason why they survive here, as Meta Povz points out in her monograph, *The Marble Trout,* is because the streams run through "the least polluted and thus at present among the least degraded areas not only in Slovenia but in Europe."

At the suggestion of Johannes Schöffmann, I have added a painting of the southern marble trout, a specimen from the Cijevna River in Montenegro. Southern marble trout (Neretva and Skadar Lake basins) are very different from the northern ones (northern Italy and Soča River), not only genetically but also in coloration and marble pattern.

MARBLE TROUT, ZADLASCICA RIVER, SOČA TRIBUTARY, SLOVENIA

Salmo trutta marmoratus

SOUTHERN MARBLE TROUT, CIJEVNA RIVER, MONTENEGRO

Salmo marmoratus

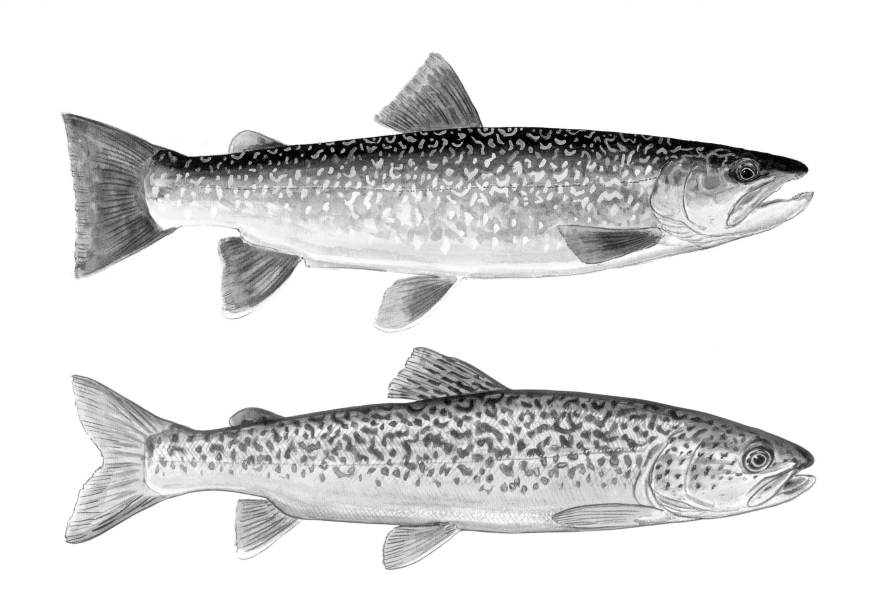

Brown Trout, Krka River, Croatia
Brown Trout, Zrmanja River, Croatia

I VISITED the Krka River in Croatia on my first expedition with Johannes Schöffmann in 1997, after a month of sampling streams for native trout in Turkey. The Krka is Schöffmann's favorite trout river, but he had not been there in the eight years since the outbreak of war. He feared that there would be few of the large handsome trout he had once known because trout are often netted or killed with explosives during hard times. What we found, though, was quite the opposite. The banks of the river had been planted with land mines, and the locals were afraid to walk and fish there. The ecosystem, left untouched, was thriving. This was also the case on the upper Zrmanja River, whose little valley was all but abandoned.

The Krka emerges full force from the ground, falls through a steep canyon, and eventually makes its way to the Adriatic Sea. It is home to two distinct native trout, a "typical" Adriatic brown trout and one with a more snoutlike jaw that the locals in the town of Knin call *zlousta pastrva,* or evil-mouth trout. The spots on the trout of the Krka and Zrmanja are irregular in shape, like cracked peppercorns, as opposed to the rounded spots of Atlantic browns. The Zrmanja trout have red spots almost exclusively, while those of the Krka have red and black spots. Both have a distinct olive-yellow hue about the flanks and back and sometimes exhibit *zébrée.*

The trout of the Zrmanja and the Krka were first described by the Austrian biologist Heckel who also named a trout from the nearby Neretva River, *Salmo dentex*, to describe their "much larger and stronger teeth, a narrow and more pointed head, low nostrils, and dark spots on the body." Some have thought that *Salmo dentex* is a natural and perhaps ancient hybrid of the marble trout, *Salmo marmoratus*, and the brown trout, *Salmo trutta.* It is still regarded by some locals as a distinct type of trout, for which the local name is *zubatak.* The prevailing view is that these names, even as subspecies designations, are taxonomically doubtful.

A question sometimes discussed by Balkan anglers and scientists alike is whether any of these trout ever spend time feeding in the sea. As far as is known, trout of the Adriatic and Mediterranean basins do not run to the sea, probably because it's too warm.

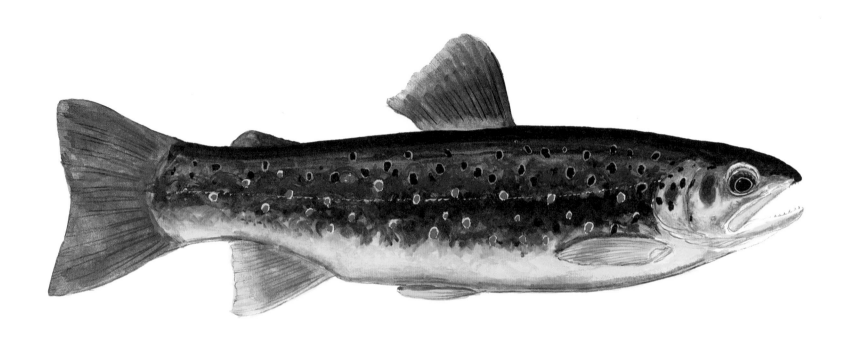

BROWN TROUT, KRKA RIVER, CROATIA

Salmo trutta visovacensis

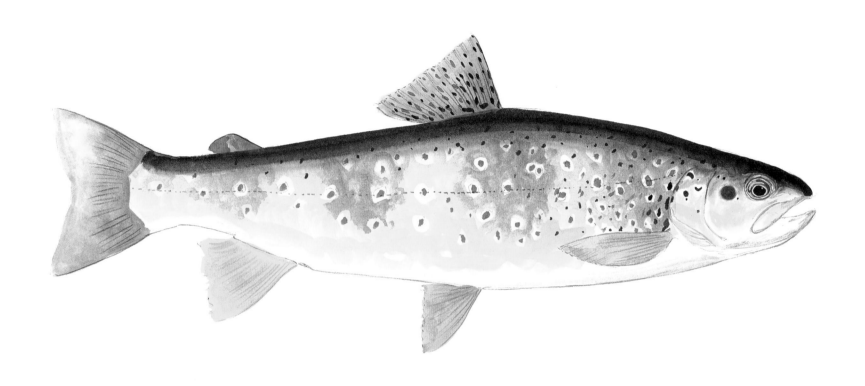

BROWN TROUT, ZRMANJA RIVER, CROATIA

Salmo trutta zrmanjensis

Softmouth Trout, Neretva River, Bosnia

Softmouth Trout, Buna River, Bosnia

Solinka Softmouth Trout, Jadro River, Croatia

Softmouth Trout, Krka River, Croatia

Golden Softmouth Trout, Vrljika River, Croatia

Softmouth Trout, Zeta River, Montenegro

THE BALKAN PENINSULA, the region north of Greece, south of Austria, and across the Adriatic Sea from Italy, is blessed with beautiful mountains, gorgeous beaches, ancient lakes, and fertile, spring-fed streams. Though small, the area harbors the most diverse array of trout in the world, the most unusual of which is undoubtedly *mekousna pastrva,* or the softmouth trout.

The characteristic that most distinguishes the softmouth from other Adriatic trout is its unique mouth, a kind of fleshy, elongated snout with a distinct overbite that is somewhere between a trout's and a grayling's. Its sides are sprinkled with black and red spots that vary in size and shape but are mostly concentrated toward the head. Its scales are larger than those of typical brown trout, and its coloration can be silvery to yellow but never with the vertical bands or *zébrée* typical of many Adriatic brown trout. Softmouth trout spawn in late winter and early spring. They are intolerant of salt water, evidence perhaps of longer isolation in freshwater rivers.

The softmouth trout was first described by the Austrian naturalist Heckel in 1891, as *Salar obtusirostris,* after specimens from rivers of Dalmatia flowing to the Adriatic Sea. The renowned Russian ichthyologist Leo Berg in 1908 expressed his opinion that the softmouth was an ancient trout of pre-glacial origin, distinct enough to warrant status as a new genus, *Salmothymus.* Berg thought that the softmouth trout had no close relatives in Europe but, based on the shape of its peculiar mouth, was a cousin to the lenok of Siberia. This theory was incorrect, just as was the prevailing thought that the softmouth was a hybrid between the salmon and the grayling. Doubtfully valid subspecies of softmouth trout—*krykensis, oxyrhynchus, salonitana,* and *zetensis*—were named from the few rivers they are

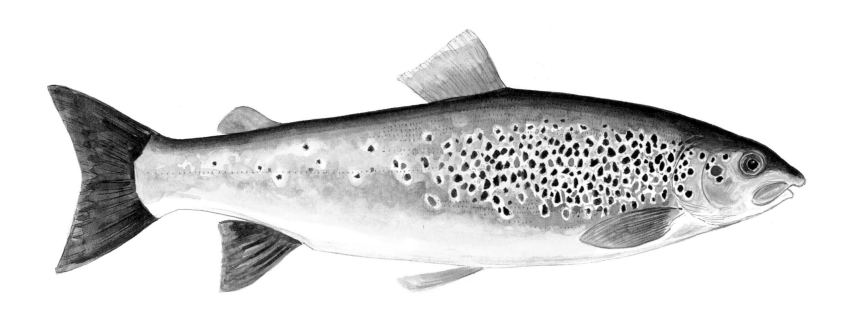

SOFTMOUTH TROUT, NERETVA RIVER, BOSNIA

Salmo obtusirostris oxyrhynchus

BROWN TROUT: MEDITERRANEAN AND ADRIATIC TROUTS

native to: the Krka, Neretva (including the Buna tributary), Jadro, and Zeta respectively.

Berg's designation of the softmouth as a separate genus went unchallenged until 2002, when Aleš Snoj and his colleagues at the University of Ljubljana in Domžale, Slovenia, published a fascinating work on the softmouth from the upper Neretva River, Bosnia. Snoj wrote that the softmouth's status as a separate genus was "ambiguous and has never been firmly established." Through analysis of mitochondrial and nuclear DNA, he has shown that softmouth trout are more closely related to brown trout than previously believed. He argued that *Salmothymus obtusirostris* should be reclassified on the species level, *Salmo obtusirostris,* thus placing it within the same genus as brown trout and Atlantic salmon.

The softmouth, separate genus or not, is clearly distinct from the brown trout, not only in appearance but also in habits. While diving in the crystal-clear Krka and Buna Rivers and observing the softmouth in their habitat, Schöffmann and I discovered that the softmouth and the native brown trout behave very differently. Unlike the brown trout, which usually appears to be solitary, the softmouth swim in pairs or small schools. Also, unlike the brown trout, which take shelter immediately under rocks when chased, the softmouth just swim in the open water, almost never taking shelter under rocks or in the weeds. Because of this behavior, the softmouth are virtually impossible to catch with a hand net, Schöffmann's preferred method of collecting specimens. Softmouths can be easily caught with lures and flies, however, and in places where they coexist with brown trout, they are often caught first.

The five known rivers where softmouth are native—the Krka, Jadro, and Cetina (Croatia), the Neretva (Bosnia), and the Zeta (Montenegro)—are all fed by significant springs. The source of the Buna, a tributary of the Neretva, emanates full force from a stalactite cave at the foot of a sheer one-thousand-foot cliff. Remains of several water mills that used to operate at the source, and the ruins of a Dervish monastery, can still be seen. The Krka has a similar impressive source, and the Jadro was once fed by a huge spring that supplied, via aqueduct, water for the palace of the Roman leader Theoclitis and the ancient city of Salona. Some think that the softmouth trout is a very archaic form of trout, and it is likely that they survive to this day because these streams—their strong sources emanating from the ground with consistent temperatures, and their southerly position beyond the reach of the last glaciation—provided a refuge across millennia. Other archaic salmonids like the *belvica* trout of Ohrid Lake in Macedonia, and the longfin char of El'gygytgyn Lake in northeast Russia, are thought to have survived because the ancient lakes they inhabit have provided a relatively stable and consistent harbor over many years through severe climatic changes.

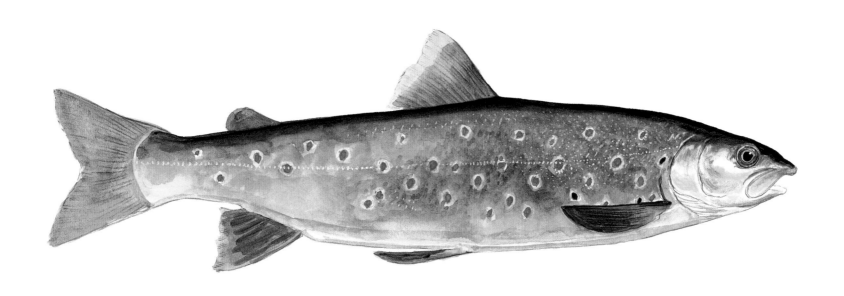

SOFTMOUTH TROUT, BUNA RIVER, BOSNIA

Salmo obtusirostris oxyrhynchus

BROWN TROUT: MEDITERRANEAN AND ADRIATIC TROUTS

Today, throughout their native range, softmouth trout are severely endangered. They are extinct in at least two of the five rivers named above. In all the other rivers, save the Buna, which has recently been closed to all fishing, softmouths are in immediate danger of extinction. Because they are often concentrated near the sources of the rivers and not as numerous downstream, they are vulnerable to poaching, especially at spawning time in spring.

As early as 1940 the Yugoslavian ichthyologist Karaman described about a hundred locals with spears in their hands lining the willow-studded banks of the upper Krka, hauling in as many softmouths as they could while those fish were on their spawning redds (the depression in which the eggs will be deposited). Some of the larger fish were 13 pounds (6 kg). While diving in the headwaters of the Krka near the town of Knin in 1997, Schöffmann and I saw at least two dozen specimens; in 1999, when Schöffmann returned alone, he saw one giant specimen that he estimated to be over 30 inches (76.2 cm) and no others. On a return trip in the summer of 2002, we saw only a single pair. An expedition to the Krka using electroshocking gear (an electric current is run through the water to temporarily stun fish so they can be counted) in the spring of 2003 revealed no softmouths. The softmouth of the Cetina are extinct, though on an expedition led by Snoj in 2003, softmouths were found to still exist in the Jadro River in Split, Croatia. The previous spring they had identified an introduced population of Jadro softmouths in the nearby Zrnovnica River.

In July of 2002, Schöffmann and I, accompanied by Snoj and his colleague Simona Susnik, made an expedition to Montenegro to determine whether the softmouth trout of the Zeta River still existed. We watched a fisherman drift down the currents of the Zeta on a wooden boat. He was fishing for chub with a hazelwood rod, no reel, and a fixed line of black horsehair. On the end of the line was a small fly that he seemed very adept at casting with a single flick in front of the boat along the trees. We asked him about the native *mekousna pastrva,* and he shook his head. We spoke to the local fisheries' president and to ichthyologists at the University in Podgorica—all were doubtful that the Zeta softmouth survived in any abundance. The Zeta River itself has been channelized near its source, water is

SOLINKA SOFTMOUTH TROUT, JADRO RIVER, CROATIA

Salmo obtusirostris salonitana

SOFTMOUTH TROUT, KRKA RIVER, CROATIA

Salmo obtusirostris krykensis

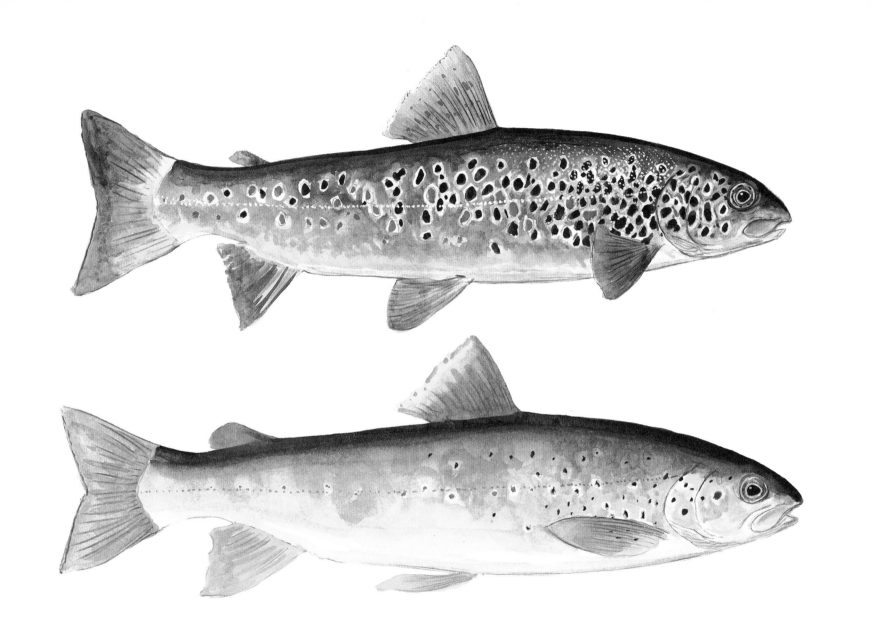

pumped out at numerous points for drinking and irrigation, and its flow is restricted by dams. The only specimen of Zeta softmouth that I saw was in a jar of formaldehyde in the biology lab of the University in Podgorica. Though it was poorly preserved, its fins ragged and colors bleached out, you could see that its mouth was identical in shape to those softmouth of the Neretva River. Without cooperation between the Balkan nations and help from elsewhere, the unique fish of the Zeta will surely disappear, if it hasn't already.

Since the publication of the first edition of this book, the Zeta softmouth trout has been "rediscovered," in a small tributary of the Zeta River in the village of Tunjevo, Montenegro (in the summer of 2004). Such rare occasions of rediscovery are always welcome and are wonderful illustrations of the resilience of nature. The latest classification by Snoj considers the softmouth trout a separate species as opposed to a subspecies of the brown trout or a separate genus, as it had once been known. I have also added a fish of the Vrljika River, another population of softmouth thought to be extinct until rediscovered by Snoj and Schöffmann, also in 2004. Distinct in its golden-yellow appearance, it is unique among softmouth trout in being the only population that does not coexist in its native habitat with brown trout. The underwater films of Spanish biologist Manu Esteve have given us a window into the unusual spawning behavior of softmouth trout. Unlike brown trout, softmouth do not bury their eggs in gravel but broadcast them on the river bottom, as do grayling.

GOLDEN SOFTMOUTH TROUT, VRLJIKA RIVER, CROATIA

Salmo obtusirostris

SOFTMOUTH TROUT, ZETA RIVER, MONTENEGRO

Salmo obtusirostris zetensis

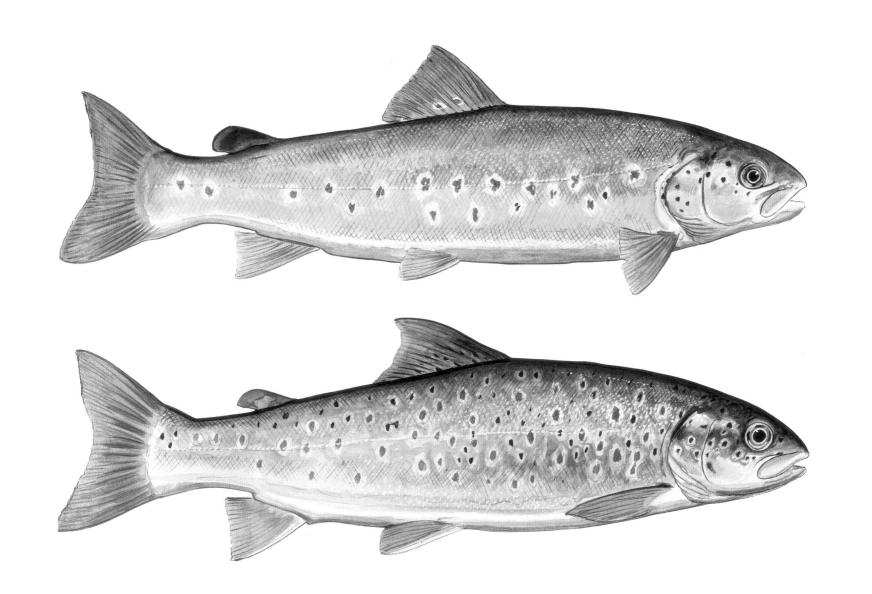

Belvica Trout, Lake Ohrid, Macedonia

Letnica Trout, Lake Ohrid, Macedonia

LAKE OHRID, on the semidesert mountain border of Macedonia and Albania, is one of the oldest lakes in Europe. In its four-million-year existence it has managed to preserve primeval flora and fauna, which has led to its moniker among local biologists as the "basin of living fossils." Along with harboring seventeen other species of native fish, it is also host to an exceptional diversity of trout known locally as *pastrmka*, *letnica*, and *belvica*.

The most comprehensive monograph of the salmonids of Lake Ohrid was written by Dusica Stefanovic in the 1940s, *Racial and Ecological Study of the Ohrid Salmonids*; its publication was suspended when Stefanovic was arrested and executed at the outset of the Second World War. In it she discusses the several distinct races of native trout, the names of which are not always clear-cut, especially among the locals in the fishing villages of Pestani and Trpejca. It is generally accepted, however, that there are three varieties of letnica, (pronounced "letnitsa"), the common name for the Ohrid trout: the *pestani,* or winter trout, which spawns in January and February on the eastern shore; the *letnica pastrmka*, or summer trout, which spawns from June to August; and the struga fish, which spawns in December on the western shore. All of them are included under the name *Salmo letnica,* a species designation first used by the Yugoslavian ichthyologist Karaman in 1924. Stefanovic also gives them subspecies names: *Salmo letnica typicus, Salmo letnica aestivalis,* and *Salmo letnica balcanicus,* respectively. These races spawn virtually every month of the year, occupying different ecological niches, and are reproductively isolated. In that way they are similar to other sympatric populations of trout, like those of Lough Melvin in Ireland, and Sevan Lake in Armenia.

Because of a still-active commercial fishery, the Lake Ohrid Hydrobiological Institute artificially spawns Ohrid trout and returns the fry to the lake to supplement natural spawning. In the late 1960s, some trout from Lake Ohrid were introduced to selected lakes and reservoirs in Colorado, Minnesota, Montana, Tennessee, and Wyoming. By all accounts the Ohrid trout did not successfully reproduce in any of its new locations, but it is possible that some Ohrid trout genes are still active in the western United States. This remains the only known introduction of an Adriatic trout to America.

The *belvica* is the most peculiar and divergent of all the Ohrid trouts. It is characterized by a small mouth and tiny teeth, and brown and red spots usually so faint that they can't easily be seen, giving the fish an overall silvery-white sheen. *Belvica,* which means "white," was

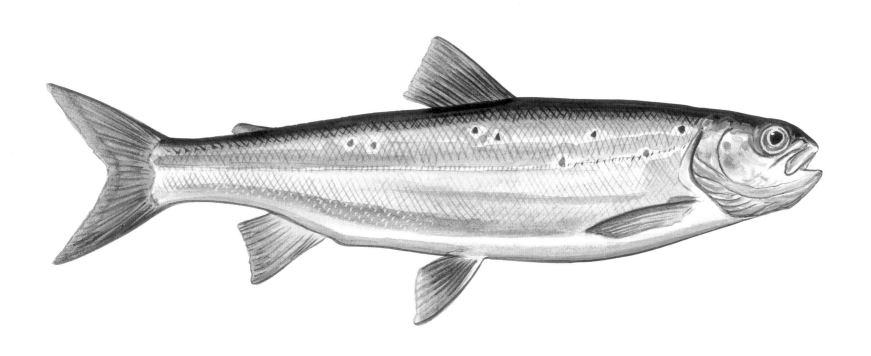

BELVICA TROUT, LAKE OHRID, MACEDONIA

Salmo ohridana

BROWN TROUT: MEDITERRANEAN AND ADRIATIC TROUTS

first described as a separate species, *Salmo ohridanus,* in 1892 by the Austrian ichthyologist Steindachner, who opined that it was closely related to the softmouth trout of Dalmatia, *Salar obtusirostris.* In 1908, Leo Berg reclassified the Ohrid *belvica* and the softmouth trouts under a new genus, *Salmothymus,* meant to describe very old trouts that were relicts of a pre-glacial origin. *Belvica* was again reclassified by renowned ichthyologist Hadzisce from Yugoslavia in 1960, as a separate genus, *Acantholigua,* although more contemporary genetic studies, like that of Aleš Snoj, support the inclusion of the *belvica* under the genus *Salmo,* as a species, *Salmo ohridana.* Snoj believes that the softmouth trout and *belvica* evolved from a common ancestor, the divergence between the two having occurred about two million years ago.

On a trip to Yugoslavia in the 1960s, Behnke attempted to collect a specimen of *belvica* to bring back to America. He was visiting with Hadzisce, who was reluctant to let any foreign scientists have a specimen, but after a week of drinking plum brandy together, Behnke was able to charm one out of him. Behnke told me in conversation that "the fish looks just like a smelt, it's white. Most recent genetics show that *belvica* is nearly identical to the brown trout, but its meristics show it to be very archaic. The dentition and skeletal structure tell me that this is a very ancient fish."

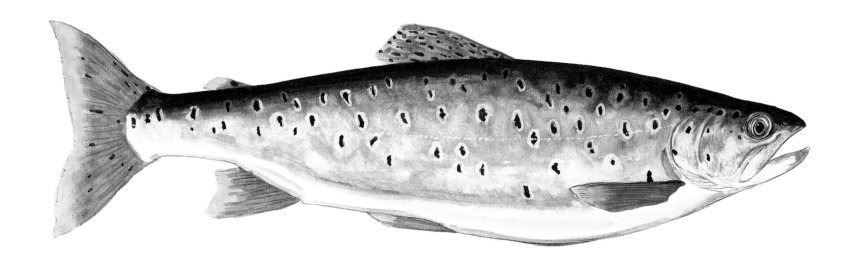

LETNICA TROUT, LAKE OHRID, MACEDONIA

Salmo letnica typicus

BROWN TROUT: MEDITERRANEAN AND ADRIATIC TROUTS

Brown Trout, Voïdomátis River, Greece

Aelian's Trout, Nástos River, a tributary of the Aliákmon River, Greece

THE CLOSEST thing to an ancient holy site for fly fishermen are the rivers of northern Greece, in particular the Aliákmon (thought to be the Astraeus in the passage below). It is here that Claudius Aelianus described the Macedonian way of catching trout, the earliest known reference to trout fishing with an artificial fly, in his second-century text, *De Natura Animalium:*

> Between the cities of Beroea and Thessalonica flows a river called the Astraeus, and in this river are fish with spotted skins. These spotted fish feed on insects unique to this countryside, which flutter over the river. The insect is not like the flies found elsewhere, nor does it resemble the wasp in appearance, nor could one describe its configuration as like a midge or the bee, yet it had something of each of these. The river people call it Hippouros.
>
> The flies seek food above the river but do not escape the attention of the spotted fish swimming below. When the fish observe a fly on the surface, they swim up stealthily, careful not to disturb the currents, lest they should frighten their prey and, coming upward like a shadow, open their mouths and seize the flies, like wolves carrying off sheep from the fold, or as eagles take geese from a farmyard—having captured the flies, the fish slip back into the rippling currents.
>
> Although the fishermen understand this, they cannot use these insects as bait, for when one touches them, they lose their natural coloring, and their wings wither. The fish have nothing to do with such damaged flies and refuse them.
>
> But the fishermen have planned another snare for the spotted fishes and deceived them with their craftiness. They wrap ruby-colored wool about their hooks and wind about this wool two feathers, which grow under a cock's wattles and are the color of dark wax.
>
> Their rods are about six feet, with a line of a similar length attached. With this they cast their snare, and the fish, attracted and made foolish by the colors, come straight to take it.

Of these two specimens of trout from northern Greece, the trout of the Voïdomátis has the vertical bands, or *zébrée,* common in Mediterranean trouts. The other trout, from a headwater tributary of the Aliákmon, is most likely identical to the trout that Claudius Aelianus saw and described nearly two thousand years ago.

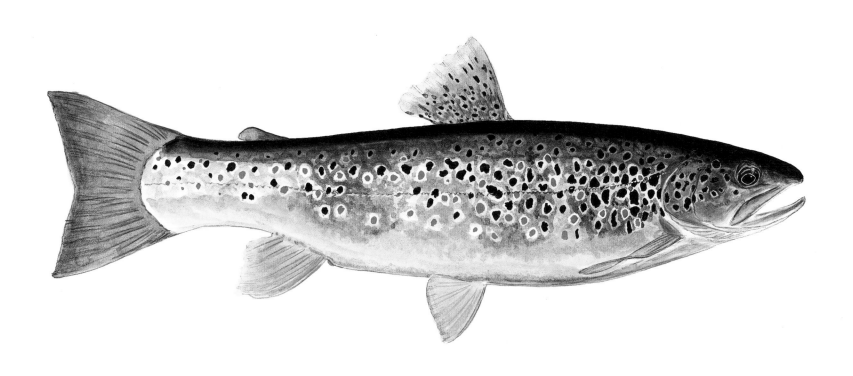

BROWN TROUT, VOÏDOMÁTIS RIVER, GREECE

Salmo trutta dentex

BROWN TROUT: MEDITERRANEAN AND ADRIATIC TROUTS

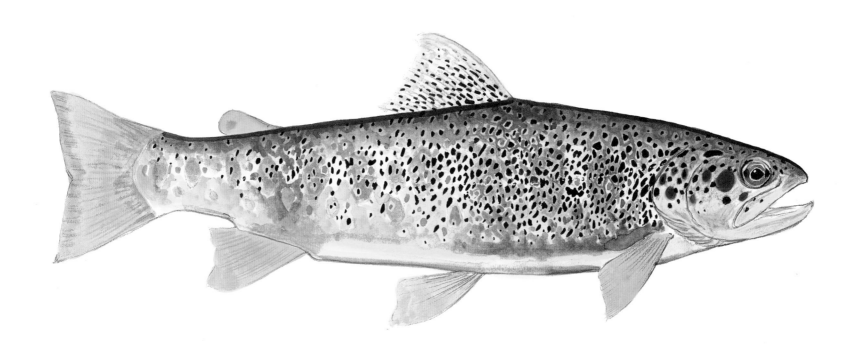

AELIAN'S TROUT, NÁSTOS RIVER, A TRIBUTARY OF THE ALIÁKMON RIVER, GREECE

Salmo trutta

BROWN TROUT: MEDITERRANEAN AND ADRIATIC TROUTS

Brown Trout, Köprü River, southern Turkey

Brown Trout, Tarsus River, southern Turkey

THERE ARE several beautiful trout streams emerging from the Toros Mountains of southern Turkey. The most dramatic of these is the source of the Kapuz River, a series of waterfalls gushing from the sides of cliffs. The fish of these rivers in southern Turkey have varying spotting patterns and sometimes *zébrée* but are characterized by a large dorsal fin that lies slightly forward on the body. Trout of the Köprü River also have a slight overbite reminiscent of softmouth trout.

In 1951, having observed the dearth of published material on trouts of Turkey, Enrico Tortonese, with encouragement by his colleague, C. Kosswig, set out to study them: "When I visited Anatolia in 1951, I had the possibility of examining and collecting specimens and of taking notes that now have proved to be very useful for the preparation of this paper. Such being the basis on which the present study rests, I must state that it is far from being an exhaustive one." Tortonese's paper was all that had been published on Turkish trouts (outside of Turkey, perhaps) before Johannes Schöffmann's papers in the Austrian journal *Österreichs Fischerei,* describing his ten or so expeditions there.

Turkey is a special place to study trout, first and foremost because it has received few to no introductions of non-native trout. If you can find a trout, then you know that it is native and pure. Tortonese wrote in the 1950s, "I am sure that no fry ever came from other countries. Such condition being nowadays rare, the study of these salmonids has an outstanding interest." Turkey is also unique because it has rivers flowing to four major basins, the Mediterranean, Black, and Caspian Seas, as well as the Persian Gulf.

BROWN TROUT, KÖPRÜ RIVER, SOUTHERN TURKEY

Salmo trutta

BROWN TROUT, TARSUS RIVER, SOUTHERN TURKEY

Salmo trutta

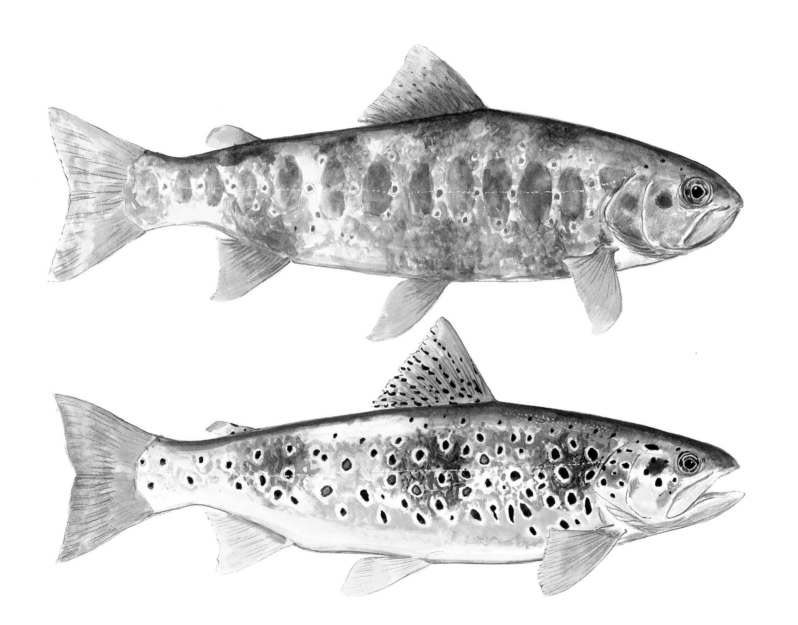

Platycephalus Trout, Soğuksu Stream, Turkey

In 1967, a team of university scientists from Hamburg made an expedition to south-central Turkey to collect specimens of native fishes. In a beautiful spring-fed stream winding through bucolic countryside, they caught trout unlike any they had ever seen. Upon returning to Germany, they mailed specimens to the renowned ichthyologist and trout taxonomist Robert Behnke, asking his opinion of the fish. Behnke was struck by its unique physical characteristics and classified it as a new subgenus, *Platysalmo*, and species, *platycephalus*, a name that alludes to its slightly elongated and flat skull. He later revised his idea of it as a subgenus and now considers it a distinct species, *Salmo platycephalus*.

The sides of the platy trout are covered with a kind of marbling or faded splotchy pattern, similar to markings on some marble trout, *Salmo marmoratus*. Some specimens exhibit the *zébrée* markings typical of trout from the Mediterranean and Adriatic basins, and the flat-head structure is reminiscent of some specimens of marble trout. Johannes Schöffmann has observed that the lower jaw on the platy trout is peculiarly fleshy, similar to the jaw of a softmouth trout. In appearance, clearly the platy trout is distinct from the brown trout.

Recent genetic work by Louis Bernatchez and Aleš Snoj, performed independently, however, has shown that the platy trout is closely related to brown trout of the Adriatic basin. Snoj believes that the fish may not even be distinct enough to warrant subspecies status. Nevertheless, in Schöffmann's words, "*platycephalus* is an evolutionarily significant unit which is worth describing and, hopefully, protecting."

In 1997, when I traveled with Schöffmann to Turkey, we visited the streams near Pinarbaşi in south-central Turkey where *Salmo platycephalus* is native. One stream, the Soğuksu, was an even-flowing spring creek that wound lazily through cow pastures and meadows of tall grass. Four years previous Schöffmann had found platy trout in abundance, but after a full day of searching, we were unable to find even a single trout. The local people had built a road near the headwaters of the Soğuksu, which silted in the spawning grounds and appeared to have caused the fish's demise. Unable to find any platy trout in other area streams, like the Karagöz, we assumed that this fish was extinct.

In September of 2002, however, Schöffmann returned to south-central Turkey with his wife, Ida, and reported that the platy trout were mysteriously abundant again in all the streams where they had been missing. The locals said that the trout had been pushed downstream by a big flood and had now returned.

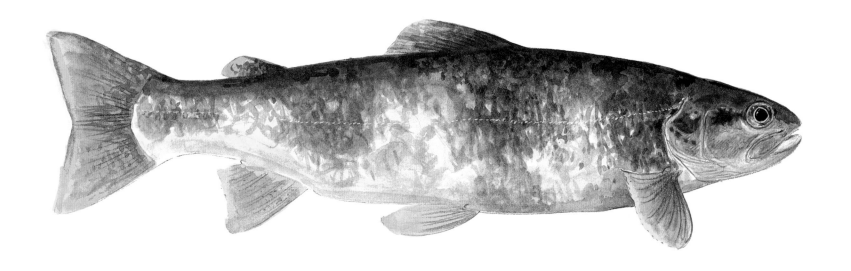

PLATYCEPHALUS TROUT, SOĞUKSU STREAM, TURKEY

Salmo platycephalus

BROWN TROUT: MEDITERRANEAN AND ADRIATIC TROUTS

Black Sea Trout, Mühl Bach, Austria

Black Sea Trout, Carinthia, Southern Austria

THIS TROUT, from a small stream called Mühl Bach, or "millstream," near Sankt Veit in southern Austria, is typical of brown trout in the Black Sea drainages, which are characterized by milky-white to yellow bellies, yellow fins, and rounded red and black spots with white haloes.

The Black Sea trout was first described as a species, *Salmo labrax,* by Petrus Pallas, after a migratory form that ran up rivers of the Crimea on the north shore of the Black Sea. According to Leo Berg, Pallas called it *labrax* after the local name used by the Crimean Greeks for this trout, *lavraki.* These sea-run fish were bright silver, sometimes with no visible spots, attaining weights up to 30 pounds (13.6 kg).

From Georgia to northern Turkey, Bulgaria to the Crimean Peninsula, small tumbling streams are host to landlocked forms of these beautiful fish.

A lovely account of fishing for *Salmo trutta labrax* in the streams near Trabzon, Turkey, can be found in Rose Macaulay's novel of 1956, *The Towers of Trebizond,* which tells the story of a young English girl who travels with her aunt and a high Anglican churchman around Turkey, attempting to convert the Turks to Christianity.

I lay by the edge of the stream among tall ferns, and the bank was covered with rhododendrons and azaleas, white and pink and yellow and scarlet, . . . and I felt that I was in a wood in Perthshire, staying with my grandparents, for the smell was the same, and I and the others used to go out early and fish the burn for trout, and I was very happy there.

The bottom fish (opposite) is from a genetically pure population in a small stream in Carinthia, southern Austria.

BLACK SEA TROUT, MÜHL BACH, AUSTRIA

Salmo trutta labrax

BLACK SEA TROUT, CARINTHIA, SOUTHERN AUSTRIA

Salmo trutta labrax

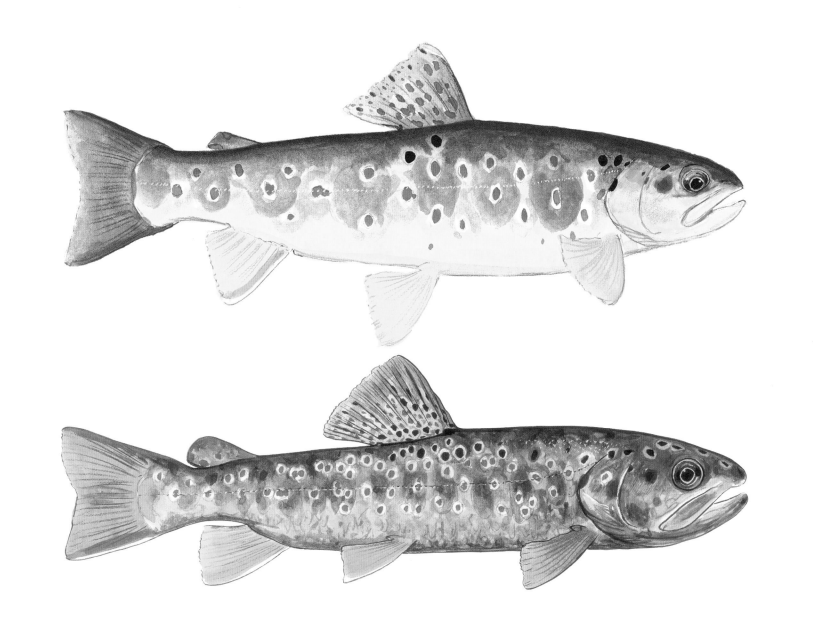

Naked Brown Trout, Bistrica Stream, near Mojstrana, Slovenia

MANY STREAMS of the Danube basin in Slovenia have clear turquoise water, almost the color of mint tooth gel. The Bistrica Stream, because of its chalk bottom, is nearly white, and its trout, which have evolved to mimic the stream bottom, are nearly white as well. Though there are other streams in Slovenia with white chalk bottoms, this is the only stream where Johannes Schöffmann has caught trout that have so few spots.

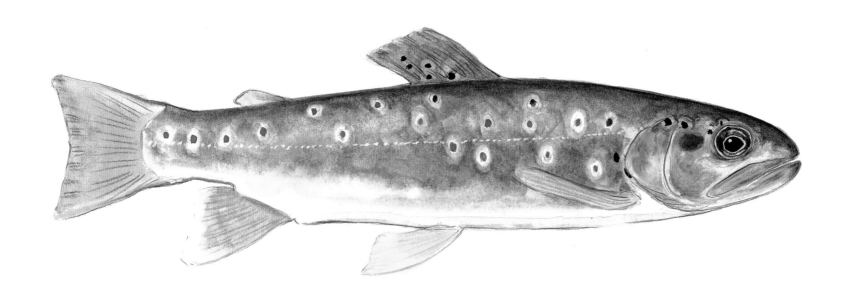

NAKED BROWN TROUT, BISTRICA STREAM, NEAR MOJSTRANA, SLOVENIA

Salmo trutta labrax

BROWN TROUT: BLACK SEA TROUTS

Black Sea Trout, Dzepska River, Serbia

Black Sea Brown Trout, Jerma Brook, Serbia

THIS SPECIMEN was caught by Goran Grubic, professor of biology at the university in Belgrade, Serbia, who describes it as a "special race of trout." It is from a mountain tributary of the Danube called Jerma Brook on the border of Serbia and Bulgaria. The trout of this stream exhibit a beautiful chain of raspberry-colored spots along their lateral line.

The name for trout in Serbian is *pastrmka,* in Croatian it is *pastrva,* and in Slovenian it is *postrv.* Slovaks, Czechs, and Poles call them *pstruh* and *pstrag.* The root of these words, "ps" or "pas," comes from the old Slavic word *pastrm* or *pastrv,* for something spotted. "Pas," for instance, is also the Slavic word for "dog," because dogs in this region were often spotted (for example, the Dalmatians of Dalmatia). Greeks have a similar name for trout, *pestrofa.*

There are many other unique strains of brown trout in the Danube basin. The trout of the Moosach River, a tributary of the Isar near Munich, Germany, for instance, were known for their large size. The Moosach is not a big river, and yet specimens in excess of 30 pounds (13.6 kg) were known to have been caught there. This Moosach strain was introduced to several rivers in the state of Arkansas in America, notably the Little Red and the White, where specimens weighing more than 40 pounds (18.1 kg) have been caught.

The fish pictured at top is from the Dzepska River in Serbia. According to Johannes Schöffmann, it "represents a very distinct and ancient genotype within the Danube lineage."

BLACK SEA TROUT, DZEPSKA RIVER, SERBIA

Salmo trutta labrax

BLACK SEA BROWN TROUT, JERMA BROOK, SERBIA

Salmo trutta labrax

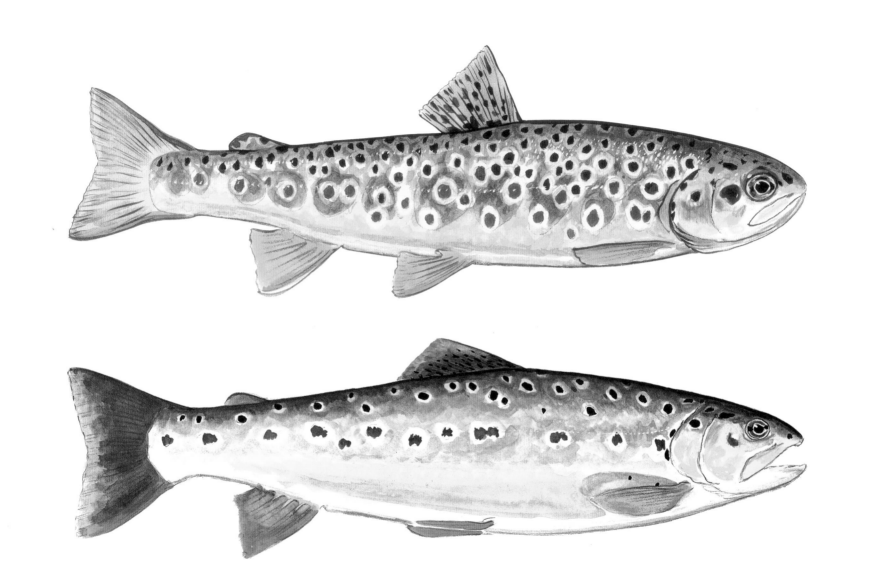

Brown Trout, Manastir Brook, western Turkey

IN THE SUMMER of 1997, Johannes Schöffmann and I found this native trout in a small stream running through an olive grove near Edremit, Turkey, to the Mediterranean Sea. Its sides were gold and blue sprinkled with rounded red and black spots haloed in white: not typical characteristics of a Mediterranean fish. We sent a tissue sample of the fish to Louis Bernatchez, who determined through genetic analysis that it was of Black Sea origin, which was in keeping with its appearance. This means that the fish migrated to this stream, either by sea (it is near the passage between the Black Sea and the Mediterranean, the small Marmara Sea) or by headwater connection several thousand years ago. All the fish we caught in this stream also exhibited an elongated spot posterior to each eye, which, seen from above, look as though they could be false eyes.

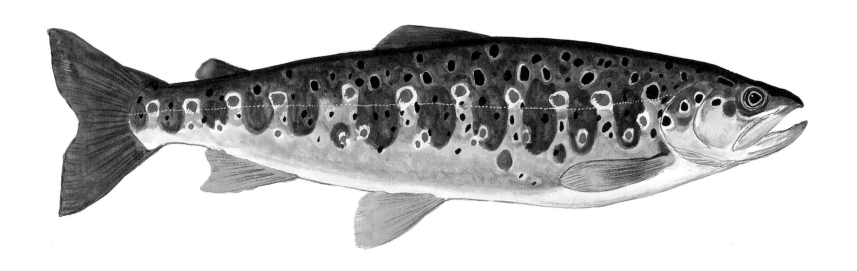

BROWN TROUT, MANASTIR BROOK, WESTERN TURKEY

Salmo trutta

BROWN TROUT: BLACK SEA TROUTS

Brown Trout, Abant Lake, Turkey

Nestled in the Köroglu Mountains of northwest Turkey is a small alpine lake called Abant, which hosts a unique trout with large well-defined spots. The landscape around the lake is typical of northern Turkey and the mountains of the Black Sea basin—very green, and studded with wildflowers in summer, with tea and corn growing on the terraced hillsides beside timber homes. The region receives a lot of rain, in contrast to the other side of the divide, in the basin of the Mediterranean Sea and the Persian Gulf, which is generally hot and dry.

The trout of Abant Lake were named a separate species by Enrico Tortonese, who made several expeditions to Turkey during the late 1950s in search of native trout. He describes them in his *Trouts of Asiatic Turkey* of 1954:

> The trouts living in Abant Lake form a small, isolated population. These fishes remind one of those present in some rivers of Sardinia, described by Pomini. It can hardly be doubted that the trouts existing in Abant are genotypically as well as phenotypically distinct from those of Sardinia. What is their taxonomic status? Of course, there is no question about their belonging to *Salmo trutta*, but I do not think they are to be included either in *Salmo trutta macrostigma* [the Mediterranean trout] or in *Salmo trutta labrax* [the Black Sea trout]. They rather represent an undescribed subspecies, for which the name *Salmo trutta abanticus* is here proposed.

Tortonese compared the trout of Abant Lake to the gillaroo of Lough Melvin, Ireland, because they both evolved a "thick-walled, hard stomach" for the digestion of snails and shellfish. "I found shells of Gastropods and Crustaceans in trouts from Abant, but further investigations will be required for allowing exact statements about the diet and its correlation with the structure of the digestive tube," wrote Tortonese.

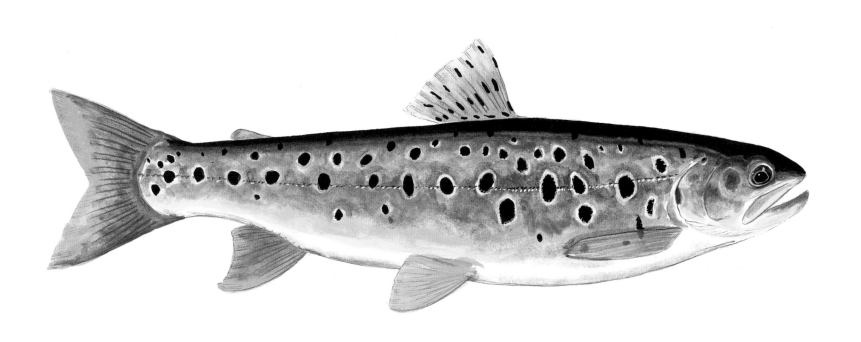

BROWN TROUT, ABANT LAKE, TURKEY

Salmo trutta abanticus

BROWN TROUT: BLACK SEA TROUTS

Tigris Trout, Çatak Çay, eastern Turkey

Euphrates Trout, Murat Çay, eastern Turkey

Euphrates Trout, Göksu River, eastern Turkey

THE WORD for trout in Turkish is *alabalik,* incorporating the prefix *ala* that can mean either a "scarlet shade of red" or "speckled," and *balik,* which means "fish."

The little-known *alabalik* of the headwaters of the Tigris and Euphrates Rivers in eastern Turkey present a fascinating evolutionary puzzle for trout biologists. Both rivers flow to the Persian Gulf, where trout were never native. It is generally accepted that trout evolved from oceangoing relatives, so if they did not get to the headwaters from the sea, then where did they come from?

Toward the end of the last Ice Age, ten to thirteen thousand years ago, when glaciers were melting and a lot of excess water was flowing off inland areas, the trout had routes available to them that they no longer have today. It is thought, therefore, that trout invaded the Tigris and Euphrates basins from headwater streams of the Mediterranean, Caspian, and Black Sea basins during post-glacial times (or as a result of other natural phenomena that created a connection between river drainages). These fish should therefore be some kind of genetic hybrid of the three or isolated populations of each. No one had really studied them, so nobody knew.

The only previous published information on the Tigris trout was in *The Trouts of Asiatic Turkey* of 1954 by Enrico Tortonese. The single female specimen he observed was from a stream he called Sitak, in southeast Anatolia, which is most likely a village and river now known as Çatak. In his list of the fish's morphology, or physical characteristics, Tortonese noted: "adipose fin large." He gave this description of its coloration: "Few and small black spots on the upper part of the sides, chiefly before the dorsal fin; they are more or less surrounded by a clear ring. Red spots along the lateral line, a few under it. Postorbital spot well marked. Oblong and oblique black spots all over the dorsal fin. Red spots on the adipose."

When Johannes Schöffmann and I traveled to the headwaters of the Tigris in the summer of 1997, we found it nearly impossible to get to the streams we wanted to explore because the Turkish military were fighting Kurdish separatists and hesitated to allow us entry to remote areas and the headwater streams. We fished part of the Çatak River, which flows through the village of Çatak about 30 miles (48.3 km) from the border with Iraq. The river was swift and very cold, and we were allowed only a short time to fish by the military police who stood watch nearby. The trout of the Tigris was the most important fish for Schöffmann on our month-long trip, and we failed to catch one.

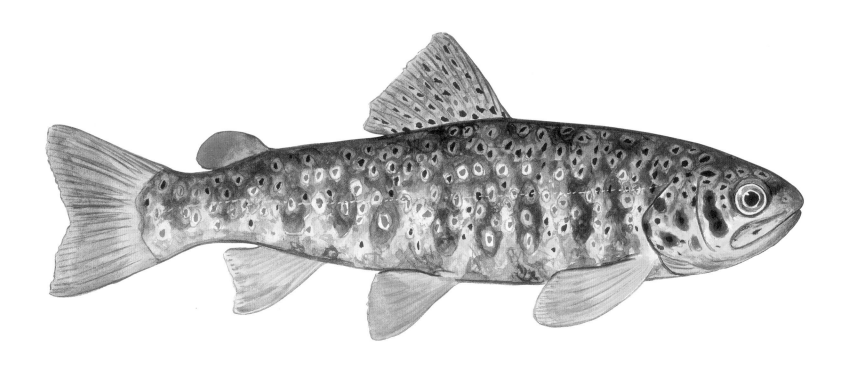

TIGRIS TROUT, ÇATAK ÇAY, EASTERN TURKEY

Salmo trutta

BROWN TROUT: TIGRIS AND EUPHRATES BASIN TROUTS

He was disappointed by this first attempt but not deterred. In September of 2002 he returned to southeast Turkey with his wife, Ida, convinced the army personnel to let him go where he wanted to, paid Kurdish militia to guide him to the streams, and caught six specimens of the Tigris trout (for which the Kurdish name is *massialé*). The red and black spots on the Tigris trout are jagged and irregular. The adipose fin is large, just as Tortonese described, but so are the other fins, and they are quite rounded. Schöffmann believes this to be an adaptation to living in very fast rivers.

The Tigris trout, as well as the trout of Sicily and North Africa, are the southernmost populations of *Salmo trutta*. It was once thought that the southernmost brown trout was native to the Orontes River in Lebanon. In June of 1998, Schöffmann traveled to Lebanon and interviewed elderly locals who had known and fished the Orontes sixty years before. According to all accounts, trout were not native to the Orontes but had been introduced by the French. The most prevalent trout in the Orontes is now the non-native rainbow trout from California.

The only trout of the Euphrates that I have caught were in a northern tributary near the village of Balikli, called *balik çay,* or "fish stream." Schöffmann and I were guided up the stream by an elderly Turkish man who invited us for tea and told us that the trout there were *çok,* or "abundant." Balik River was a beautiful and fast-flowing stream framed by a range of low-lying mountains. The trout were black- and vermillion-spotted, with large adipose fins. They looked very much like trout we had caught in tributaries of the Black Sea. Genetic analysis by Bernatchez of specimens collected by Schöffmann has shown that many trout of the upper Euphrates, including those of Murat River pictured here, are closely related to Black Sea trouts.

Not all trout of the Euphrates, however, are of Black Sea origin. Those of Tohma River in the southeast of Turkey, a very fast and cold stream, are genetically of Adriatic Sea origin. In appearance they are typical Mediterranean/Adriatic fish, with irregular spots and faint *zébrée*. It is the easternmost trout I have seen that exhibits *zébrée,* the westernmost being those of the Tejo River in Spain. The trout of the Tohma undoubtedly crossed from the Mediterranean basin to that of the Persian Gulf when such a connection was available.

EUPHRATES TROUT, MURAT ÇAY, EASTERN TURKEY

Salmo trutta

EUPHRATES TROUT, GÖKSU RIVER, EASTERN TURKEY

Salmo trutta

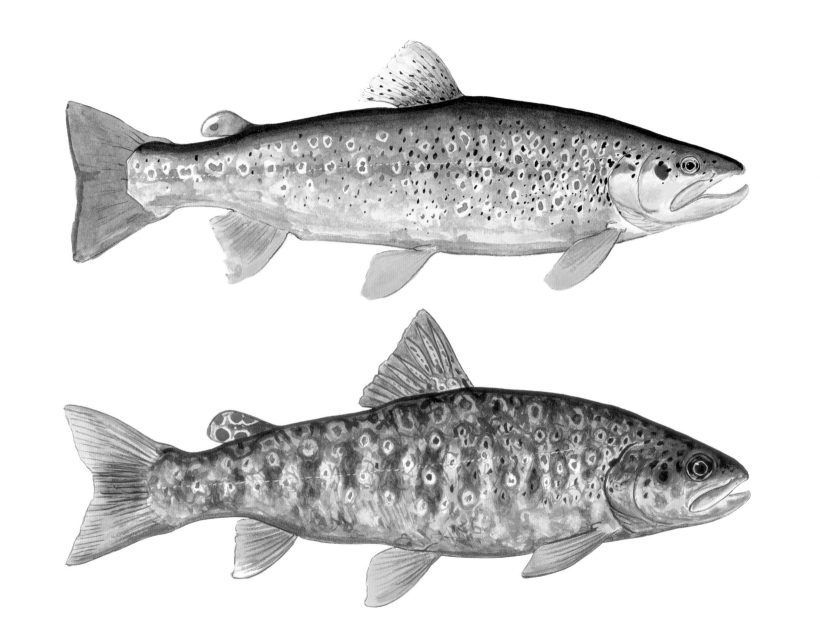

Caspian Sea Brown Trout, small stream near Çildir Lake, eastern Turkey

Brown Trout, Arpa River, Jermuk, Armenia

Brown Trout, Ligvan River, Iran

IN THE MID-1970S, the Colorado Department of Wildlife developed an exchange program with that of the Commission of the Environment in Iran (when the shah was still in power), through the work of Robert Behnke at Colorado State University. The idea was to study and help preserve native populations of trout, known in Persia as *gaozelleh*, or *gezel-âlâ*. The main American envoy was a graduate student from Fort Collins named Barry Nehring who lived in Iran for four years, during which time he discovered a unique population of trout near Tabriz with very fine, mostly red spots. Nehring wrote me:

> There was not much of that country that I had not traveled extensively in, except for far northeastern and east central Iran around and south of Mashhad. I found brown trout to be quite widely distributed throughout the Elburz Mountains all the way around the Caspian basin, as well as on the southern slopes of the Elburz up to the Russian border on both the southeastern and southwestern shores of the Caspian Sea. Most of the brown trout looked very similar, all except for the population we found in a stream probably some twenty to forty kilometers southeast of the city of Tabriz in the Rezaiyeh Lake desert basin.

The stream ran through the mountain village of Ligvan, where they produced a special kind of Turkish cheese. Nehring referred to the unique trout as the "Ligvan chai brown trout" and marveled at the profusion of fine red spots, averaging two hundred to four hundred on each side of the body.

Nehring said that Ligvan River, partially protected by the shade of dense willows, was looked after by the people of the village, and the trout were abundant. But in order to ensure the preservation of this unique fish, Nehring carried out the monumental task of transplanting about 325 of the fine-spotted trout into a river in the central Zagros Mountains, some 800 miles (1300 km) to the southeast. "We did that in the fall of 1975," Nehring remembered. "We hauled the trout from Ligvan to the Central Zagros region by truck, a 36-hour non-stop trip, and then by helicopter into a narrow river canyon, tributary to the Ab-e-Bazoft."

Part of the mission of Nehring and Behnke was to train a director of Iranian fisheries and leave him with a foundation of conservation knowledge. This man was named Feruz. According to Nehring, when the shah was deposed, Feruz was made into a tea boy and then jailed by the Ayatola.

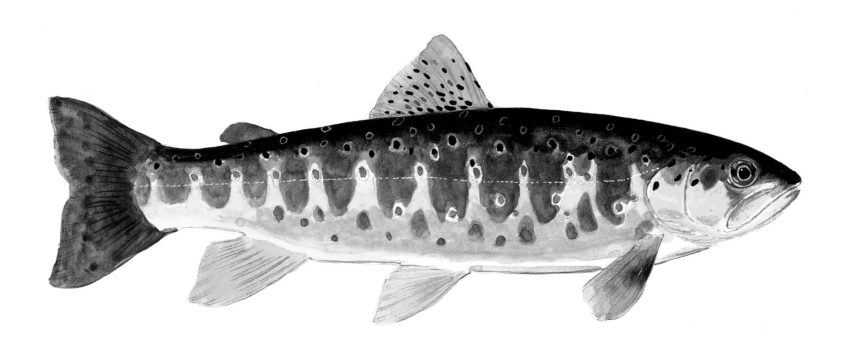

CASPIAN SEA BROWN TROUT, SMALL STREAM NEAR ÇILDIR LAKE, EASTERN TURKEY

Salmo trutta caspius

BROWN TROUT: CASPIAN, ARAL, AND AMUDARYA TROUTS

Trout I have caught in other streams draining into the Caspian Sea—like those in tributaries of the Arpa River in Armenia near Jermuk, a town known for its curative spring water, those in eastern Turkey from a tiny stream near Çildir Lake, and others I have seen from Azerbaijan—have blunt noses and a slightly more compact and stocky appearance.

There is not as rich a tradition of sportfishing for trout in the Caspian Sea basin as there is in Europe. Stories of Western travelers fishing in the East do, however, exist. For a delicious, old-fashioned account of an imperialist British sportsman in Central Asia, read Valentin Baker's *Clouds in the East* of 1876. Part travel journal, part military report, the title is derived from "the distant clouds which threaten our possessions in the East," meaning Russia. In the book, Baker rhapsodizes about the native trout of the Elburz Mountains of Persia, just north of Teheran:

> It was a very pretty camp, a small stream running in front, almost too small to fish but full of trout, though not of any size. That night we had fresh trout and moufflon [which he describes as a kind of mountain deer] steaks for dinner; and until you have tasted trout fresh from the streams in the Persian mountains, you do not know this fish. Talk of Loch Leven [in Scotland]! Its trout are not to be named in the same breath with those of Shiristanik and the Lar.

Among the streams in the rugged and beautiful Elburz, the Lar and the Dooab were the author's favorites. He routinely caught and killed fifty to sixty trout a day, up to 4 pounds, to feed the members of his camp: "Our whole camp lived on trout, and we had to devise many different ways of cooking them, by way of variety. Boiled trout, fried trout, curried trout, pickled trout, stewed trout, were all tried in turn, until at last I hit upon an excellent dish—trout pie."

Baker enthusiastically described the source of the Lar, which must still be a stunning trout stream:

> Clear as crystal, the river came foaming out of the rock, not through a cavern or channel that it was possible to enter, but bursting forth like a gigantic spring, and dashing into the valley a full-grown river.
>
> What a lovely river for fishing it was! Sometimes so deep and rapid and narrow that you could throw a fly across it, at other places so broad that you could barely reach the middle. It was just perfection in every way; running through a broad rocky valley with bare grim peaks on either side, while straight in front, with broad pyramidal base and snowy top, rose Demavend, the greatest mountain in Persia, 20,000 feet in height. Add to this a magnificent climate, perfectly cool in the great heats of summer, and you have a fisherman's paradise.
>
> Oh! ye epicures, take a trip to Persia; stimulate your appetites by the fresh air of these mountain-tops, and then tell me if ever you ate a fish to compare with a Lar trout that only an hour before was in his native stream. This is one of the most pleasant remembrances of Persia. How few there are!

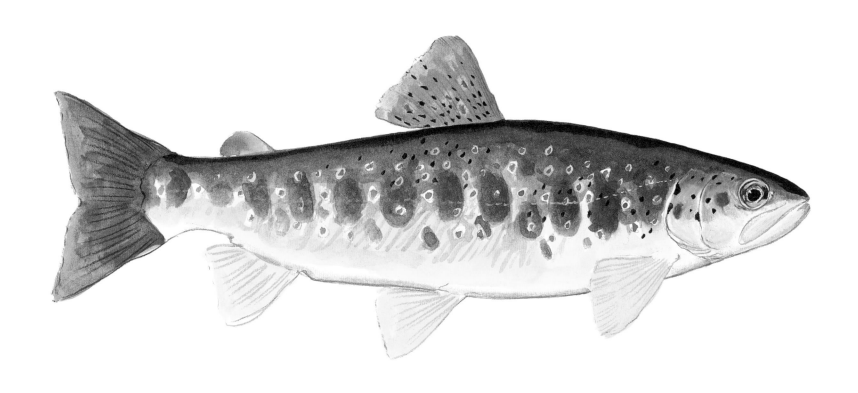

BROWN TROUT, ARPA RIVER, JERMUK, ARMENIA

Salmo trutta caspius

BROWN TROUT: CASPIAN, ARAL, AND AMUDARYA TROUTS

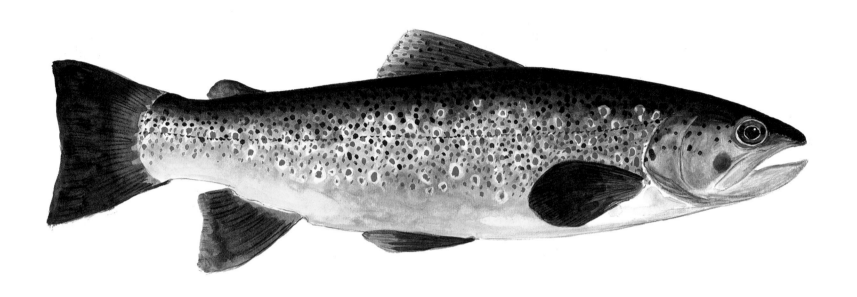

BROWN TROUT, LIGVAN RIVER, IRAN

Salmo trutta caspius

BROWN TROUT: CASPIAN, ARAL, AND AMUDARYA TROUTS

Brown Trout, Balik Lake, Turkey

BALIK GÖLÜ, or "fish lake," lies near the foot of Mount Ararat in eastern Turkey. It is on the summit of Ararat, in the Biblical flood, that Noah was said to have parked the ark. A real-life deluge once occurred in northern Turkey when the land bridge that existed near the Bosporus Strait broke, and the Black Sea, which was at a lower elevation, was flooded by the Mediterranean. This, like all geological phenomena and change, surely affected the evolution of these trouts, because the high water gave them new routes through which to travel. Most trout of Balik Lake are spotted and resemble those of another lake whose outlet flows to the Caspian Sea, Sevan Lake in Armenia. Some specimens of trout in Balik Lake have no spots at all.

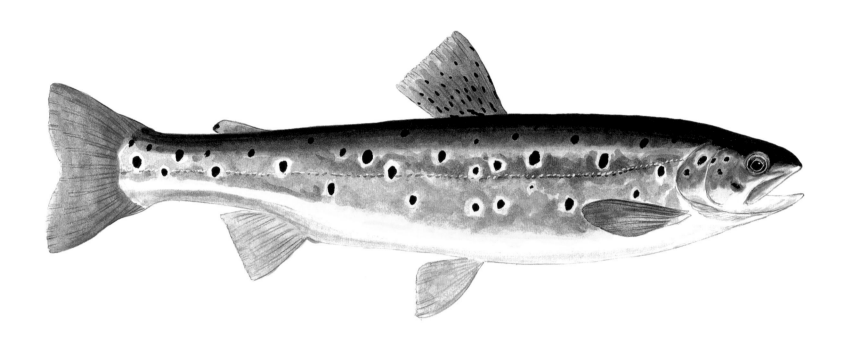

BROWN TROUT, BALIK LAKE, TURKEY

Salmo trutta caspius

BROWN TROUT: CASPIAN, ARAL, AND AMUDARYA TROUTS

Gegarkuni Ishkhan, Sevan Lake, Armenia

Summer Ishkhan, Karchaghbyur River, Armenia

Bodjak, Sevan Lake, Armenia

Kharmrakhait, Argichy River, Armenia

LEGEND HAS it that an ancient Urartian prince (the Urartian people pre-dated the Armenians) lost his beloved to drowning in Sevan Lake. He pined for her at the lakeside and decided he wanted to live with her forever. At the prince's request, a local sorcerer turned him into a beautiful silver fish. Thus the word for trout in Armenian is the "prince fish," or *ishkhan*.

Sevan, from the Urartian word *siuna*, or "country of lakes," is a vast and ancient desert lake, a remnant of a once larger inland sea. Its surface area covers a good part of the small country of Armenia, formerly a Soviet republic. The lake lies at the end of a long parched road from the capital, Yerevan, and is surrounded by some of the oldest stone churches in the world. (Armenia was the first nation to adopt Christianity, in 301 A.D.) This beautiful lake, almost a mirage in the summer heat and once a stopping point for caravans on the great Silk Road, is home to at least four distinct races of brown trout.

The diversity of the lake's trout has given rise to over a dozen names, both common and scientific: *kharmrakhait*, *gegarkuni*, winter *bahtak*, summer *bahtak*, *ishkhan*, *alabalakh*, *gokcha ishkhan*, *yabani*, *bodjak*, *kiryusha*, *danilewski*, *typicus*, *aestivalis*. According to Leo Berg,

the Armenians use the word *ishkhan* to describe non-breeding fish and *bahtak* for those that are sexually mature. The fishermen in the villages around the lake all have their own opinions on what the different trout should be called; some say the various races can only be distinguished at spawning time. My initial interest was not so much what to call the fish, but to find out how many of these races of trout were left; recent reports on the health of the lake and its trout were not optimistic.

When Johannes Schöffmann and I traveled to Armenia in the summer of 2000, we were discouraged by the following passage in a paper by the Moscow University ichthyologist Ksenia Savvaitova:

> The structure of the species *Salmo ischchan* has changed in the course of time under the influence of the declining water level of the lake, eutrophication, and artificial reproduction. The winter *ischchan* and some of the biotypes and local groupings have virtually disappeared, and the *alabalakh* [riverine form of *Salmo ischchan*, also *kharmrakhait*] is verging on extinction.

Sevan Lake and its fauna suffered greatly during the twentieth century. In the 1940s a scheme by the Soviet Union to draw immense

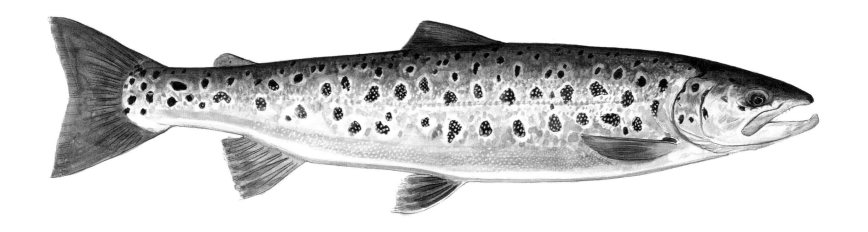

GEGARKUNI ISHKHAN, SEVAN LAKE, ARMENIA

Salmo ischchan gegarkuni

BROWN TROUT: CASPIAN, ARAL, AND AMUDARYA TROUTS

amounts of water for irrigation, while simultaneously exposing beaches to create more arable land, lowered its level almost 60 feet (18.3 m). Consequently, the native race of brown trout known as *bodjak,* which once spawned in early autumn on the eastern shore of the lake, is now extinct. Other races that reproduce in inlet streams have had trouble reaching their spawning grounds. The brown trout is generally considered an autumn-spawning fish. This is not the case with the Sevan Lake trout, whose different races once spawned virtually every month of the year. The spawning of these reproductively isolated types of trout has been greatly disrupted by the changes in the lake caused recently by man.

Driving around the lake, we asked local fishermen if they had caught any trout and whether we might be able to see them. Many of the fishermen were initially reluctant to show us because the trout-fishing season was closed when we were there in July. But once they had warmed up to us and saw that we were not international police protecting red-book fishes, they proudly showed us their catches. The largest fish were of the *gegarkuni* race, sleek silver fish up to 27 inches (68.6 cm) that would have looked exactly like Atlantic salmon were it not for their huge rounded black spots. (Berg described the pattern on *gegarkuni* compared to other races, saying their "spots are larger and more crowded.") The fishermen had other fish that they described as summer *ishkhan.* These had large beautiful black spots as well, but the sides were more yellow, and they had occasional red spots. According to Berg, the trout of Sevan Lake on average did not reach weights over 8 pounds, with the exception of the yabani race of *gegarkuni* that ran up the Mazra, Gezal, Balyk, and Bakhtak streams.

"In exceptional cases," wrote Berg, "specimens weighing up to [35 pounds] 16 kg may be encountered." *Gegarkuni* introduced to Lake Issyk-Kul in Kyrgyzstan have been reported up to 45 pounds (20.4 kg).

Ishkhan, transplanted from Sevan Lake in the spring of 1930 to Lake Issyk-Kul, thousands of miles away, offer a good study on whether trout several generations removed from their native habitat still retain their natal coloration and habits (in other words, whether coloration and behavior in trout is environmental or genetic). I had always maintained that the offspring of trout introduced to another stream or lake would look like their parents. We were able to test this hypothesis when we traveled to Kyrgyzstan and saw several freshly caught specimens of what the local people called *sevanski forel,* or "Sevan trout." We observed that, although the fish were at least a dozen generations removed from the original stock, they were still identical in form and color to the native trout of Sevan Lake.

Trout in Sevan Lake are becoming increasingly scarce. Because the fish live deep in the lake for most of the year, the best fly-fishing opportunities in the vicinity are in its feeder streams. Native resident brown trout, which the locals usually call *kharmrakhait,* or "red-spotted," are still abundant in upper tributaries. Streams like the Argichy tumble gently between the hills and meander through verdant meadows. In the lower reaches of the Karchaghbyur River, an Armenian man and his family have created a kind of hatchery where they keep, preserved in three different ponds, what they see as three distinct races of Sevan trout. If you travel to this region near the south shore of the lake, it is worth visiting this trout zoo and asking the keeper if you can make a cast. The Karchaghbyur is a spring-fed stream to rival in beauty

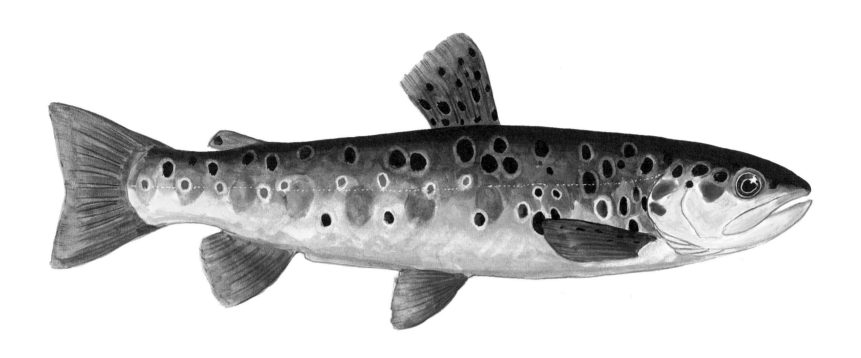

SUMMER ISHKHAN, KARCHAGHBYUR RIVER, ARMENIA

Salmo ischchan aestivalis

BROWN TROUT: CASPIAN, ARAL, AND AMUDARYA TROUTS

the famed chalk streams of southern England. When we visited the stream, the ranunculus, a green waterweed, was flowering with snow-white blossoms, like it does on the Itchen, or the Test of Hampshire.

The locals fish for trout with any number of destructive methods. In the lake, the commercial fishermen primarily use gill nets that, of course, are indiscriminate killers no matter what the legal season or limit. In upper tributaries of inlet streams, Schöffmann and I observed evidence of where locals had dug diversion channels to dry the creek beds so they could pick up all the trout downstream. This technique has been used in this vicinity for at least a century. I imagine that these sections of stream were once harvested only occasionally and then left to repopulate for several years. In recent years, I'm afraid most of these streams have been fished too heavily and are now devoid of all but the smallest fishes. Valentin Baker describes the Persians fishing by building diversion channels in the mountain streams on the southern end of the Caspian Sea in his memoir, *Clouds in the East* of 1876:

> When we reached the Lar valley we found but a small stream, and just below us, in and about it, we came upon an excited group of twenty or thirty men and boys engaged in a curious system of fishing. They had made a dam of stones across the river, and so turned the mass of the main stream into a new channel. The shallow water below, only two or three inches deep, was full of trout, which could just swim, but not without being seen. The men were armed with sticks, and whenever a trout moved they gave chase and knocked it on the head. Each man had some five or six pounds' [about 2.5 kg] weight of trout, and the sport caused immense excitement.

BODJAK, SEVAN LAKE, ARMENIA, EXTINCT

Salmo ischchan danilewski

KHARMRAKHAIT, ARGICHY RIVER, ARMENIA

Salmo ischchan

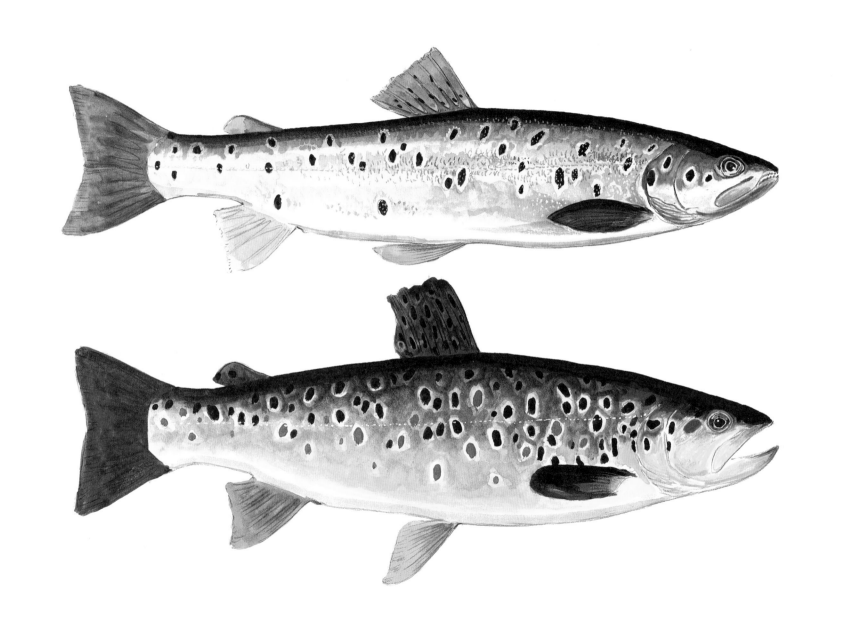

Caspian Sea Trout, Azerbaijan

Aral Sea Trout, Uzbekistan

DIVERSE STRAINS of trout once roamed the vast inland sea called the Caspian, ascending its tributary rivers to spawn. They were once known by many local names—*losos*, *lokh*, *azatman*, *samur-balyk*, *kizilbalyk*, *oraguli*—the most remarkable of which once spawned in the Kura River on the western shore.

The Kura River trout, in the words of the Russian ichthyologist Leo Berg, were "the giants among the salmonids of Europe." Indeed, they were so large that, in Berg's long and distinguished career, he could not decide whether to classify them as a trout or a salmon. Most commonly he referred to them as the "Caspian salmon," with specimens recorded by the Russian ichthyologist Kravaiskii over 100 pounds. "This author," wrote Berg, "often saw specimens weighing [73 pounds] 33 kg, the largest specimen weighed [112 pounds] 51 kg." This strain of Caspian "salmon" was once the largest trout in the world, without question.

"In the middle of April 1909," Berg continues, in his compendium on Russian fishes, "I observed many Caspian salmon which had more spots than the type form of *S. salar* [Atlantic salmon]; these salmon measured about [3 feet] 1 m and more; some of them were colored like the typical *S. trutta*. They had numerous black spots on the dorsal fin and sometimes also on the caudal fin. The Caspian salmon is very close to *S. salar*, on the one hand, and to *S. trutta*, on the other. It may be more correct to assign the Caspian salmon to the type *S. salar*."

Berg noted that there were two forms of migratory trout in the Caspian Sea: the spring salmon, which was the smaller, and the winter salmon, which made longer migrations to spawn. The winter salmon entered the Kura between November and February, but mostly in December, reaching the capital of the Soviet republic of Georgia, Tbilisi, by April. Ascending even farther to reach their spawning grounds in tributaries emerging from springs and snowmelt in the Caucasus Mountains, the Kura trout did not actually begin to spawn until mid-October—from eight to eleven months after entering the river mouth from the sea.

"The average weight of winter salmon in 1916 was [33 pounds] 15 kg," wrote Berg, and added, almost as a lament, that "since the construction of the hydroelectric power plants, which bar the way to the Aragvi for salmon migrants, salmon spawning occurs in some tributaries of the Alazani." To witness that run of brown trout must have been humbling; to witness their extinction, devastating.

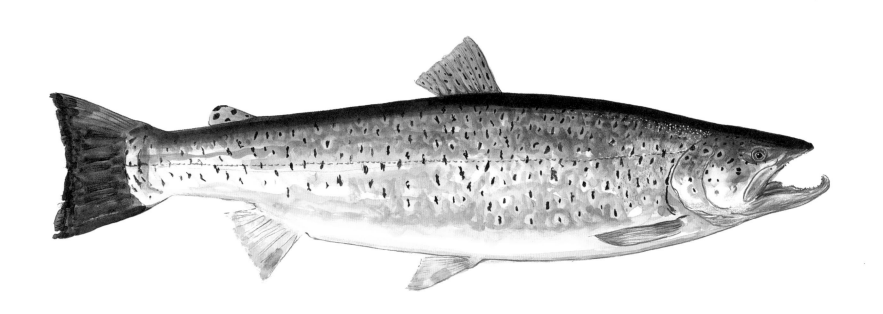

CASPIAN SEA TROUT, AZERBAIJAN

Salmo trutta caspius

BROWN TROUT: CASPIAN, ARAL, AND AMUDARYA TROUTS

After hatching in the rivers and spending two years there, the offspring of these fish migrated down to the vast inland sea, spending four or five years there before returning to the rivers themselves to spawn. Because of the polluted state of the Caspian Sea, most of the sea-run fish are now gone, though there are still many diverse and beautiful landlocked trout in the Caucasus and in Persia (see page 118), descendants of their magnificent ancestors.

The equally prodigious runs of trout in the nearby Aral Sea have also been depleted, if not extirpated. The main tributary where these fish once spawned, the Amudarya, has been severely degraded. The exploitation of the river for power and irrigation in Uzbekistan, Kyrgyzstan, and Afghanistan has greatly reduced its flow. This once-great river now barely reaches the Aral Sea, and the sea itself is slowly desiccating, concentrating its minerals to levels toxic for trout.

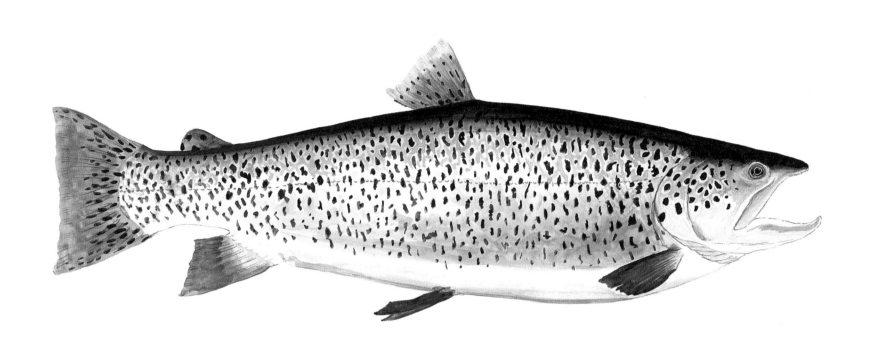

ARAL SEA TROUT, UZBEKISTAN

Salmo trutta aralensis

BROWN TROUT: CASPIAN, ARAL, AND AMUDARYA TROUTS

Oxus Brown Trout, Daraut Stream, southwest Kyrgyzstan
Oxus Brown Trout, Kokcha River Headwaters, Afghanistan

WHILE PASSING through what is now Afghanistan, the merchant-traveler from Venice, Marco Polo, wrote in his journal:

> These mountains are exceedingly lofty, insomuch that it employs a man from morning till night to ascend to the top of them. Between them there are wide plains clothed with grass and with trees, and large streams of the purest water precipitating themselves through the fissures of the rocks. In these streams are trout and many other delicate sorts of fish.

These fish are the native trout of the Amudarya River, the easternmost native brown trout in the world. The Latin name of this trout, *oxianus*, is derived from the Greek name for the Amudarya, the Oxus, which makes its sinuous way through the desert country of Central Asia to the Aral Sea. The river once provided water to those merchants traveling the great Silk Road from Asia to Europe.

Salmo trutta oxianus populates streams on the fringe of the Hindu Kush in Afghanistan and those high in the Pamir Mountains of Kyrgyzstan and Tajikistan. For some reason, the Amudarya's sister river to the north, the Syrdarya, was never known to have native trout.

In the summer of 1999, I traveled with Johannes Schöffmann to southwest Kyrgyzstan and caught specimens of *Salmo trutta oxianus* in Daraut Stream, a small tributary of Kyzyl-Suu River near the Tajik border. These trout had few red and black rounded spots on the sides and a dull yellowish-brown color with a concentration of spots near the head and at times below the pectoral fin toward the belly.

The natal rivers of the Oxus trout are extremely swift. Staring into the currents of these roiling streams, one doesn't seem to see any holding water, but the trout are there, surviving in the small eddies behind boulders. Because of these harsh currents, some fish we observed appeared to have abraded fins. The most abundant population of Oxus trout that we found in Kyrgyzstan was in a river near the capital, Bishkek, where they had been introduced. The stream, Issyk-Ata (which in Kyrgyz language means "warm father"), is in the Syrdarya River drainage.

Though I have not fished for trout in Afghanistan, I have heard reports of great trout fishing in rivers of the north, especially the Kokcha River. A Scottish friend of mine, Robin Ade, has made several trips to northeast Afghanistan in search of trout, especially in a series of lakes at the Kokcha River headwaters in the Badakhshan Province.

When we compared notes from our travels to different headwaters

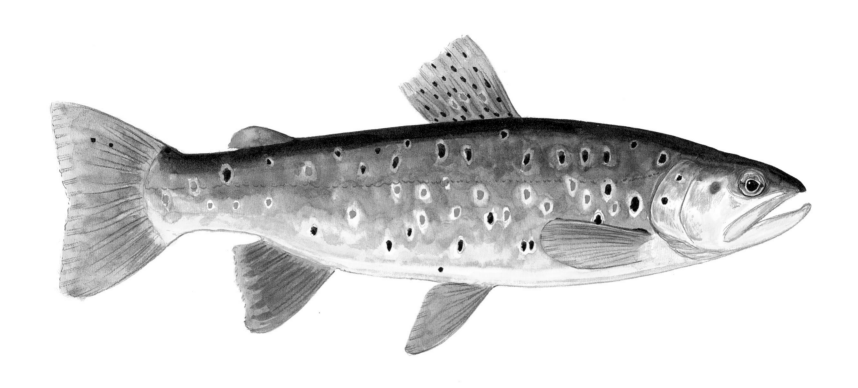

OXUS BROWN TROUT, DARAUT STREAM, SOUTHWEST KYRGYZSTAN

Salmo trutta

BROWN TROUT: CASPIAN, ARAL, AND AMUDARYA TROUTS

137

of the same river in distant countries, we were pleased to find that the trout we had caught looked identical. It is likely that within the range of *Salmo trutta oxianus* there is some aberrant form. One specimen from Tajikistan analyzed by Louis Bernatchez was distinct from our Kyrgyz specimen.

In a report from his 1997 expedition to the Kokcha River, Ade speculated that because they possess a low number of vertebrae—which, according to Robert Behnke, "indicates a relatively early evolutionary form"—the trout of the Oxus River may be "quite ancient." Results of genetic analysis do not support this theory.

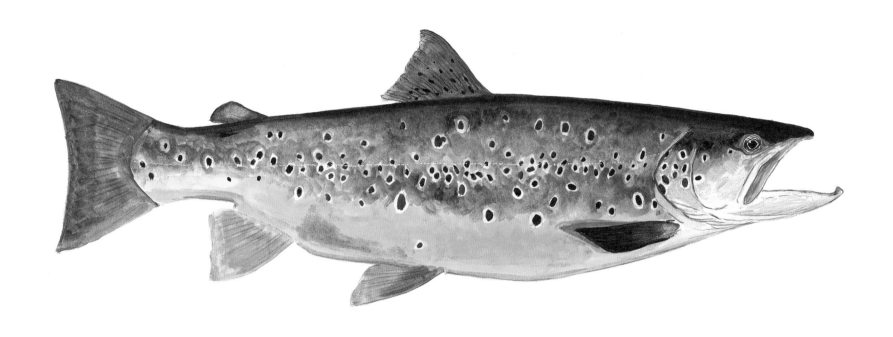

OXUS BROWN TROUT, KOKCHA RIVER HEADWATERS, AFGHANISTAN

Salmo trutta

Atlantic Salmon, Alta River, Norway

Atlantic Salmon, spawning colors, Ponoy River, Kola Peninsula, Russia

Atlantic Salmon, Otra River, Norway

ONE OF THE most fiercely debated questions in angling is why salmon on their spawning run, when their stomachs have shrunk and they are determined to spawn, vigorously take a fly. Fresh from the sea, they obviously have memories of feeding in the open water and are still attracted to a flash of color that may indicate baitfish or shrimp. This impulse is alluded to in a story from Jonathan Couch's *History of the Fishes of the British Isles* of 1877:

> I was informed by Mr. Bewick, the eminent engraver on wood, that when a gentleman of Newcastle had lost a gold ring from a boat on the Tyne, he was so fortunate as to recover it from the stomach of a Salmon which was purchased in the market at Newcastle.

Though highly disdained by fly-fishing purists, it is interesting to note that salmon in the river will take worms and shrimp even in the fall, when they are no longer apt to take a fly. Izaak Walton wrote of fishing for salmon with worms doused in the oil of ivy berries.

Fresh from the sea, having traveled thousands of ocean miles from their feeding grounds, salmon are silver like a newly minted coin, their bellies violet like the undersides of cumulus clouds. "A bar of silver!" is something you might hear shouted by your Irish gillie (British term for a kind of fishing caddie) when one leaps at the end of your line. But the oceanic blues of the fresh fish soon give way to matrimonial carmine and scarlet. They undergo a transformation prior to their spawning that can eventually turn them a brick-red infused with an erratic honeycomb pattern. The males develop what is called a kype, a beaklike curved jaw with teeth, which is used to fight off other males. I lost a huge spawning male, close to 30 pounds, in Iceland one September when it jumped and showed its sides, red like a cardinal's robe.

The salmon's transformation from bright pelagic fish to slugging red log, as its priorities shift from feeding to reproduction, are well reflected in literature, perhaps because they hold such a startling mirror to our own mortality. Ted Hughes, former poet laureate of England, describes this in his poem "October Salmon":

> With the sea-going Aurora Borealis of his April power—
> The primrose and violet of that first uplifting in the estuary—
> Ripened to muddy dregs,
> The river reclaiming his sea-metals.
> In the October light
> He hangs there, patched with leper-clothes

ATLANTIC SALMON, ALTA RIVER, NORWAY

Salmo salar

ATLANTIC SALMON

The Atlantic salmon, make no mistake, is not a Pacific salmon, for it does not necessarily die when it spawns. It is genetically most like the brown trout and therefore is classified under the same genus, *Salmo*. Its species name *salar* means "the leaper," for it often jumps clear out of the water when first hooked. Atlantic salmon are known to clear eight-foot waterfalls on their migration to the place where they were born.

A big salmon is considered to be about 20 pounds (9 kg). A monster would be 60 or 70 (27.2 or 31.8 kg), and these are occasionally caught on both coasts of the Atlantic. An enormous salmon of 113 pounds (51.3 kg) was purported to have been caught in Russian nets in the Barents Sea. It is an interesting fact that many of the biggest salmon in the United Kingdom have been caught by women, explanations for which abound.

Almost as remarkable as the salmon's journey itself is the artful fly-fishing it inspired. During the Victorian era in England, salmon fishermen began adopting as flies the colorful and iridescent feathers from bird skins that explorers of the British Empire sent home from far-off New Guinea, Africa, and South America. With feathers from macaws, blue chatterers, bustards, birds of paradise, scarlet ibises, blue kingfishers, spotted turkeys, silver and amherst pheasants, and ostriches available, there was no end to the diversity of flies imagined and tied. It must have been a pleasure to fish for salmon with such flies. The salmon itself became the fish of the elite, the landed gentry, even the king and queen—what fish was more fit for kings than the king of fish itself?

If we are not careful to monitor commercial fisheries for salmon and reverse the devastating effects of salmon farms in the river estuaries (such as waste runoff and the proliferation of sea lice), only a few generations from now there may be very few Atlantic salmon left. Future generations of anglers will be left to wonder, was the salmon as noble a fish as everyone said it was?

The salmon's native range on the European front extends from the Douro and Tejo Rivers in Portugal and Spain in the south (41° north latitude) all along the Atlantic coast to the Pechora River in northern Russia (70° north latitude). The range reaches west to Iceland and rivers of the New England and eastern Canadian coasts. In each major river drainage the salmon are genetically distinct; in other words, each river to which they are native holds a different genetic stock, evolved over thousands of years. The salmon of the relatively short Alta River of Norway, for instance, are behemoths, as are those giants of the Grand Cascapédia on the Gaspé Peninsula of Quebec. It used to be that in a week of fishing on one of these two famed rivers you'd have a good chance of catching a fish weighing in around 35 pounds (15.9 kg). Today such catches are not nearly as common. Now perhaps the best fishing for salmon is in Iceland and on the Kola Peninsula of Russia just east of Finland. Among the most famous rivers of the Kola Peninsula are the Kharlovka, Litsa, Yokanga, Ponoy, and Rynda.

On my first hard days on Canadian salmon rivers, the Miramichi and the Matapédia, I neither caught nor saw a salmon. I began to wonder if it was true that the salmon was the king of game fish. But I have to admit that my skepticism was greatly reduced when I caught an 18-pounder (8.2 kg) on the Bonaventure in Quebec. Its strength

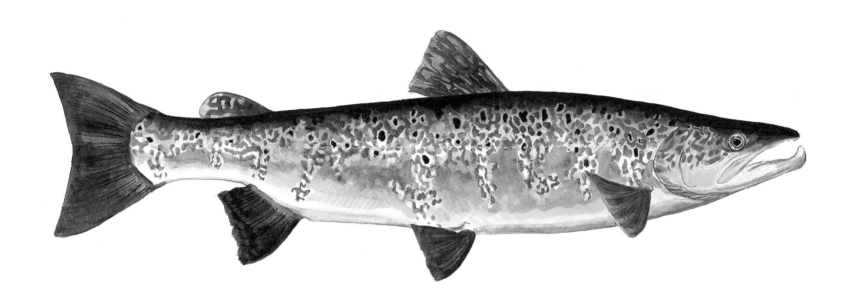

ATLANTIC SALMON, SPAWNING COLORS, PONOY RIVER, KOLA PENINSULA, RUSSIA

Salmo salar

and girth and cobalt-blue mass were enough to convince me of its greatness. One of my most cherished possessions is a sculpture made by my Parisian friend François Calmejane, which depicts a leaping salmon, its body pieced together from such objects as a dried head from an actual salmon from the Baltic Sea, a scythe blade, old reels and lures, the gas tank of a French motorcycle, and lathe chips. He calls it *le grand bécard vainquer*, "the big male salmon that won." For me it symbolizes the resilience and determination of the salmon to survive despite the adversity it faces. On its journey to spawn, the *grand bécard* has swallowed all the fishermen's tackle, broken their lines, and cursed the industry of man.

There are several landlocked populations of Atlantic salmon throughout Europe, notably in Sweden and Norway. They resemble the landlocked salmon of Maine and eastern Canada, where it is called the Sebago salmon, or the Ouananiche. In many of the rivers where landlocked Atlantic salmon live, like the Otra River in Norway, where they are known as *blege,* they coexist with native brown trout. Landlocked salmon are as streamlined as their anadromous brothers, with elegant blue-black dorsal fins and tails that remind one of butterfly wings, especially when such a fish is sailing through the air on the end of your line.

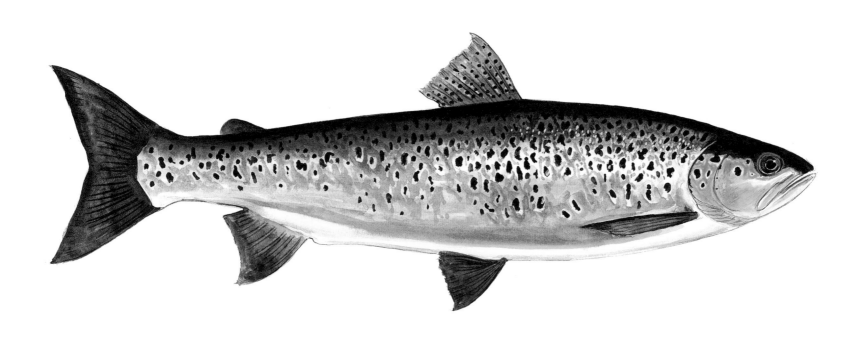

ATLANTIC SALMON, OTRA RIVER, NORWAY

Salmo salar sebago

ATLANTIC SALMON

THE CHAR

CHAR, or fishes of the genus *Salvelinus,* are distributed about the Northern Hemisphere from mountain lakes in Switzerland to rivers of the bleak Arctic. They are the northernmost fish found living in freshwater and have been observed feeding in seawater below the freezing point of 32°F (0°C).

Within the char's vast circumpolar range, there is an enormous amount of diversity both between and within species. Albert Günther wrote of the char in 1866: "There is no other group of fishes which offer so many difficulties to the ichthyologist with regard to the distinction of species as well as to certain points in their life history as this genus." Perhaps the most variable of the char species is *Salvelinus alpinus,* or the Arctic char. A single lake, for instance, can be host to three or four distinct and reproductively isolated populations.

The word "char" is derived from the Gaelic *ceara,* or "blood-red," which describes the rich golden oranges and reds that they develop toward spawning time. Jonathan Couch in his book *A History of Fishes of the British Islands* of 1877, suspected that the name given by Linnaeus to describe the char he observed from the Swedish Lapland, *salvelinus,* or *salvelin,* came from the German name *saibling.* The word *saibling* was adopted in England and America and is still used to describe landlocked Arctic char in parts of New England (the char of Lake Sunapee in New Hampshire were sometimes known as the golden *saibling*). Char differ from trout in having only light spots on a dark body and no black spots.

Arctic Char, Hafralónsá River, Iceland

THE ARCTIC CHAR of the Hafralónsá, a small river near the town of Thórshöfn in northeast Iceland, coexist with anadromous brown trout and Atlantic salmon and are themselves anadromous.

In mid-September, when the low-growing heather is turning to golds and reds, and the partridge that you flush while walking the uneven ground to the river are molting white, forecasting the arrival of snow, the char are turning from silver to olive and deep red in preparation for spawning. Iceland is beautiful and typical char country: open, treeless, rugged, and windswept.

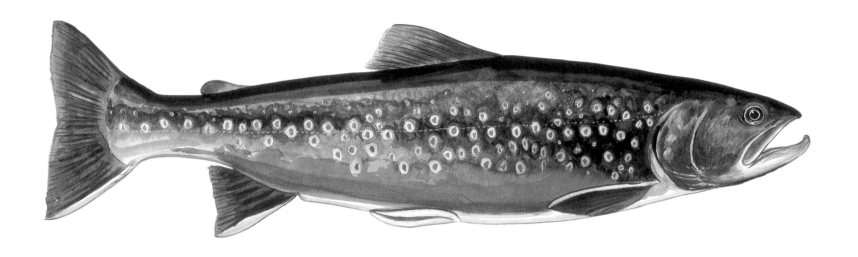

ARCTIC CHAR, HAFRALÓNSÁ RIVER, ICELAND

Salvelinus alpinus alpinus

THE CHAR

Large benthivorous form of Arctic Char, Thingvallavatn Lake, Iceland

Planktivorous form of Arctic Char or Murta, Thingvallavatn Lake, Iceland

IT IS COMMON to have several morphs of Arctic char within the same lake, each retaining their genetic uniqueness through reproductive isolation. This phenomenon, known as sympatry, has been observed among populations of Arctic char in lakes from Norway to Siberia as well as in brown trout (like those of Sevan Lake, Armenia; Lough Melvin, Ireland; and Lake Ohrid, Macedonia). In few lakes, however, are the distinctions between sympatric char as startling as in Thingvallavatn, the largest natural lake in Iceland.

Biologists who study them have called the char of Thingvallavatn "the finches of the fish world," comparing their diverse and specialized mouth shapes (evolved to feed on plankton, crustacea, and stickleback minnows) to the varied beaks of the finches that Darwin observed on the Galápagos Islands. It is a suitable analogy because, like the finches of the volcanic Galápagos, these fishes evolved relatively recently, on a relatively young island with abundant thermal activity.

Of the four sympatric morphs in Thingvallavatn, the most interesting is the large benthivorous (meaning "bottom-feeding") form that has a mouth with a distinct overbite specialized for feeding specifically on snails. (The mouth is similar in shape to those of the softmouth trout of the Balkans, some populations of trout in southern Turkey, or the lenok of China, Korea, Mongolia, and Siberia.) The large benthivorous form spawns between July and August, depositing its eggs on the stones of the lake bottom. Three other Arctic char morphs have been identified from Thingvallavatn—a small benthivorous form with an overshot mouth and blunt snout (spawns from August to November), a small planktivorous char called *murta* that feeds on crustacean zooplankton and chironomid larvae, and a large piscivorous form that feeds on stickleback minnows and juvenile char and can reach lengths close to 30 inches (76.2 cm)—the latter two spawn between September and November.

For several decades, Thingvallavatn supported a significant commercial fishery for the *murta* char, with annual catches as high as seventy tons. Originally the char were salted and sold locally, but then a canning operation opened outside Reykjavík, producing canned *murta*. By the late 1980s the catches had become so small that the canning operation was abandoned.

There is some considerable debate whether reproductively isolated populations of char within a body of water should be considered separate subspecies or even species. More and more ichthyologists, however, are sidestepping taxonomy and simply acknowledging

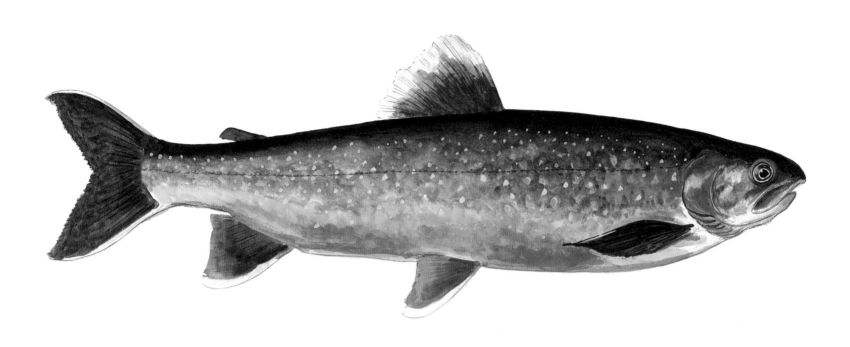

LARGE BENTHIVOROUS FORM OF ARCTIC CHAR, THINGVALLAVATN LAKE, ICELAND

Salvelinus alpinus

THE CHAR

genetic distinctiveness while trying to preserve it. In a fascinating monograph on Thingvallavatn Lake, the editor Pétur M. Jónasson writes: "In Thingvallavatn the char occupy different ecological niches. They are morphologically different and genetically distinguishable. Their feeding habitats are different." Later in the book, however, Jónasson writes that, though distinguishable, the forms are "genetically very similar." It is interesting to note that these forms of char likely evolved into separate populations relatively recently—the lake was formed only about ten thousand years ago.

The Icelandic lakes are young, as Iceland itself is young, a part of the Mid-Atlantic Ridge (stretching from the Arctic to the South Atlantic) that has risen above the surface of the ocean. Jónasson infers that what makes this deep (maximum depth 374 feet, or 114 m) oligotrophic lake unique, and its fishes as well, is that it was formed by the influence of volcanoes since the last glaciation. "In two places the drifting apart of crustal plates is of particular interest to limnology [the study of freshwater bodies]," writes Jónasson, "on islands of the Mid-Atlantic, and within the Rift Valley system of East Africa. The latter hosts some of the world's most famous tropical lakes: Lake Malawi, Lake Tanganyika, Lake Kivu, and Lake Victoria." Jónassen tells us of an old Icelandic saying, that "lakes that originate from lava are rich in life and fish"—and there may be more truth to this than we realize. Tijs Goldschmidt, a Dutch scientist who studied the diverse and colorful cichlid fishes of the East African Rift lakes (especially Lake Victoria), wrote in his book *Darwin's Dreampond* that "each [of these lakes] is an evolutionary laboratory in its own right, with its own radiations of cichlids."

The crustal plates are drifting apart beneath Thingvallavatn Lake at the rate of about $\frac{1}{4}$ to $\frac{1}{3}$ of an inch, or 5 to 10 mm, a year—it is physically in the rift zone, an area mad with volcanic activity, like an open wound in the earth. In some places in the rift zone, even on the bottom of Lake Thingvallavatn, the scar is still eruptive and emits lava. One could infer that the unique geological state of these rift lakes has created unusual evolutionary circumstances that have given rise to diverse forms of fish. This is especially the case with trout and char, whose spawning is inextricably linked with the stones and gravel where they deposit or bury their eggs.

Jónasson explores the relationship between char morphs and the geology of Thingvallavatn's bottom (in terms of both spawning and feeding). "The complex structure of the lava bottom creates two physically different habitats, which may enable the coexistence of the two morphs." The small benthic char feeds in the crevices of the lava rock like a small reef fish, while the large benthic form roams the entire lake shore, foraging and finding more and bigger foods.

The water of Thingvallavatn is crystal-clear, filtered by the porous lava rock. If you are lucky enough to hook a native char there, you will marvel at its broad fins splayed like ornamental fans as it nears the surface on the end of your line.

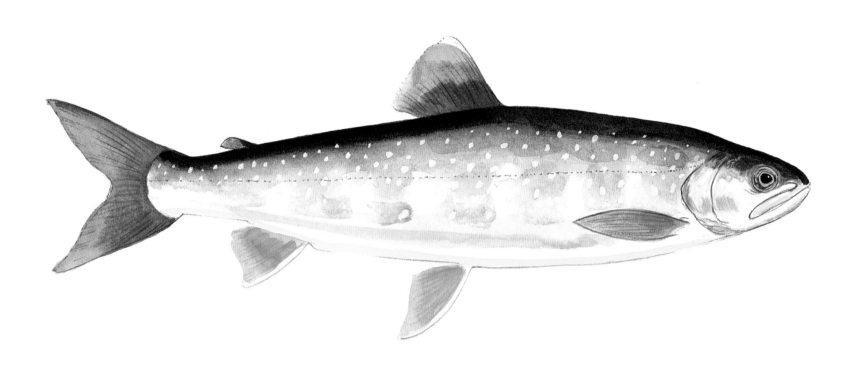

PLANKTIVEROUS FORM OF ARCTIC CHAR OR MURTA, LAKE THINGVALLAVATN, ICELAND

Salvelinus alpinus

THE CHAR

153

Arctic Char, Windermere, England, silver summer phase
Arctic Char, Loch Brodainn, Scotland

THE *New World of English Words,* published in 1658, describes *chare* as "a kinde of fish, which breeds most peculiarly in Windermere in Lancashire." Similarly, William Camden, who wrote of his travels in the sixteenth century, mentions this fish peculiar to Windermere in his book *Britannia*. "Among the mountains lies the greatest lake in England now call'd Winandermere ... well stored with a sort of fish no where else bred which they call Chare." Izaak Walton also mentions this char in *The Compleat Angler* of 1653: "There is a fish that they in Lancashire boast very much of, called a char; taken there (and I think there only), in a mere called Winander-Mere ... I do not know whether it make the angler sport, yet I would have you take notice of it, because it is a rarity, and of so high esteem with persons of great note." In Couch's *History of Fishes of the British Islands* of 1877 he says the Windermere char is locally known as Willoughby's Char. The name Willoughby has also been ascribed as a species name for this fish—one of as many as fifteen distinct species of char once recognized in the United Kingdom.

There are two races of Windermere char, one spawning in spring and one in the fall. The fall population spawns in water less than 12 feet (3.7 m), while the spring spawner deposits its eggs in deeper water, below about 50 feet (15.2 m). Most Arctic char spawn in the fall, between September and November.

In the seventeenth century, Windermere char were netted in the spawning season and made into large char-pies. Charlotte Kipling, a research biologist at Windermere Laboratory, recounts this unique method of preserving these fish for shipment to London. "By putting them into pies the fish could be preserved for many months. To make the pies, cloves, nutmeg, pepper and other ingredients were bought. The char-pies were large; records show that four pies were made from eleven dozen fish, and in March 1673 two pies from eight dozen fish. They were packed in specially made wooden cases, and transported to London by pack-horse, a distance of about 300 miles (483 km). Before about 1675, the pies were made with pastry crust, then for a few years tin containers were used and later pottery dishes. These were called pots, and the contents were known as potted char." By the mid-eighteenth century, the demand for potted char in London had significantly reduced the population of char in Windermere.

Sarah Bowdich, who painted some of the most exquisite portraits of fish I have seen, described the Windermere char beautifully in her book of 1838, *The Fresh-water Fishes of Great Britain*:

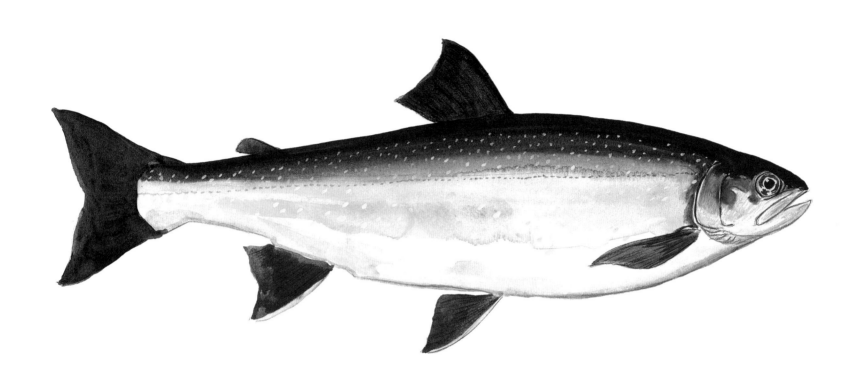

ARCTIC CHAR, WINDERMERE, ENGLAND, SILVER SUMMER PHASE

Salvelinus alpinus

THE CHAR

The back of the Northern Charr, when in season for eating, is of a deep rich brown, with a blue tinge; the belly is white; the head brown; the lips of a dusky orange; the opercula, deep yellow and red; the irides, dark brown, and a circle of gold round the pupil. All the fins are brown and orange, except the adipose, which is yellow; and the first rays of the anal fin are white.

The char of Brodainn, Scotland, also known as *torgoch,* are similar to chars of other Scottish lochs in having large sail-like pectoral, pelvic, and dorsal fins. In the large lakes of Scotland—Awe, Rannoch, Brodainn, and others—these char are an important food source for the ferox brown trout.

Occasional debates arise as to the spelling of the word *char*. Some adamantly prefer *charr*. Scottish members of the International Society of Arctic Char Fanatics settle this debate with humor: "In deference to the pronunciation of those anglers who habitually pursue it in Scotland, the word shall be spelled as c-h-a-r-r-r."

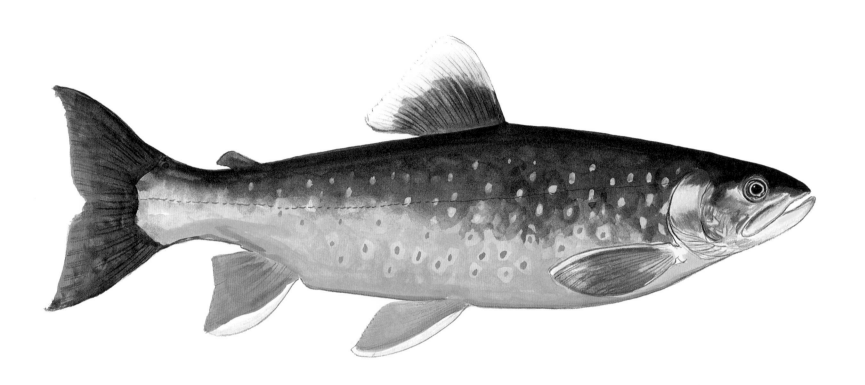

ARCTIC CHAR, LOCH BRODAINN, SCOTLAND

Salvelinus alpinus

THE CHAR

Omble Chevalier, Lac Léman, France

THE WORD for char in French, *omble,* originally used in eastern France and Switzerland, is thought to have come from the word *humble,* which means the same in French as it does in English. Yoichi Machino, a zoologist of Grenoble, France, described to me the evolution of the word for char in French. "In earlier days [up to the sixteenth century], the name 'humble chevalier' was used. Later on the 'h' was left out, and finally the 'u' was replaced by an 'o' to form the name 'omble,' and later 'omble chevalier.'" *Chevalier,* or "knight," I assume, was added to describe the fish's bright, shiny appearance, like a knight's silver armor.

According to Machino, the Arctic char "is indigenous to France but to two lakes only, Lac Léman and Lac du Bourget." Machino thinks that transplants of char to other lakes in France may have been made by the Romans, though the earliest documented successful transplant of Arctic char to France was to Lac Pavin in the Massif Central in 1860. Later, naturalized populations were established in Lac d'Annecy in the French Alps in 1890, and in the French Pyrenees in the 1920s. "Today," wrote Yoichi, "spawning populations of Arctic char are found in 138 lakes in France."

Izaak Walton, the father of angling as recreation, mentions the *omble-chevalier* of Lac Léman in *The Compleat Angler.* Evidently the name was widely known by the seventeenth century. But Walton mistakenly placed the *omble-chevalier* in his chapter about grayling—he had confused the word for char in French, *omble,* with the French word for grayling, *ombre.* Because of Walton, this mistake has been repeated in many fishing texts since.

Louis Agassiz, the renowned Swiss naturalist at Harvard and one of the last "creationists" who vowed to outlive the "mania" of Darwinian evolution "to the very last," mentions the *omble-chevalier* in his book of 1842, *Histoire naturelle des poissons d'eau douce de l'Europe centrale.* It is accompanied by a beautiful painting, hand-colored with silver heightening. Jonathan Couch mentions the fish in his *History of British Fishes* of 1877, telling us that Linnaeus described it as the species *Salmo umbla,* the same fish Rondeletius described as *Salmo lemanilacus* (from Lac Léman, France). But Couch repeats the Waltonian error in referring to it as the *ombre-chevalier.*

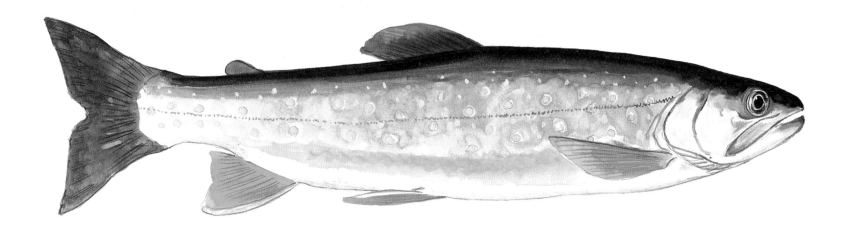

OMBLE CHEVALIER, LAC LÉMAN, FRANCE

Salvelinus alpinus

THE CHAR

159

Taranetz Char, Chukotka Peninsula, Russia

THE TARANETZ CHAR was named for a famous ichthyologist of the Russian Far East. The specimen shown here is a lake resident from the Kurukpa River drainage. It was caught by Yoichi Machino of Grenoble, France, who for the last twelve summers has plied the waters of northern Siberia and the Russian Far East for native char, lenok, and taimen. Often he has traveled on specimen-collecting expeditions with Mikhail Skopets, a trained biologist and bush guide who resides in Magadan on the Sea of Okhotsk.

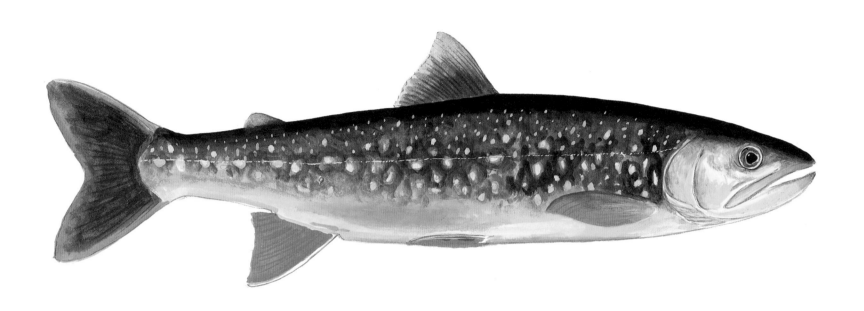

TARANETZ CHAR, CHUKOTKA PENINSULA, RUSSIA

Salvelinus alpinus taranetzi

THE CHAR

Boganid Char, Lake El'gygytgyn, Russia

Longfin Char, Lake El'gygytgyn, Russia

ON A COLLECTING expedition in June of 1986 to Lake El'gygytgyn in northeast Siberia, biologists Igor Chereshnev and Mikhail Skopets caught specimens of a large predatory char, sometimes called the Boganid char, at the mouth of a brook entering the lake. These fish themselves were stunning, but more interesting was what they'd been eating. Their stomach contents revealed many specimens of a peculiar char with unusually long fins.

It took two subsequent trips before Chereshnev and Skopets dropped their nets deep enough to catch any live specimens of the longfin char. (The char lived at depths of 160 to 330 feet [50–100 m].) Chereshnev and Skopets theorized that the large Boganid char went to the deep cold water to prey on the smaller longfin char and then returned to the shallows, where the warmer water aided their digestion.

The longfin char is known only from El'gygytgyn, or "white lake" in the language of the native Chukchi reindeer herders. It is located in the center of the plateau at the headwaters of the Enmyvaam and Anadyr River basins. The surface of the lake is frozen nine to ten months of the year to a thickness of up to 6 feet (1.8 m); in 1994 there were only eleven days of open water.

El'gygytgyn was formed 3.5 million years ago by the impact of a large meteor that left a crater seven miles in diameter and almost 600 feet deep. Skopets and Chereshnev describe El'gygytgyn as follows: "The lake is almost circular in shape, 12 km [7.5 miles] in diameter, and very deep. A maximum depth of 179 m [590 feet] has been recorded … with shallow areas being rare. The region surrounding the lake was not affected by the Pleistocene glaciation. The climate is severe."

In the few weeks or months of open water, pockets of warm water cause localized algae blooms, turning the water in spots to a yellow-green or even purplish color. Zooplankton come to feed on the algae; longfin char then feed on the plankton. The Boganid char then comes to feed on the smaller fish that mass in thick schools.

The unique longfin char is a delicate black-indigo-colored fish with a golden-white underbelly and winglike pectoral and pelvic fins margined with white. It is thought that the longfin char may be a type of "ancestral char" that survived unchanged since before the last glaciation. Based on fifty years of combined field observation, Chereshnev and Skopets named the longfin char a new genus of salmonid fish, *Salvethymus svetovidovi*.

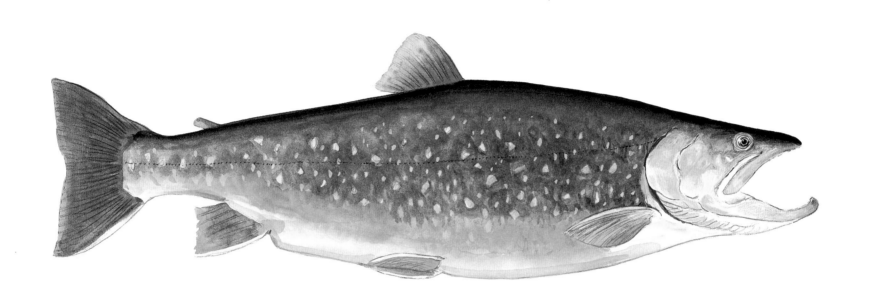

BOGANID CHAR, LAKE EL'GYGYTGYN, RUSSIA

Salvelinus boganidae

THE CHAR

The longfin char grows very slowly, reaching its maximum size, 13 inches (33 cm), at an age of about thirty years. They primarily occupy depths between 164 and 328 feet (50–100 meters), and if they are pulled to the surface too quickly, their air bladders become inflated by the pressure change. Little is known of the reproductive history of the longfin char.

There is yet a third char native to the lake, identified by Russian biologists Viktorovsky and Glubakovsky as the smallmouth char, *Salvelinus elgyticus.* According to Skopets, the smallmouth char is a "highly specialized zooplankton feeder." It spawns only late at night on sandy-pebble bottoms in one to three meters of water.

The name Boganid char, *Salvelinus boganidae,* was given by Leo Berg originally to describe char of Lake Boganidshoe in the basin of the Boganida River, a tributary of the Khatanga, and also for char of Lake Taymyr. It was adopted to describe the large predatory char of El'gygytgyn. Boganid char can reach a size of 15 pounds and an age of 23 years. The largest specimens subsist on a diet of smallmouth and longfin char.

The ecosystem of El'gygytgyn is fairly secure and its fishes abundant. It is threatened, nonetheless, by pollution through the dumping of fuel products and waste materials (from tourist industry near the lake), as well as by a commercial fishery for the larger predatory Boganid char. Chereshnev and Skopets warn at the end of their paper: "The region of Lake El'gygytgyn is currently denoted a 'nature memorial'—the lowest category of protected territories in the former U.S.S.R." Skopets suggests that the level of protection be raised to preserve this unique ecosystem and its fishes.

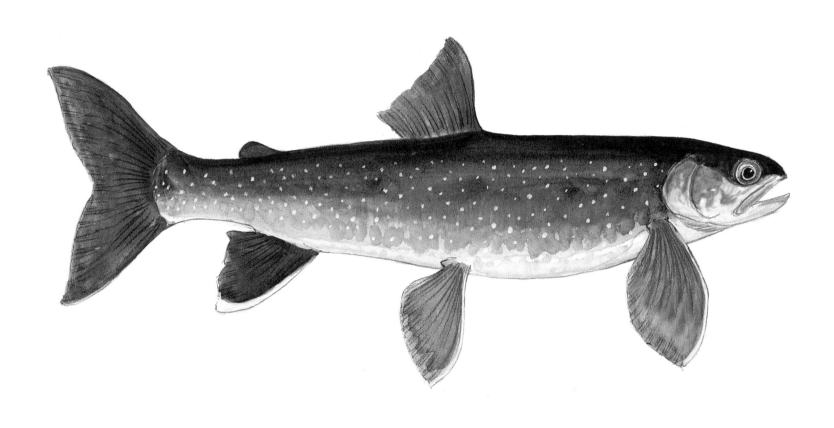

LONGFIN CHAR, LAKE EL'GYGYTGYN, RUSSIA

Salvethymus svetovidovi

THE CHAR

Large Arctic Char, Lake Bol'shoi Namarakit, Transbaikalia, Russia

IN THE late summer and early fall of 1995, Sergei Alekseyev of Moscow University and two other research biologists spent several months sampling remote mountain lakes northeast of Lake Baikal for Arctic char. Some areas of this region that they explored (known as Transbaikalia) were so remote that the native Evenk people, herding reindeer in the spruce forests, had never heard the Russian word for char, *galeats.*

In many of the fifteen lakes they surveyed, they found two or three sympatric forms of char that occupied different ecological niches and were most likely reproductively isolated. The standard terms for these forms were dwarf, small, and large. The most unusual chars they found, in terms of coloration and fin size, were from Bol'shoi Namarakit Lake, in the basin of the Kuanda River, a tributary of the Vitim.

A remarkable feature of this char was the beautiful snow-white band across the leading edge of the large dorsal fin. This band can be seen on other chars with relatively large fins like those of Loch Brodainn in Scotland, and the large benthivorous form of char from Thingvallavatn in Iceland (especially toward spawning time).

It is logical to assume, as Pétur Jónasson does in his monograph about Thingvallavatn Lake, that "the number of sympatric morphs in any one lake appears to be related to the number of vacant niches available to the species." Alekseyev also makes an interesting observation concerning sexual dimorphism, that the males of both the "normal" and "dwarf" forms have larger dorsal and pelvic fins than the females. This would suggest that the fins act as a kind of attractive plumage in the fish.

The char of Transbaikalian lakes are known in Leo Berg's *Freshwater Fishes of the* U.S.S.R as *Salvelinus erythrinus.* Alekseyev considers them a subspecies, *Salvelinus alpinus erythrinus,* but this name is only useful for political purposes, to emphasize the fish's endangered listing in the *Red Data Book* of the Russian Federation. Alekseyev writes in his paper on the char of this region that "we agree with Savvaitova that all of the chars from Transbaikalia cannot be considered within the frame of this subspecies."

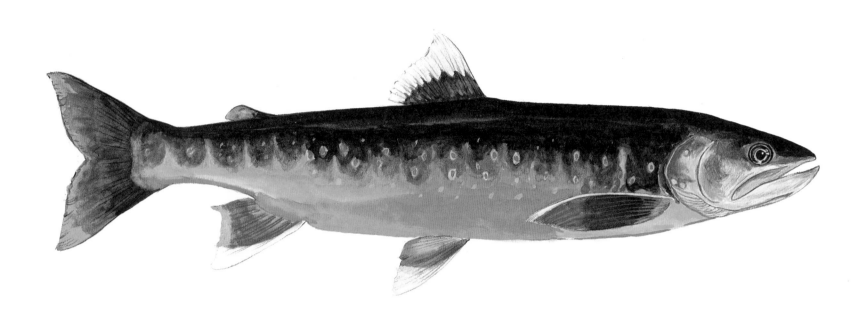

LARGE ARCTIC CHAR, LAKE BOL'SHOI NAMARAKIT, TRANSBAIKALIA, RUSSIA

Salvelinus alpinus erythrinus

THE CHAR

Male stream-resident Dolly Varden Char, Chukotka, Russia

Spawning Dolly Varden Char, Raduga River, Kamchatka, Russia

White Char, Raduga River, Kamchatka, Russia

Dolly Varden Char, Shiretoko Peninsula, Hokkaido, Japan

Miyabeiwana, Lake Shikaribetsu, Hokkaido, Japan

SALVELINUS MALMA is native to eastern Russia and northern Japan, from Chukotka throughout the Kamchatka Peninsula, Sakhalin Island, and the island of Hokkaido. It appears in many diverse forms, with equally diverse patterns of spots and blotches and the red colors that led to its common name in America, Dolly Varden. Dolly was a character in Charles Dickens's 1841 novel, *Barnaby Rudge,* and was in the author's words, "the very impersonation of good-humour and blooming beauty." She wore "a little cherry-coloured mantle, with a hood of the same over her head, and upon the top of that hood, a little straw hat trimmed with cherry-coloured ribbons." To some imaginative angler, this char resembled the vibrant and beautiful Dolly.

The Dolly Varden species, like the Arctic char, includes anadromous, lake-dwelling, and stream-resident types. In Hokkaido, Japan, where it is known as *oshorokoma,* it inhabits cold streams that run through beautiful groves of a small bamboo-like grass called *kuma zsasa,* or bear grass. I fished for them on the eastern point of

Hokkaido, the Shiretoko Peninsula, and caught many of these small beautiful fish that resembled the brook trout I caught as a boy in Connecticut. This char is known as a subspecies *Salvelinus malma krashenikkovi,* named by Taranetz in 1933, and is native to the southern Sakhalin Island and Primorye areas.

Another distinct form of *Salvelinus malma* in Japan is that from Shikaribetsu Lake in central Hokkaido, known locally as *miyabeiwana* (first described as *Salvelinus miyabei* by Oshima in 1938). This fish displays the kind of wavy markings characteristic of some populations of Dolly Varden throughout its native range. (These markings can also be seen in the specimen pictured from Chukotka, northeast Russia; I have also seen such markings on landlocked forms of Arctic char, like the blueback of northern Maine.) Migration of the *miyabe* char up the main tributary stream (the Yambetsu Stream) to spawn takes place from July to November, when the silver summer dress with pink spots intensifies and the fish become dark with red bellies. The *miyabe* char is the only fish native to the lake (rainbow trout

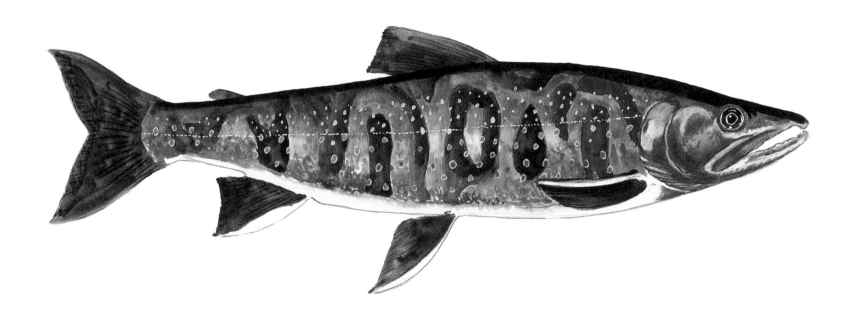

MALE STREAM-RESIDENT DOLLY VARDEN CHAR, CHUKOTKA, RUSSIA

Salvelinus malma

THE CHAR

169

have been introduced) and feeds primarily on plankton and insects on the lake bottom and in the inlet stream. On still evenings in late spring the char of Shikaribetsu Lake can sometimes be seen making small dimples on the quiet surface.

The Dolly Varden from Kamchatka (where it was originally described by Walbaum in 1792) is nearly identical to those found across the Bering Sea in Alaska. There are both anadromous and river-resident forms, sometimes occurring with other types of char, like the white-spotted char *Salmo leucomanis* and yellow-mouth char *Salvelinus levanidovi. Salvelinus malma albus,* known as the white char, is a local variation of Dolly Varden from the Raduga River in northeastern Kamchatka. Its status as a species or subspecies is doubtful.

SPAWNING DOLLY VARDEN CHAR, RADUGA RIVER, KAMCHATKA, RUSSIA

Salvelinus malma

WHITE CHAR, RADUGA RIVER, KAMCHATKA, RUSSIA

Salvelinus malma albus

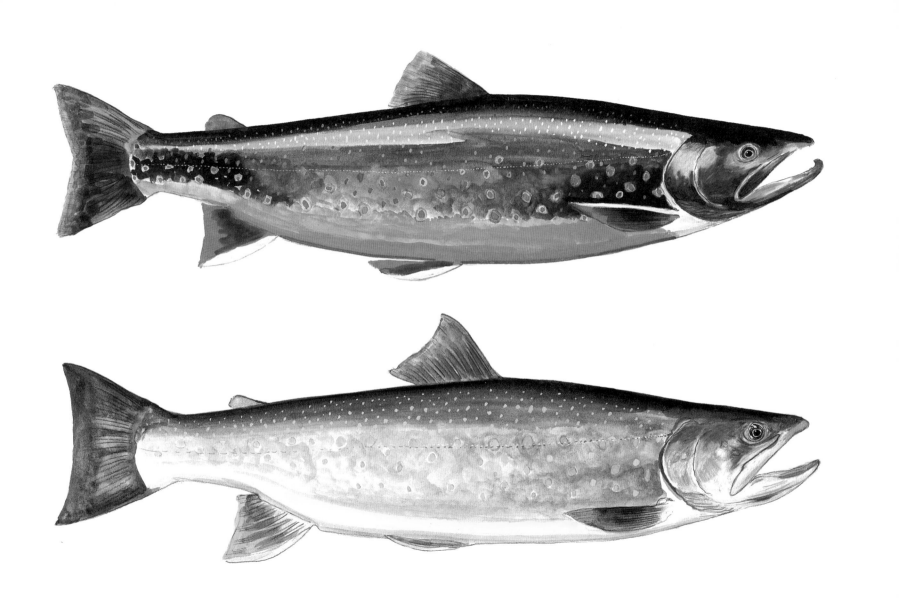

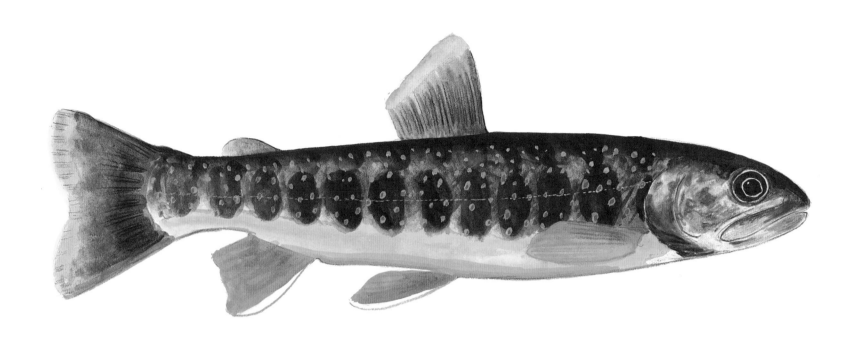

DOLLY VARDEN CHAR, SHIRETOKO PENINSULA, HOKKAIDO, JAPAN

Salvelinus malma krashenikkovi

THE CHAR

173

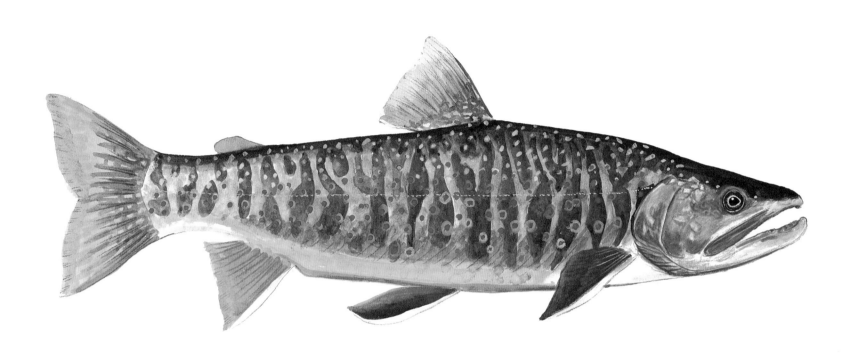

MIYABEIWANA, LAKE SHIKARIBETSU, HOKKAIDO, JAPAN

Salvelinus malma miyabei

Yellowmouth Char, Yama River, Russia

THE RUSSIAN Far East, including the Kamchatka Peninsula and islands in the Sea of Okhotsk, offers some of the best angling for fishes of the genus *Salvelinus.* It is a largely pristine coldwater wilderness, but one that is increasingly threatened by habitat degradation from logging and mining, as well as poaching. A pamphlet for the Wild Salmon Center, an organization concerned with saving the fishes of this region through the monetary support of foreign sportfishermen, warns, "in our lifetime, the pressures of development may overwhelm even the most pristine salmonid ecosystems."

The yellowmouth is an anadromous char from the Yama River near Magadan (on the west coast of the Sea of Okhotsk). It coexists in the Yama with the white-spotted char, or *kundzha (Salvelinus leucomanis),* and the Dolly Varden *(Salvelinus malma).* According to Mikhail Skopets: "you will find the biggest diversity of char species in the Magadan, Kamchatka, and Chukotka area. I am living in this area for twenty years; during this time I have discovered three species of Salmonid fishes new to science. Two species are char, smallmouth char *Salvelinus elgyticus;* and yellowmouth char *Salvelinus levanidovi;* and the third is a char-like fish, for which we have named a new genus *Salvethymus.*"

Ksenia Savvaitova of the University of Moscow wrote in her paper "Taxonomy and Biogeography of Charrs in the Palearctic" of 1980, that "many chars of northern Russia are in the process of speciation, and because they exhibit high plasticity you can find innumerable variations occupying diverse ecological niches." This, Savvaitova says, "makes it difficult to solve the problem of the chars' taxonomic status." The yellowmouth char is among the many variations that have been given species names. Another is the white-spotted char, *Salvelinus leucomanis,* which is common in rivers of the Magadan area, as well as Kamchatka and Japan.

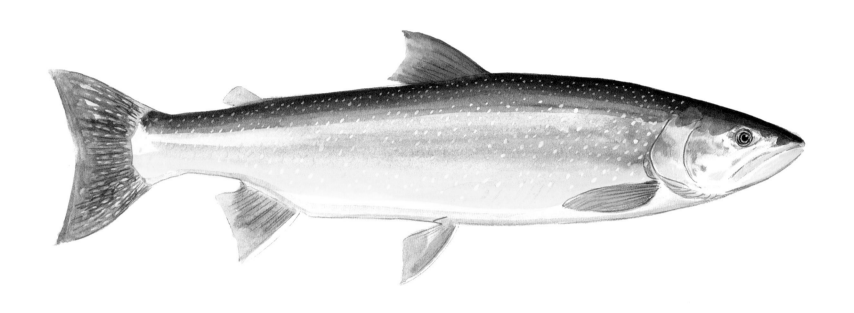

YELLOWMOUTH CHAR, YAMA RIVER, RUSSIA

Salvelinus levanidovi

THE CHAR

White-spotted Char or Kundzha, Zhupanova River, Kamchatka, Russia

White-spotted Char, Raduga River, Kamchatka, Russia

Gogi Char, Japan

Yamatoiwana, Kiso River, Japan

THE WHITE-SPOTTED char is native from the western part of the Bering Strait to the islands of Japan, inhabiting rivers on Sakhalin and Kuril Islands, the Kamchatka Peninsula, and mainland Far East Russia as far south as Vladivostok. It is also native throughout Japan in mountain streams of Hokkaido and Honshu.

As its name suggests, the white-spotted char is characterized by white to yellowish-pink spots, sometimes large. In Japanese it is called *iwana* and is written with three kanji characters (stone, mountain, and fish). The larger and sometimes anadromous form is called *amemasu.*

Scientists who study the white-spotted char, sometimes called *iwana*-ologists, try to classify the great diversity of appearances of this fish throughout its native range. Three subspecies of landlocked *iwana* are generally accepted. They differ from the anadromous *amemasu* in that they often have yellow, orange, or even red spots in addition to white spots. The nikkoiwana, *Salvelinus leucomanis pluvius,* is native to streams of central Honshu and Hokkaido; the yamatoiwana, *Salvelinus leucomanis japonicus,* is native to south-central Honshu; and the gogi, *Salvelinus leucomanis imbrius,* is native to south-west Honshu.

The average trout caught by Japanese anglers in small brooks is likewise miniature, rarely over 12 inches (30.5 cm). Dunking flies in small fern-covered pools seems an appropriate extension of the Japanese aesthetic for the diminutive. At the heaviest end of the *iwana*'s range, Mikhail Skopets has heard of specimens of 40 pounds (18.1 kg), though L. S. Berg in his compendium of Russian fishes lists a maximum size of 3 feet (0.9 m) and almost 9 pounds (4 kg).

The white-spotted char is a fine fly-rod trout. Japanese have been fly-fishing as early as the fifteenth century, using floating flies on the end of a braided horsehair line tied to a bamboo wand. I have also heard of a Japanese technique for catching *iwana* called hammer-fishing, where the fisherman hits a sledgehammer on streamside stones, and the resulting vibrations sent through the water temporarily stun the fish, after which they can be collected.

The Russian word for the white-spotted char is *kundzha,* though Berg notes that Pallas, who classified this fish in 1755, was misled by this local name: "On the coasts of the Arctic Ocean and in the Far East, the Russian name 'kundzha' is applied to widely different fish; on the White Sea, it is applied to *Salmo trutta;* in Siberia, where *Salmo trutta* does not occur, the name 'kundzha' is applied to *Salvelinus alpinus,* and in the Far East, to *Salvelinus leucomanis.*"

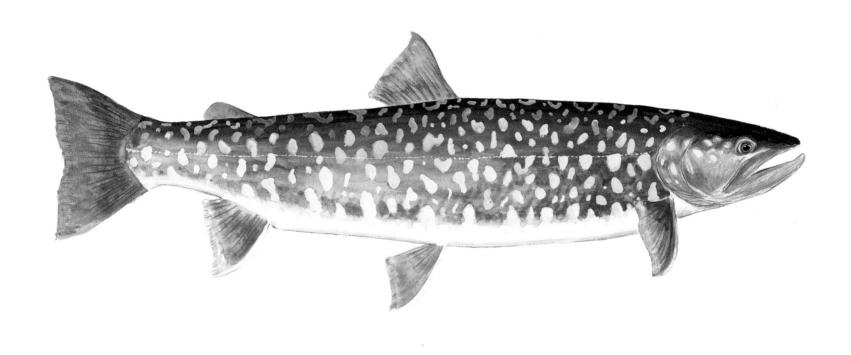

WHITE-SPOTTED CHAR OR KUNDZHA, ZHUPANOVA RIVER, KAMCHATKA, RUSSIA

Salvelinus leucomanis

THE CHAR

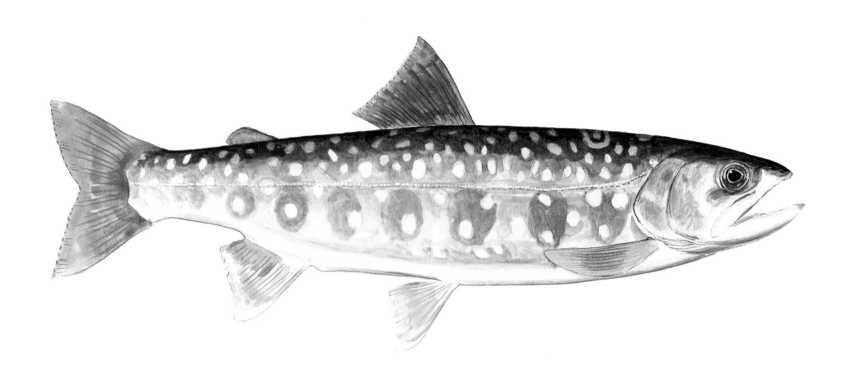

WHITE-SPOTTED CHAR, RADUGA RIVER, KAMCHATKA, RUSSIA

Salvelinus leucomanis

THE CHAR

181

GOGI CHAR, JAPAN

Salvelinus leucomanus imbrius

YAMATOIWANA, JAPANESE CHAR, JAPAN

Salvelinus leucomaenis japonicus

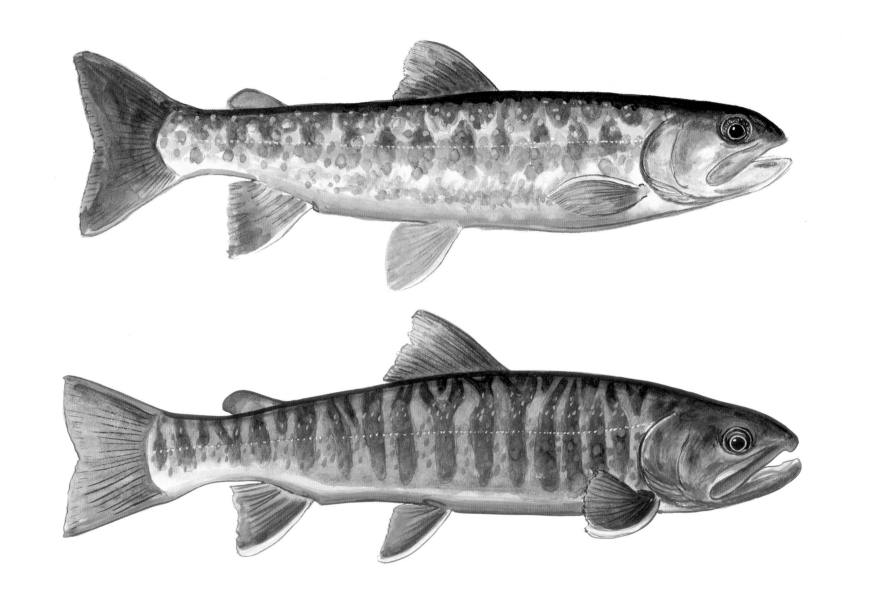

LENOK AND HUCHEN

LENOK AND HUCHEN of the genera *Brachymystax* and *Hucho,* respectively, are thought to be primitive forms of salmonid fish. They are both characterized by small scales and black spots scattered over reddish to silver sides. The lenok differs from trout most strikingly in having a mouth with a distinct overbite. The closest cousin of the lenok and huchen is the char.

The native range of the lenok and huchen in Asia seems to pick up where the brown trout's ends, although huchen coexist with brown trout in the western part of their range in the Danube River basin. They offered great sport to British living in China in the early twentieth century who caught them on flies and mistook them for brown trout. The huchen, or *taimen,* as it is called in the East, is the largest salmonid fish in the world. The record of one well over 200 pounds (90.7 kg) was caught by a Yakutian fisherman on the Kotuy River in Siberia in 1943. Not surprisingly, these huge fish are revered among the nomadic peoples of Mongolia, the Xinjiang province of northwest China, and Siberia. The following legend about a giant taimen is related in the book *The Eurasian Huchen* by Juraj Holcík:

> Mongols tell a tale of a huge taimen found icebound in a river, from which nomadic tent dwellers cut off pieces of flesh throughout the winter, which saved them from starving to death. Next spring, after the thaw, the taimen swam away without any detriment, as it was so big that the people did no harm to it.

Blunt-nosed Lenok, Vitim River, tributary of the Lena, Siberia
Sharp-nosed Lenok, Orhon River, Mongolia

THE LENOK, named *Brachymystax* by Günter in 1866, is most closely related to the char and to the fish of the genus *Hucho*. They are characterized by a distinct overbite, which would lead one to believe that the lenok is primarily a benthic, or bottom-feeder. Anyone who has dropped a dry fly into a pool where they abound, however, knows that they feed eagerly on the surface as well. It is quite a shock to see them shoot up from the bottom, grab a fly, and return to the depths again. I have heard of anglers catching lenok up to 10 pounds (4.5 kg) on large surface flies meant to imitate mice.

Lenok inhabit small mountain streams and wide rivers through open tundra from Siberia and Mongolia to northern China and Korea. In the Altai Mountains it is called *uskuch;* the Yakut word is *byit;* in Mongolian, *chad-tsagas,* or "yellow fish." I was told by a friend stationed in Seoul, Korea, that healthy populations of lenok exist outside of the city, where they are known as the mountain trout, sometimes co-existing with landlocked cherry salmon or *masu.* These small fish are delicately colored with pastel golds and pinks and fine dark spots. Large specimens throughout their range have gorgeous brick-red sides. I have observed in specimens destined for the dinner table that these colors become more intense and darker as the fish dies.

British fishermen living in China in the early twentieth century often mistook lenok for brown trout because of their troutlike appearance, general coloration, and black spots. Arthur de Carle Sowerby in his book, *A Naturalist's Notebook in China* of 1925, quotes several articles published in the *North China Daily News* that describe "brook trout" (the common name in England for brown trout) in streams of the hills and mountains near "Treaty Port." He knew that what they were catching were not brown trout, but lenok:

[The lenok's] range extends from the Baikal region eastward through the Amur and southward through Manchuria into Northeastern Chihli, where in the clear mountain streams of the Tung Ling area it is still to be found, though becoming increasingly rare. It is extremely like the British brook trout in its shape, color, and markings. This fish readily takes a fly, and in Manchuria, where it is very common in some parts, I have seen the Koreans and Chinese catching it with an improvised fly of red and white silk. It reaches a large size, fully grown specimens looking more like a salmon. It is said that a weight of 30 pounds (13.6 kg) is attained by this fish in Siberia.

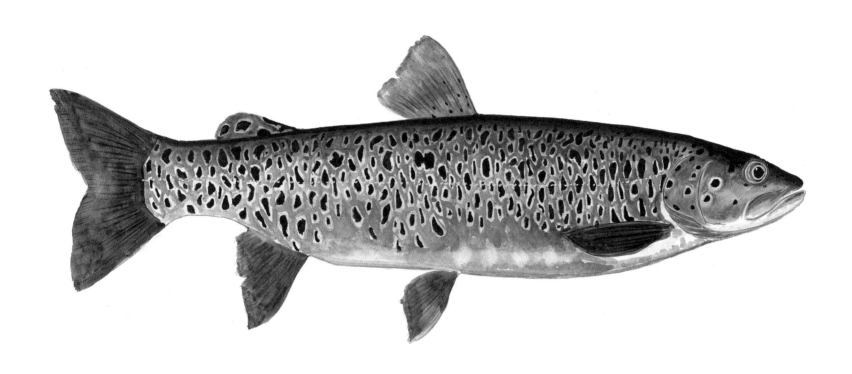

BLUNT-NOSED LENOK, VITIM RIVER, TRIBUTARY OF THE LENA, SIBERIA

Brachymystax lenok

LENOK AND HUCHEN

Two forms of lenok are recognized by ichthyologists—blunt-nosed and sharp-nosed. In some rivers both forms are present but remain reproductively isolated, while in other streams only one form exists. The shape of the snout and the degree of its sharpness or bluntness may be determined in part by environmental factors, in particular the temperature of the water at spawning, and the type of food the juvenile lenok are feeding on. (Atlantic eels in freshwater develop a sharp- and a blunt-nosed type; the shape of the snout is thought to be determined by diet.) Most recent studies by Osinov and Sergei Alekseyev have discussed the factors that may have led to the evolution of two types but conclude that the fish are not distinct enough to be considered separate species (as was once believed). Both forms spawn in spring between May and June.

Besides being beautiful, lenok are a nice gastronomic alternative to rehydrated mutton in bland soups—the common meal to be had in a nomad's yurt in Mongolia—though I prefer the fine texture of a grayling, if they are available, to the somewhat grainy flesh of the lenok. The lenok and grayling offer some of the best recreational fishing to be had in the East.

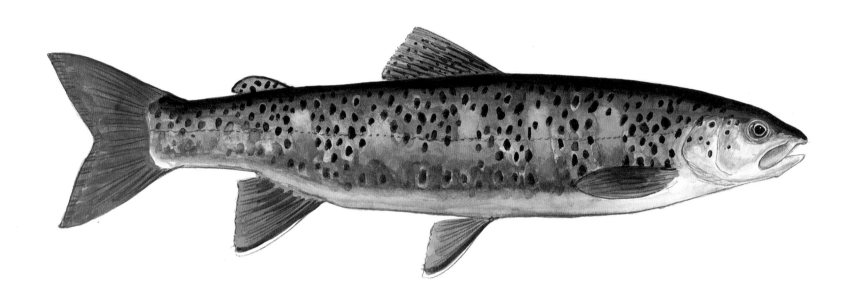

SHARP-NOSED LENOK, ORHON RIVER, MONGOLIA

Brachymystax lenok

LENOK AND HUCHEN

Mongolian Taimen, Orhon River, Mongolia

Sea-run Huchen, Hokkaido, Japan

Sakhalin Taimen, spawning male, Northern Hokkaido, Japan

Taimen, upper Yalu River, Korea

Chinese Huchen

THE EURASIAN HUCHEN—known variously as *taimen* (Russian), *dunavska saomka* (Bulgarian), *glowacica* (Polish), *lostoca* (Romanian), *hlavatka podunajska* (Slavic), *glavatica* (Slovenian), *bil-balyk* (Tatar and Yakut), *itô* (Japanese), *Yuan-dong zhéloyú* (Chinese), *Solongosyn tul* (Khalkha-Mongolian)—is the largest salmonid fish in the world. They are efficient predators, characterized by a long, flat head and broad jaws suitable for capturing and swallowing large prey. Specimens of the eastern subspecies *Hucho hucho taimen* have been recorded in excess of 200 pounds and up to fifty-five years of age.

Though the huchen is widely distributed, from the Danube River basin in Europe to Japan, it is not nearly as diverse in form, shape, and color as other salmonids, such as the brown trout or Arctic char. Its closest relative is the lenok, genus *Brachymystax*—natural hybrids between taimen and lenok have been documented in the Amur River drainage—and its next of kin is the char. There are anadromous and landlocked forms, both of which have potential for growing very large. The huchen is thought to be a primitive salmonid, especially the sea-run form, *Hucho perryi,* which is the most genetically distinctive of the *Hucho* species.

Four species (or possibly subspecies) of huchen are generally accepted. *Hucho hucho* is exclusively a freshwater fish of the Danube River basin of Eastern Europe and is almost identical to its cousin in Mongolia and Siberia, *Hucho hucho taimen. Hucho ishikawai* is also a freshwater species, native to the upper Yalu River in Korea, as is *Hucho bleekeri* from the headwaters of the Min and Dadu Rivers in the drainage of the Yangtze in Sichuan Province of China. The fourth huchen is the only sea-run form, *Hucho perryi.* This huchen roams the Japan and Okhotsk Seas, spawning in rivers of the Russian Far East and the islands of Hokkaido, Honshu, Sakhalin, and Kunashir. While the offspring of a cross between *Hucho hucho* and *Hucho hucho taimen* will produce a fertile hybrid, the offspring of *Hucho hucho* crossed with *Hucho perryi* are not fertile.

Spawning of the huchen takes place in spring, usually during April and May though as late as July in Mongolia and Siberia, over huge elliptical-shaped redds as long as 20 feet (6 m) and as wide as 6 feet (2 m). While excavating the redd, the female may move up to one ton of gravel, rock, and other debris. During spawning, the males develop deep red and purplish colors. The European huchen tends to

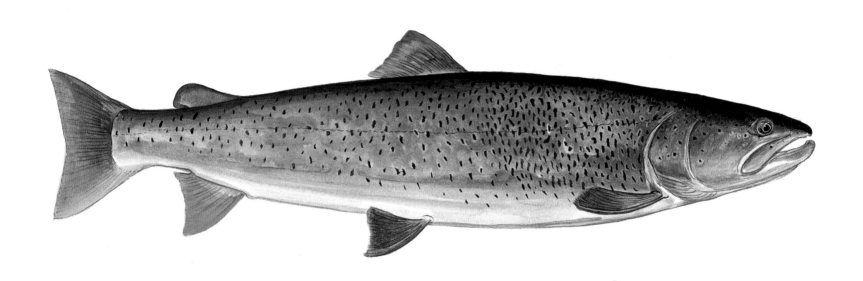

MONGOLIAN TAIMEN, ORHON RIVER, MONGOLIA

Hucho hucho taimen

LENOK AND HUCHEN

191

be more coppery on the sides, while the eastern taimen can sometimes have blotches of bright orange. Unlike the males of other salmonid genera—*Salvelinus* (char), *Salmo* (brown trout and Atlantic salmon), and *Oncorhynchus* (rainbow trout and Pacific salmon)—huchen do not develop a kype, or beaklike hooked jaw, at spawning time.

Young huchen are thin and elongated, resembling a pike more than a trout. The frequency, density, and arrangement of dark-brown to black spots varies, but usually the spots are irregular in shape and evenly distributed along the sides. According to Holcík, some specimens of *Hucho perryi* seem to be the most heavily spotted but can also show an absence of spots close to the tail.

The huchen is endangered through much of its native range because of construction of dams, canalization of rivers, deforestation of riverbanks, the use of explosives by poachers, and the release of industrial waste into rivers. Healthy populations, however, still exist in remote areas of eastern Russia and Mongolia and offer great catch-and-release sportfishing to adventurous anglers.

The largest and oldest huchen are vulnerable to poachers especially at low-water seasons and when they are spawning (because they usually spawn in water less than 3 feet, or about 1 m, deep). Mongolians are beginning to see the value in preserving their taimen rivers as tourist destinations for western fly fishers. Remote regions of Mongolia and Siberia have the most healthy populations of huchen, whereas those in China, Korea, and parts of Eastern Europe are severely endangered.

Huchen have been introduced unsuccessfully to England with an eye toward replacing dwindling populations of Atlantic salmon. Limited introductions have been attempted in North America but without success.

Huchen bones have been found in Neolithic, Bronze Age, and early Iron Age settlements in the Aldan, Angara, Lena, Baikal, and Kama River basins, showing that man's appreciation of huchen goes back at least fifteen thousand years. The skin of large taimen was once used by natives of Siberia to make clothing and footwear. We can only hope that future generations will be able to observe and perhaps even catch these huge and noble fish in pristine wilderness habitats.

SEA-RUN HUCHEN, HOKKAIDO, JAPAN

Hucho hucho perryi

SAKHALIN TAIMEN, SPAWNING MALE, NORTHERN HOKKAIDO, JAPAN

Hucho hucho perryi

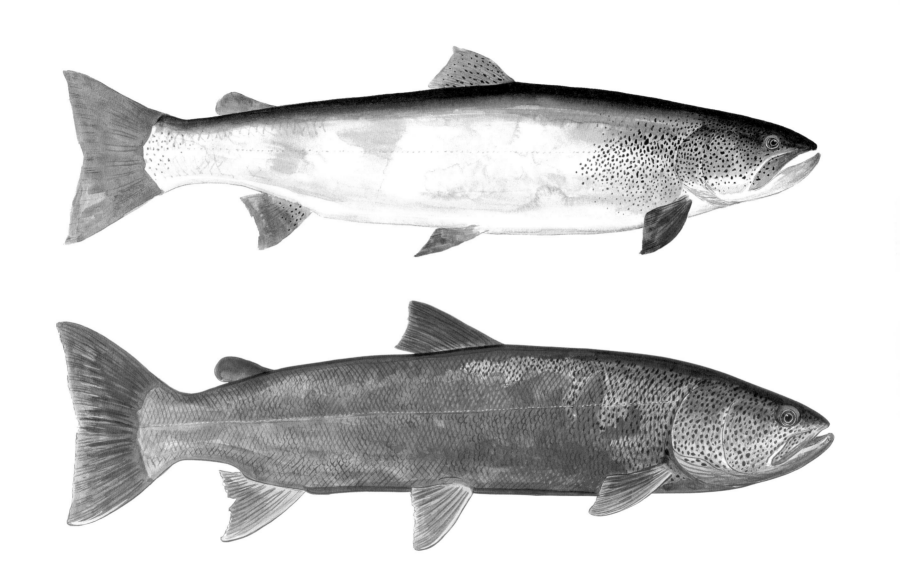

TAIMEN, UPPER YALU RIVER, KOREA

Hucho ishikawai

CHINESE HUCHEN

Hucho bleekeri

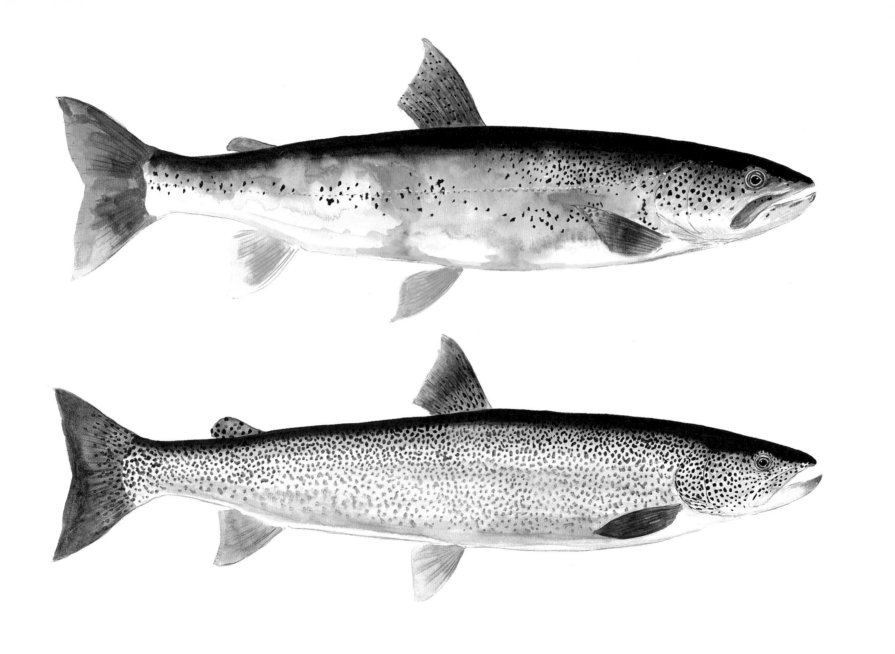

LANDLOCKED CHERRY SALMON, RAINBOW, AND CUTTHROAT TROUT

ON THE Asian side of the Pacific, the genus *Oncorhynchus* includes at least one species of trout and six species of Pacific salmon. The name *Oncorhynchus* was given by Suckley in 1861 and is derived from the Greek for "hooked" and "snout," meant to describe the kype, or curvature, that can develop in the jaw of these fishes toward spawning.

I include the rainbow trout and steelhead here as well as the "cutthroat"—although whether this is indeed a cutthroat is a matter of some debate. I also include one Pacific salmon—the masu of Japan, Korea, and the Russian Far East—as it seems to be a close cousin to the rainbow trout.

Yamame Trout, Hokkaido, Japan

Amago, southern Honshu, Japan

Masu, Taiwan

AMONG JAPAN'S many varieties of native salmonids is a beautiful pink and violet salmon that exists in both anadromous and landlocked forms. The sea-run form ascends rivers of Japan in May, when the cherry trees are in bloom, and therefore is known as the *sakura masu,* or "cherry salmon."

The cherry salmon was first named *Salmo masou* by James Carson Brevoort on his expedition to China and Japan in the 1850s. It is now classified *Oncorhynchus masou,* with the Pacific salmon. The migratory populations of masu spend less time in salt water than any other species of Pacific salmon and are therefore thought to have the greatest affinity for freshwater. While the coho and king salmon spend three to four years feeding in the sea and mature at weights of 10 to 70 pounds (4.5–31.8 kg), the cherry salmon spends only two years and matures at 2 to 5 pounds (0.9–2.3 kg). Like other Pacific salmon, the sea-run form of masu dies when it spawns. The landlocked form, however, called *yamame* and *amago* in Japan, often lives to spawn a second or third time. In this sense the *Oncorhynchus masou* is the Pacific salmon most akin to its cousin, the rainbow trout.

The *yamame* and *amago* are gorgeous fish of high mountain streams in Japan, Korea, and Taiwan. They have plum-colored oval parr marks over a field of pink that resemble the cherry blossoms on the mountain hillsides of Japan in spring. The *yamame* form has only black spots, while the *amago* has black and red spots with a few black spots around the eye. (The *amago* is the only fish of the genus *Oncorhynchus* with red spots.) The body of the *yamame* is smooth and shiny like polished leather, and the scales are small enough that it is hard to see them with the naked eye. *Yamame* and *amago* spawn from early September to late November, depending on the latitude, the spawning usually corresponding with the changing of autumn foliage. Toward spawning time the males become a bit darker but not as dark as the sea-run fish whose sides look like they've been streaked with dripping paint.

I have caught *yamame* in the northern island of Hokkaido, Japan, where they are abundant and readily take wet or dry flies. Throughout the mountain wilderness streams of Honshu, the main island of Japan, mostly north of the Sakawa River and south of the Bansho River, they offer fantastic sport for fly fishers. The seagoing cherry salmon are native in the Pacific, the Japan Sea, East China Sea, eastern Korea, the Russian Far East, Sakhalin Island, and the Sea of Okhotsk, but below the middle of Honshu the sea is too warm for their liking, and most populations are confined to cold headwater tributary

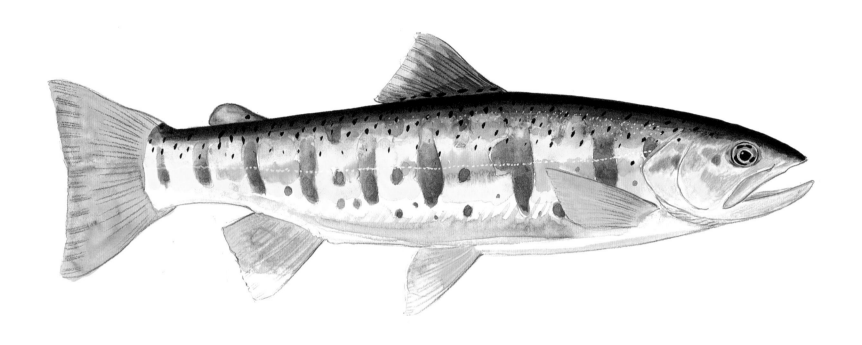

YAMAME TROUT, HOKKAIDO, JAPAN

Oncorhynchus masou formosanus

LANDLOCKED CHERRY SALMON, RAINBOW, AND CUTTHROAT TROUT

streams. The *amago* has a more southerly range than the *yamame*. It is native to the Pacific side of Japan, from the Sakawa River in the Kanagawa prefecture throughout Shikoku and Kyushu Islands, to the Ono River in the Oita prefecture. Because of artificial introductions, the native strains of *yamame* and *amago,* historically separate, are mixed in some regions.

The name *yamame,* usually spelled out in hiragana (the phonetic alphabet), in addition has its own kanji symbols. The kanji for *yamame* is represented by three symbols that taken separately mean "mountain," "woman," and "fish." Why woman is part of the kanji for *yamame* is a matter for speculation, but this mélange of images somehow describes the delicate beauty of this fish.

The southernmost range of the cherry salmon is a small relict population on the island of Taiwan in the mountain headwaters of the Tachia River. This rare landlocked salmon, vigorously guarded by Taiwanese officials, is among the southernmost native salmonid fishes in the world (in close competition with the native trout of mainland Mexico at or below 24° north latitude). The fish was protected as a national landmark by the Japanese colonial government until 1945, when Taiwan gained its independence, at which time it went unprotected and became nearly extinct through habitat degradation and overfishing. In 1984, the Taiwanese government designated it a cultural asset, and since then it has been protected, and a thriving population now exists.

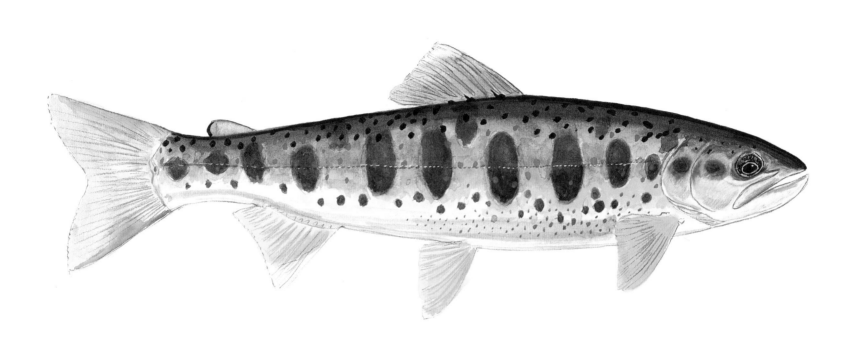

AMAGO, SOUTHERN HONSHU, JAPAN

Oncorhynchus masou rhodurus

LANDLOCKED CHERRY SALMON, RAINBOW, AND CUTTHROAT TROUT

201

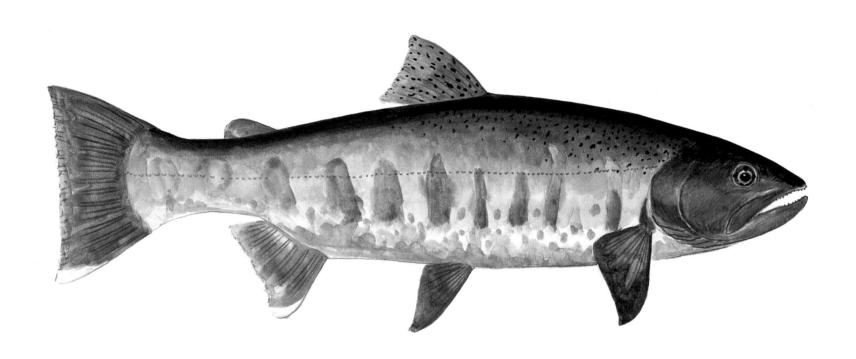

MASU, TAIWAN

Oncorhynchus masou formosanus

LANDLOCKED CHERRY SALMON, RAINBOW, AND CUTTHROAT TROUT

Rainbow Trout, Kamchatka, Russia

Steelhead Trout, Kamchatka, Russia

Cutthroat Trout, Shantar Islands, Sea of Okhotsk, Russia

THE RAINBOW TROUT was first classified by J. Walbaum as *Salmo mykiss* from a Russian specimen in 1792. *Radudgna forel,* as it is known in Russia, while abundant along much of the Pacific coast of North America, is native only to a few coastal rivers in Asia. They are distributed throughout the Kamchatka Peninsula—which hangs down like a tongue from northeast Russia—and islands in the Sea of Okhotsk. The Sakhalin and Shantar Islands have landlocked forms of rainbow trout and possibly cutthroat.

The fantastic fishing for steelhead (anadromous rainbow trout) and resident rainbow trout has attracted many foreign anglers since the fall of the Soviet Union. Kamchatka, because it is one of the largest untouched coldwater wildernesses on the planet, offers a unique opportunity for the study of pristine salmonid ecosystems. Outside of the port city of Petropavlosk, the peninsula is sparsely populated. The reindeer herders or Koryak peoples were largely wiped out by diphtheria, smallpox, and alcoholism, and it was off-limits to most Russians until perestroika. Massive volcanos (Mount Krushchevskaya, 14,000 feet, or about 4200 m), the largest brown bears in the world, and beautiful rivers with native trout and char all make Kamchatka an attractive destination for anglers with wanderlust.

The Wild Salmon Center in Edmonds, Washington, headed by Pete Soverel, has done a great deal (in tandem with Moscow State University) to preserve salmonid habitats in the Russian Far East. Limiting widespread poaching and pollution has helped keep the Kamchatkan fisheries pristine. Soverel has caught steelhead in Kamchatka close to 30 pounds (13.6 kg) and has spoken of Russian poachers who caught fish over 40 pounds (18.1 kg).

The coastal rainbow trout of Russia are abundant and similar to those in Alaska, Oregon, or California. More of a mystery, in Kamchatka and its neighboring islands, is the possible existence of cutthroat trout. What is certain is that trout have been caught with characteristic cutthroat markings, orange-red slashes under the jaw.

Mikhail Skopets recently sent me photographs of wild trout from the Shantar Islands, in the Sea of Okhotsk, that exhibit what he described as "one hundred percent cutthroat markings." Skopets believes that this trout is more ancient than the American rainbow and cutthroat. "It is older than the time of the division of American *Parasalmo* into two species and many forms." In an article in the summer 1996 issue of *Trout* magazine, Robert Behnke remarked on cutthroat-like specimens that had been recently caught in the Sedanka

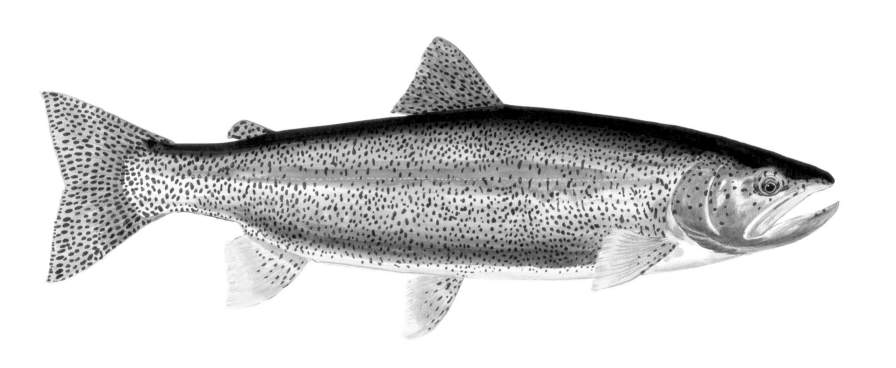

RAINBOW TROUT, KAMCHATKA, RUSSIA

Oncorhynchus mykiss mykiss

LANDLOCKED CHERRY SALMON, RAINBOW, AND CUTTHROAT TROUT

River in the Tigil River drainage: "The new trout from Kamchatka appears to represent a new subspecies of cutthroat trout, most closely related to North American coastal cutthroat." But Behnke has since revised his opinions on the cutthroat of Kamchatka and does not believe they are separate from rainbow trout.

The rainbow trout, *Oncorhynchus mykiss,* was thought to have originated in Russia and crossed to North America by leapfrogging rivers across the Bering land bridge when it was exposed during the last Ice Age. It is possible that the Kamchatkan cutthroat that Skopets describes is also the progenitor of North American cutthroat trout. Whatever the taxonomic diagnosis turns out to be, it is certain that these are beautiful fishes from fragile environs.

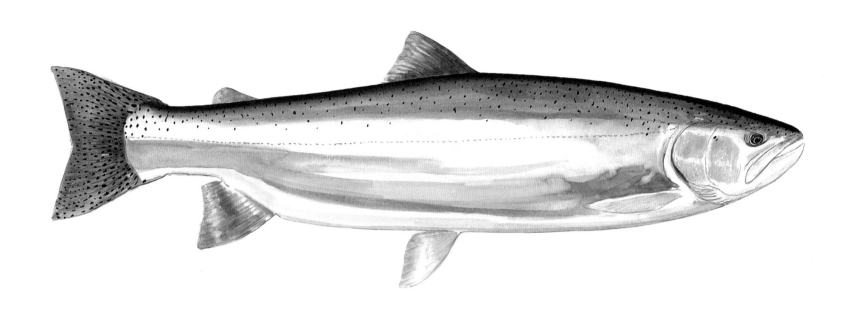

STEELHEAD TROUT, KAMCHATKA, RUSSIA

Oncorhynchus mykiss

LANDLOCKED CHERRY SALMON, RAINBOW, AND CUTTHROAT TROUT

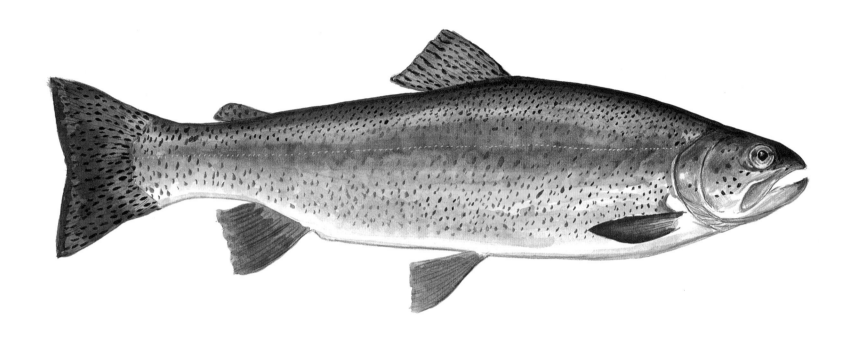

CUTTHROAT TROUT, SHANTAR ISLANDS, SEA OF OKHOTSK, RUSSIA

Oncorhynchus clarki

LANDLOCKED CHERRY SALMON, RAINBOW, AND CUTTHROAT TROUT

SELECTED DIVERSITY OF NORTH AMERICAN TROUTS

In September 2000, driving east from California to Colorado, I decided to stop in the desert to try to catch a native trout called the Humboldt cutthroat. I took Route 50 along Lake Tahoe and then into the desert wasteland, where the air hovered around 100 degrees. I spent the night in Elko, Nevada, lights flashing from casinos, the vibration of trucks on Route 80 shaking the water in the glass on my bedside table.

The next day I drove along the roads outside Elko toward the upper tributaries of the Mary's River. Rabbitbrush was in flower along the dirt trails, mountains formed up ahead, and a plume of dust behind me obscured what had come before. Antelope congregated around a water hole. A golden eagle flew across the road. I hit a whip-poor-will with my car and stopped to look for it and lament its death.

I was following a publication put out by the state of Nevada in the 1970s, a survey of remaining populations of the native cutthroat trout in these upper tributaries. It looked as if the stream with the greatest abundance of fish was one called Wildcat Creek. I wondered if, some thirty years later, the fish were still there. I followed a topographical map to find it. After turning onto a smaller dirt road on the other side of a cattle guard, I slowed to speak with a man standing by his truck—the only person I'd seen for miles. His name was Bill Gibbs, and he owned the ranch through which Wildcat Creek ran. He was watching yearling cattle that would soon be brought along Route 80 to feedlots in Nebraska. I asked him if he knew about the trout in Wildcat Creek. Would he mind if I fished it? He said that the summer before, a wildfire had burned on the property and gone right over the creek, and he wasn't sure if the trout had survived. He pointed to where the creek was. It would be about a mile walk from the road, and I was welcome to fish it.

When I saw the creek after a walk through the hot desert country, it looked like a creek in Hades. I half expected to see a fallen angel crouched beside it. The willows along the bank had been charred black, but there was a small intermittent blue ribbon of water coursing through. It resembled a sliver of sky. And when I peered into the water through the tangle of burned brush, I saw fish, remarkable luminous trout, and not so small, considering that the creek was no more than three feet across in most places.

I used only the top segment of my three-piece fly-fishing rod to dap a fly into small pools that I approached quietly and carefully.

In short order I caught one. Then another, and another. I carefully laid them on my hat to take pictures and then let them go. I made sketches with graphite and colored pencil that might help me remember the pink, purple, and ochre hues that I would try to recreate in the studio. The trout I released were so eager to bite that I probably could have caught each one a second time. I was covered in dust from crawling along the bank, and charcoal lines were drawn on my clothes from the burned limbs of sagebrush and willow and aspen that I'd pushed through as I walked. That evolution could produce such a fish, able to survive what nature had thrown at it for millennia, was remarkable.

We sometimes, correctly, think of nature as fragile. I have described the trout this way, too, and it is indeed vulnerable to rapid alterations of its habitat by humans, from pollution, climate change, or drawing water for irrigation. But all I could think of at that moment was the resilience of nature, the relentlessness of these fish in holding on in an ecosystem that most would consider hostile. I walked back, parched and humbled, to my car, conflicted about having disturbed this place but elated over what I had witnessed.

This, of course, was a personal experience that went beyond what a single name or even theory can impart. People called the fish in these upper tributaries the Humboldt cutthroat trout, related to a fish called the Lahontan cutthroat trout. Individuals argued over whether the Humboldt cutthroat should be given a subspecies name or not. Is it a subspecies? Is it distinct enough a population to be given species status? The question *What is that?* did not seem the most relevant one to ask. In the desert the only clear answer to me at that moment was: *It is.* You can argue over what category an individual fish fits into and never come up with a definitive answer—this kind of argument might never be resolved. But one truth you cannot deny is that it exists.

GOLDEN TROUT, VOLCANO CREEK, CALIFORNIA

Oncorhynchus mykiss aguabonita

HUMBOLDT CUTTHROAT TROUT, MARY'S RIVER BASIN, NEVADA

Oncorhynchus clarki

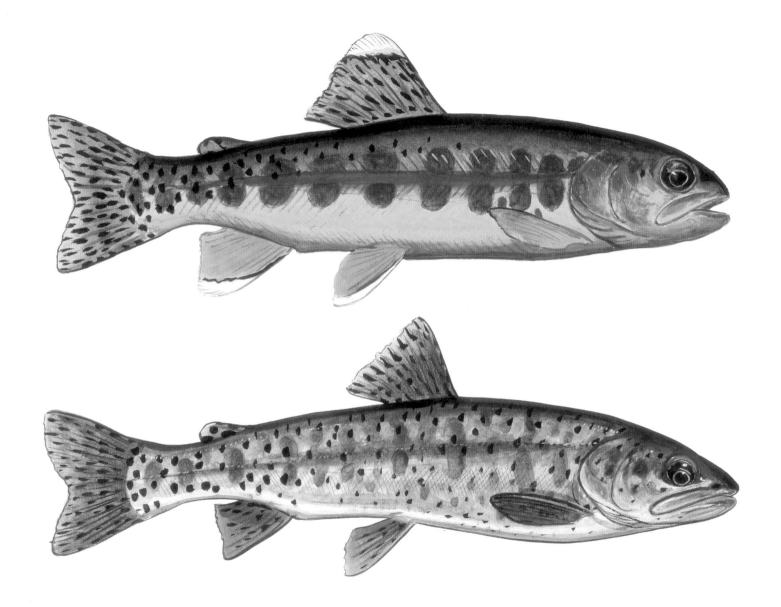

I believe that in the future we will no longer need to answer the question *What category does that fish fit into—what family, order, genera, or even species?* Rather, the relevant questions will be: *What is it related to? What is its position in the history of life? How long ago did X separate from Y?* I am not a taxonomist, one who spends his life trying to make sense of evolutionary history and then classify accordingly, though I admire that pursuit. My job is easy in comparison. I have set out to create a visual record of biological diversity. Instead of asking *What is that?* I am simply saying *Here it is.*

Since the publication of the first edition of this book, great changes have taken place in the communication and collection, retention, and dissemination of information about trout and other creatures on the planet. Not long ago, even as recently as the year 2000, my friends and I planned expeditions by handwriting letters to knowledgeable people in far-off lands and occasionally trying to coordinate a phone call. At that time, if you wanted to learn about a fish like the Humboldt cutthroat trout, there was very little written information and few images available. You had to go see it yourself.

The Internet has changed this. Personal blogs and Web sites kept by the trout-obsessed, mostly amateur anglers, contain hundreds of photos of native trout, often geo-referenced to the place where they were caught. Such aggregations of information are valuable growing catalogs of biological diversity that—in my opinion, as they accumulate with new knowledge of genetic relationships, behavior, and habitat requirements—will help the importance of certain taxonomic categories fade away. The arguments over what to call fish, I feel, will lose out to an interconnected, complex, reticulate story of life.

More than sixty of the fish in this book represent diversity within a single species—the brown trout, known by the Linnaean binomial *Salmo trutta*. By painting and presenting them here, I hope I have conveyed that the word *species*—in the way it is used in public, conservationist, and even scientific circles—is insufficient to communicate biological reality.

Darwin expressed his frustration with the word *species* and questioned where to draw lines amid infinite beauty and diversity.

YELLOWSTONE CUTTHROAT TROUT, SPAWNING MALE, YELLOWSTONE LAKE TRIBUTARY, WYOMING
Oncorhynchus clarki bouvieri

ADIRONDACK BROOK TROUT, ST. REGIS RIVER, WEST BRANCH, NEW YORK STATE
Salvelinus fontinalis

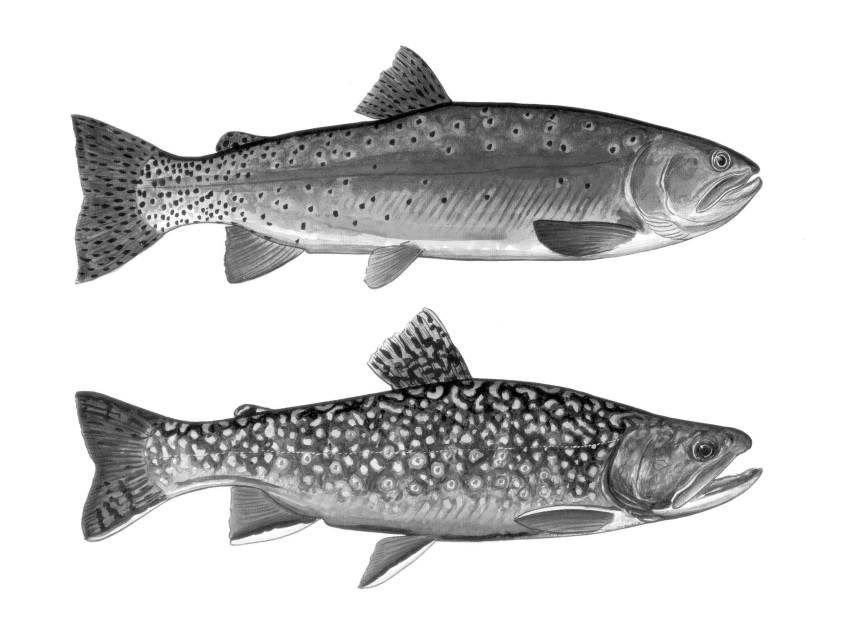

"It is really laughable," he wrote, "to see what different ideas are prominent in various naturalists' minds, when they speak of 'species' . . . It all comes, I believe, from trying to define the undefinable." In *Origin of Species*, he wrote, "I look at the term 'species' as one arbitrarily given, for the sake of convenience, to a set of individuals closely resembling each other."

Such is the source of my preoccupation—you could even say obsession—with our legacy of naming nature, which started with Adam's task to name all the creatures in the garden (as the story goes) but is really as old as language itself. Naming is a necessary act in communicating about the natural world, and an essential part of being human, but it also has great limitations in expressing the real nature of reality—which Darwin exposed to us with his account of the ever-evolving origins of species. Ours is a fluid, continuous, chaotic, and ever-changing world.

One hundred and twenty watercolors hardly do justice to the diversity of trout of the world. This book is, of course, a fiction, as you could never build an aquarium large enough or nuanced enough to house all these fish, but here, within these few pages, we can gaze at a fraction of their beauty and see just what we are talking about when we warn that we may lose them. Unless there is an international concerted effort to save trout, we will be the last generation to see many of these fish alive in their native habitats. Their disappearance would not only be a physical loss but a loss to the human imagination.

GILA TROUT, NEW MEXICO

Oncorhynchus gilae gilae

MEXICAN GOLDEN TROUT, RÍO VERDE, CHIHUAHUA, MEXICO

Oncorhynchus chrysogaster

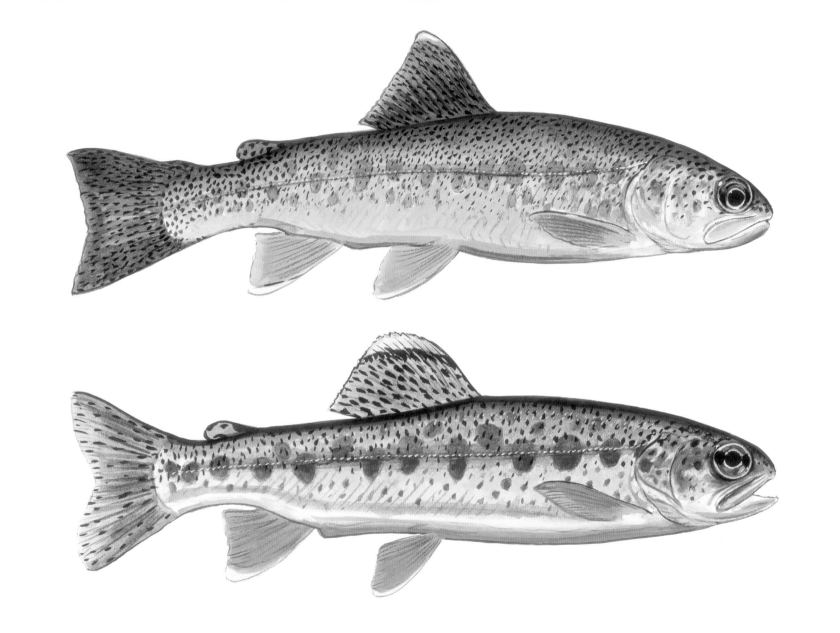

RIO GRANDE CUTTHROAT TROUT, NEW MEXICO

Oncorhynchus clarki virginalis

COLORADO RIVER CUTTHROAT TROUT, UINTA MOUNTAINS, UTAH

Oncorhynchus clarki pleuriticus

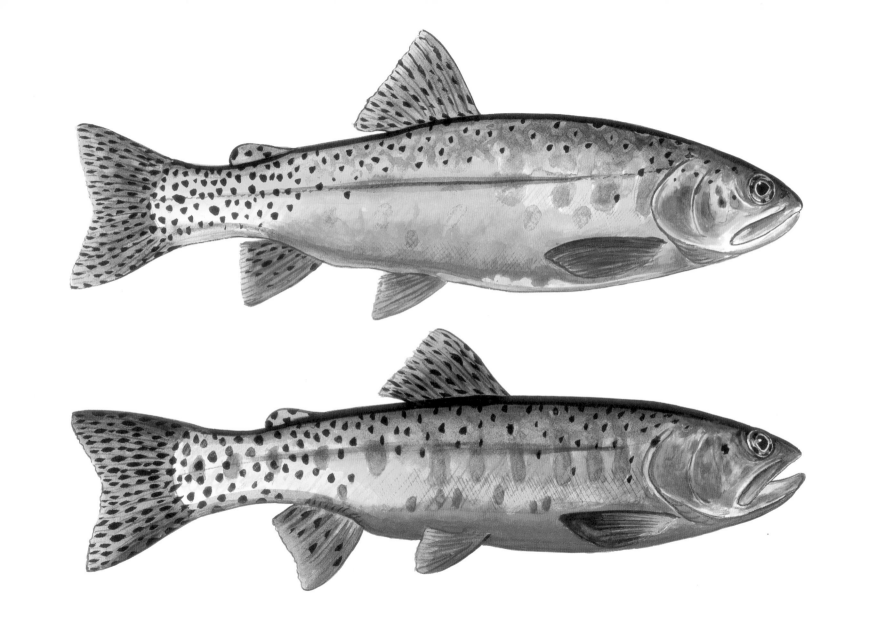

BLUEBACK TROUT, RAINBOW LAKE, MAINE

Salvelinus alpinus oquassa

BULL TROUT, HOOD RIVER, OREGON

Salvelinus confluentus

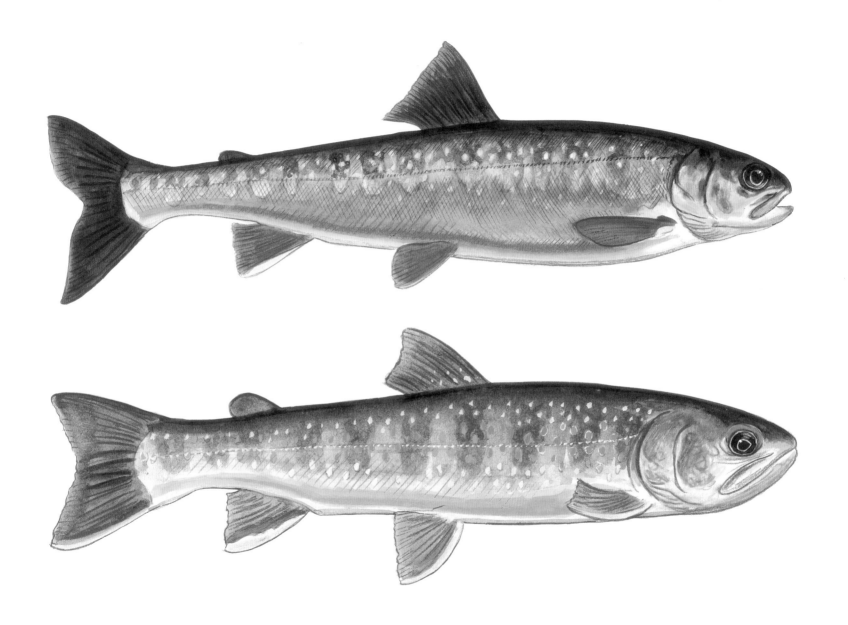

Acknowledgments

T HIS BOOK is dedicated to Johannes Schöffmann, an Austrian baker with a monomania for trout, who has been a faithful travel companion and friend for eight years. He, I am certain, has seen more indigenous specimens of the brown trout in their native habitat than anyone else on earth.

Bob Behnke also deserves many thanks, both for his help on my first book on the trout of North America (Knopf, 1996), and for his insights on the trout of Europe, Asia, and North Africa. He is part of a line of great American ichthyologists who have loved and studied trouts, which includes Louis Agassiz, David Starr Jordan, Paul Needham, and Carl Hubbs.

There are many others who have made my extensive travels more pleasant and have led me to rare and unusual trout, in particular Yoichi Machino, who specializes in Arctic char and crayfish. He is part of an esoteric group that call themselves the International Society of Arctic Char Fanatics, who have contributed much to the worldwide appreciation of *Salvelinus alpinus*. Pierre Affre, a retired veterinarian in Paris, possibly the craziest sportfisherman on the planet, has fed my mind with his knowledge of native trout and wine. Johannes and I, as well as Pierre, Bob, and Yoichi, have formed our own society, the International Society of *Schwarzfischers*, who are beholden to the

following motto: "to foster the urge to fish by any means possible in order to advance the awareness through art and science concerning salmonid fishes, especially trout and char." Incidentally, *Schwarzfischer*, literally "black fisher," is German for "poacher." *Schwarzfischers* meet at the Sonnhof bar in St. Veit an der Glan, Austria.

Among the other anglers, naturalists, scientists, and editors who have helped me in the seven years it took to put this book together: Dr. Katsuhiko Yoshiyasu, Robin Ade, James Card, Vincent Lalu, Philippe Boisson, Agnes and Bill Peele, Palmer Baker, Taylor Hoyt, Fred Kircheis, Takeo Kada, Aleš Snoj, Simona Susnik, Louis Bernatchez, Andrew Ferguson, Bill Young, Don Byrne, Jim Murphy, Julia Hertz, Michael Hansen, Johan Hammar, Myles Kelly, Dannie Goldrick, Jim Stafford, Mikhail Skopets, Sergei Alekseyev, Igor Chereshnev, Derby Anderson, Charles Rangeley-Wilson, David Scott, Mislav Jukic, Jim Mooney, Leslie Stoker, Beth Huseman, Paul Wagner, Elaine Markson, and Larry Ashmead. For the revised edition I would like to thank Hampton Carey, Manu Esteve, Waqas Wajahat, Travis Rummel, Yvon Chouinard, Bill Klyn, Jennifer Levesque, Jen Graham, Darilyn Carnes, Michael Jacobs, and Steve Tager. I would also like to thank Harold and Jeanne Bloom for their love and support of my work.

Selected Bibliography

This bibliography provides sources for those wishing to read more extensively on salmonid topics that are not discussed in depth in this book.

ALEKSEYEV, S. "Ontogenetic Changes in Diagnostic Characters of the Sharp-snouted and Blunt-snouted Lenok." *Zoologicheskiy Zhurnal* 69, 7 (1990): 80–88.

ALEKSEYEV S., M. Pichugin, and E. Krysanov. "Studies of the Transbaikalian Charrs Salvelinus alpinus, listed in the Red Data Book of the Russian Federation: Sympatric Forms from Lake Bol'shoi Namarakit." *Journal of Ichthyology*, 37, 8 (1996): 553–568.

ALLENDORF, FRED W., AND ROBB F. LEARY. "Conservation and Distribution of Genetic Variation in a Polytypic Species, the Cutthroat Trout." *Conservation Biology* 2, 2 (1988): 170–182.

BAKER, VALENTIN. *Clouds in the East: Travels and Adventures on the Perso-Turkoman Frontier.* Unabridged facsimile. London: Chatto and Windus, 1876; Elbrion Classics, (1900).

BEHNKE, ROBERT J. "American Brown Trout: An Immigrant's Story." *Fish and Fly Magazine* (Spring 2001): 25–33.

BEHNKE, ROBERT J. "Organizing the diversity of the Arctic charr complex." Biology of the Arctic Charr: Proceedings of the International Symposium on Arctic Charr, Winnipeg, Manitoba, May 1981 (1981), ed. L. Johnson and B. L. Burns. 3–21.

BERG, L. S. *Freshwater Fishes of the U.S.S.R and Adjacent Countries.* Vol. 1. 4th ed. Washington, D.C.: published for the National Science Foundation, by Israel Program for Scientific Translation, 1962 (originally published 1948).

BERNATCHEZ, LOUIS. "The Evolutionary History of Brown Trout (*Salmo trutta L.*) Inferred from Phylogeographic, Nested Clade, and Mismatch Analyses of Mitochondrial DNA Variation." Evolution 55 (2001): 351–379.

BOWDICH, LEE AND SARAH (MRS. T.) EDWARD. *The Fresh-Water Fishes of Great Britain, Printed for the Authoress and R. Ackermann.* London: n.p., 1838.

COUCH, JONATHAN. *A History of Fishes of the British Islands.* London: Groombridge and Sons, 1877.

FERGUSON, A. "Genetic Differences Among Brown Trout, Salmo trutta, Stocks and Their Importance for the Conservation and Management of the Species." *Freshwater Biology* 21 (1989): 35–46.

FERGUSON, A. "The Role of Genetics in Fish Conservation with Particular Reference to the Identification of Irish Brown Trout Bio-diversity." Belfast: Queen's University, 2002.

GREER, RON. *Ferox Trout and Arctic Char.* Shrewsbury, England: Swan Hill Press, 1995.

GOLDSCHMIDT, TIJS. *Darwin's Dreampond,* Cambridge: MIT Press, 1996.

HOLCÍK, J. et al. *The Eurasian Huchen, Hucho hucho, Largest Salmon of the World.* Dr. W. Junk Publishers, 1988.

IVANOVIC, B. M. *Ichthyofauna of Skadar Lake.* Titograd, Podgorica, and Montenegro: Institute for Biological Research, 1973.

JARDINE, SIR WILLIAM. *British Salmonidae.* Edinburgh: privately printed, 1839–41.

JÓNASSON, PÉTUR M. ed. *Thingvallavatn.* Hillerod, Denmark: Freshwater Biological Laboratory, University of Copenhagen, 1992.

KIPLING, CHARLOTTE. "The Chars in English Books." ISACF Information Series. 5 (1991): 95–96.

MACHINO, YOICHI. "The Arctic Charr (*Salvelinus alpinus*) in France." ISACF Information Series 5 (1991): 113–20.

MACHINO, YOICHI. "The Status of *Salvelinus* in France." *Nordic J. Freshw. Res.* 71 (1995): 352–358.

MACAULAY, ROSE. *Towers of Trebizond.* New York: Carroll and Graf, 1956.

MAEKAWA, K. "Life history patterns of the Miyabe Charr in Shikaribetsu Lake, Japan." Biology of the Arctic char Ir (1984): 233–250.

POVZ, M., et al. *The Marble Trout in the Soca River Basin.* Slovenia: Tour de Valat, 1996.

SKAALA, OYSTEIN, AND KNUT E. JORSTAD. "Fine-spotted Brown Trout (*Salmo trutta*): Its Phenotypic Description and Biochemical Genetic Variation." *Can. J. Fish. Aquat. Sci.* 44 (1987): 1775–79.

SKAALA, OYSTEIN, AND GEIR SOLBERG. "Biochemical enetic Variability and Taxonomy of a Marmorated Salmonid in River Otra." *Nordic J. Freshw. Res.* 73 (1997): 3–12.

SKOPETS, MIKHAIL B., AND IGOR A. CHERESHNEV. "The Unique Charr Ichthyogenesis of the Ancient Lake El'gygytgyn (central Chukotka)." ISACF *Information Series* 5 (1991): 157–260.

SNOJ, ALEŠ, et al. "DNA phylogeny supports revised classification of Salmothymus obtusirostris." *Biological Journal of the Linnaean Society* 77 (2002): 399–411.

STEFANOVIC, DUSICA. "Racial and Ecological Study of the Ohrid Salmonids," trans. Paul Pignon. Belgrade, Yugoslavia (1966).

TORTONESE, ENRICO. *The Trouts of Asiatic Turkey.* Istanbul: Basimevi, 1954.

Selected books by James Prosek

Trout · Joe and Me · The Complete Angler · Early Love and Brook Trout · Fly-fishing the 41st Parallel · Eels · Ocean Fishes

This book was composed in Perpetua and Trade Gothic.
Perpetua was designed by the British typographer Eric Gill between 1925 and 1932 and released by the Monotype Corporation.
Trade Gothic was designed by Jackson Burke for the Linotype Corporation between 1948 and 1960.

Editors: Beth Huseman and Jennifer Levesque · Production: Kim Tyner and Anet Sirna-Bruder · Design: Paul G. Wagner
Printed and bound by Toppan Printing Co., Ltd.